0	20	200	–	(formerly
0,03	20	200	–	(from
0,05	20	200	–	(from
0,1	21	200	–	(From
0,19	22	200	–	(from
0,2	25	210	–	(furniture,
0,3	25	210	–	(granule
0,4	25	210	–	(grass
0,4	35	220	–	(in
0,5	40	240	–	(in
0,5	40	250	–	(in
0,5	45	250	–	(in
0,5	50	250	–	(including
0,5	50	250	–	(increasingly
0,7	50	250	–	(increasingly
0,7	50	280	–	(industrial
0,8	50	280	–	(infinite
0,97	50	300	–	(inside
1	50	300	–	(involving
1	50	300	–	(it
1	50	300	–	(Krüpex,
1	50	300	–	(LCF)
1	50	305	–	(LEDs
1	50	350	&	(length
1	50	350	&	(light
1	53	350	&	(made
1	54	350	(0.05	(made
2	55	355	(10	(mainly
2	55	355	(10,	(mainly
2	60	400	(1000	(maximum
2	60	432	(120°C)	(maximum
3	61	432	(150°C)	(maximum).
3	61	432	(20	(mirrors),
3	70	447	(25°	(Ø
3	70	447	(30	(often
3	70	500	(300%	(only
4	75	570	(4	(partitions,
4	80	600	(400	(phase-change
5	80	600	(5	(phase-changing
5	80	700	(54°C).	(PMMA,
5	90	935	(60%	(polyhedral,
5	90	956	(a	(polylactate)
5	97	980	(a	(preservation)
5	100	1000	(a	(pulsating)
5	100	1000	(a	(PVB)
5	100	1070	(also,	(quite
5	100	1200	(among	(roofing
7	100	1250	(and	(small,
8	100	1300	(and	(smoother
8	100	1300	(automotive).	(standard
10	100	2000	(available	(starch-bound
10	100	2000	(boat	(steel,
10	100	2004	(brightness	(Stockholm
10	100	2050	(by	(straw,
10	100	2050	(can	(stretched
10	100	2550	(catalyser	(such
10	100	3000	(certified	(such
10	100	3500	(CM500)	(such
10	100	5110	(CM590).	(such
10	100	–	(comparable	(sunlight
11	120	–	(computer	(tabletops).
12	122	–	(construction,	(uniform
12	125	–	(curtains	(unlike
12	125	–	(filled	(vapour
13	140	–	(flakes,	(w
14	150	–	(flat	(walls
14	150	–	(foam-filled	(wash
15	150	–	(footpaths,	(waves,
15	160	–	(for	(while
15	180	–	(for	(wood,
16	197	–		(www.metosilicio.com).
18	200	–		.
20	200	–		
20	200	–		
20				

.	3D	a	a	a
.	3-D	a	a	a
/	3-D	a	a	a
/	3-D	a	a	a
/	3-D	a	A	a
/	3-D	a	a	a
?	3-D	a	a	a
'active'	3-D	a	a	A
'carved'	3-D	a	a	a
'communicate'	3-D	a	a	A
'depth	3D-Tex	a	a	a
'digital'?	3D-Tex	a	a	a
'floating'	3M	a	a	a
'luminescent	40.5%	a	A	a
'memory',	40.5%	A	a	a
'pinpoints'	40°C).	a	a	a
'sculptural'	41,000-75,000	a	a	a
'traditional'.	46-micron	a	a	a
'30s-look	5%,	a	a	a
'70s,	50%)	a	a	a
'90s	-50°	a	a	a
+125°C.	50-metre	a	A	a
°C,	54°C,	a	a	a
0.13	5B,	a	A	a
0.2	6.3	a	a	a
0.28	6.5	a	a	A
0.3	60%.	A	a	a
0.3	600%.	a	a	a
0.3	70°C	a	a	a
0.3	800°C.	a	a	a
0.3/0.4	900°C,	a	a	a
0.5	99.8%	a	a	A
0.5	a	a	a	a
0.5	A_	a	a	a
0.5	a	a	a	a
0.50	A	a	a	a
0.7	a	a	a	a
0.7	a	a	a	a
1.07	a	a	a	a
1.5	a	a	a	a
1.5V	a	a	A	a
1.7	a	a	a	a
1:2.	a	a	a	a
10%.	A	a	a	a
100%-recyclable	a	a	a	a
100°C.	a	a	A	a
1000°C	a	a	a	A
1045-mm-wide	a	a	a	A
120°C.	a	a	a	a
120°C.	a	a	a	A
1200°C.	a	a	a	a
121°C.	a	a	a	a
125°C.	a	A	a	a
1310°C.	a	a	A	a
1450°C.	a	a	a	a
15°C	a	a	a	a
190°-210°C	a	A	a	a
190°C.	a	a	a	a
1920s,	a	a	a	a
1960s,	A	a	A	a
2.5	a	a	A	A
20th	a	a	a	A
20th	a	a	a	a
240°C	a	a	A	a
25-x-25-cm	a	a	a	a
260°C,	a	a	a	a
2-cm-wide	a	a	a	a
3.5	a	a	a	a
300.	a	a	a	a
37.5-centilitre	a	a	a	a
3D	a	a	a	a
3D	a	a	a	a

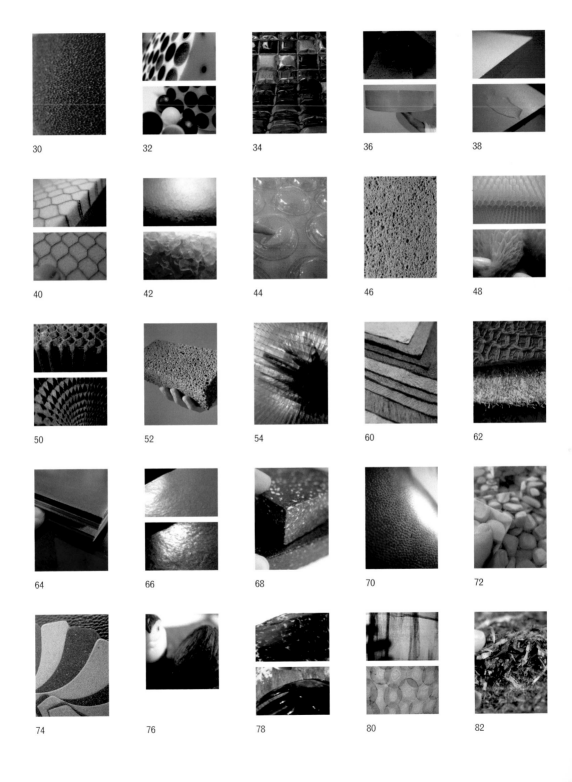

30

32

34

36

38

40

42

44

46

48

50

52

54

60

62

64

66

68

70

72

74

76

78

80

82

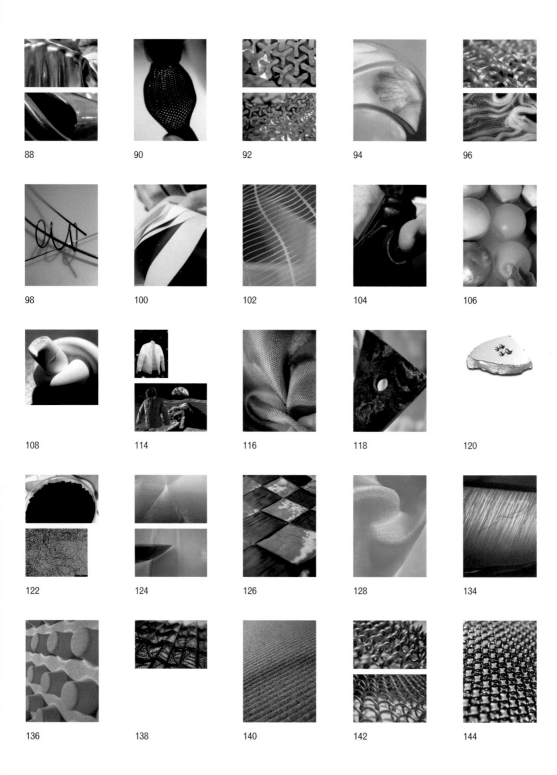

88

90

92

94

96

98

100

102

104

106

108

114

116

118

120

122

124

126

128

134

136

138

140

142

144

146 148 150 152 154

156 158 160 162 164

166 168 174 176 178

180 182 184 186 188

190 192 194 196 202

204

206

208

210

212

214

216

218

220

222

224

226

228

230

232

234

236

242

244

246

248

250

252

254

256

258

264

266

268

270

272

274

276

278

280

282

288

290

292

294

296

298

300

302

304

306

308

314

316

318

320

322

324

326

328

330

332

334

336

338

340

346

348

350

352

354

356

358

360

362

368

370

372

374

376

a	a	absorbs	adhesion,	airport
a	a	absorbs	adhesive	airy
a	a	absorbs	adhesive.	alarm
a	a	absorbs	advanced	Albeflex,
a	a	absorbs	advantage.	Albeflex's
a	a	absorbs	advantages	alder,
a	a	absorption	advantages	alder,
a	a	absorption	advantages	Alfa
a	A	abundance	advantages	alike.
a	a	abundant	advantages	Alioscopy
a	a	accelerates	advertising	Alioscopy
a	a	access	advertising	alkaline
a	a	accessories	advertising.	all
a	a	accessories	advice	all
a	a	accessories	aerated	all
a	A	accessories,	aerogel	all
a	a	accessories,	aerogel	all
a	a	accessories,	aerogel	all
a	a	accessories.	aerogel.	all
a	a	accessories.	Aerogel-crystal	all
a	a	accessories.	aerospace	all
a	a	accessories.	aerospace	all
a	a	accessories.	aerospace	all
a	a	accessories.	aerospace	all
a	a	according	aerospace,	All
a	A	according	aerospace,	all
a	a	according	aesthetic	All
A	a	according	aesthetic	all
a	a	accurate	aesthetic	all
a	a	achieve	aesthetic	all
A	a	achieve	aesthetic	all
a	a	achieved	aesthetic	all
a	a	achieved	aesthetic	all
a	a	achievement	aesthetic	all
a	a	acid,	aesthetically	all
a	a	acoustic	Aesthetically	all
a	a	acoustic	aesthetically	all
a	a	acoustic	aesthetically	all-in-one
A	a	acoustic	aesthetics,	allow
a	a	acoustics.	affecting	allow
a	a	acquire	affixed	allowed
a	a	across	African	allows
a	a	acrylic	After	allows
a	a	acrylic	After	allows
a	a	acrylic	after	allows
a	a	acting	After	allows
a	a	active	After	alloy
A	a	activities	against	alloy
a	a	actually	age,	alloy;
a	a	actuated	aged.	alloys
a	a	actuated.	agent	alloys
a	a	adapt	agent.	alloys
a	ability	adapted	agents	alloys
a	ability	adapted	age-old	alloys
a	about	added	aggressive	alloys
a	about	Added	ago	alloys,
a	above	added.	air	almost
a	abrades	addition	air	almost
a	abrasion	addition	air	almost
a	abrasion-resistant	addition	air	along
a	abrasion-resistant,	addition	air	along
A	Absolute	addition	air	already
a	Absolute	addition,	air	also
a	Absolute	Additional	air	also
a	absorb	additional	air	also
a	absorb	additives,	air	also
a	absorb	addressable,	air,	also
a	absorb	adds	air,	also
A	absorb	adds	air,	also
a	absorbers.	adds	air,	also
a	absorbing	adhere	airbrush.	also
a	absorbing	adheres	aircraft	also

also	an	and	and	and
also	an	and	and	and
also	an	and	and	and
also	an	and	and	and
also	an	and	and	and
also	an	and	and	and
also	an	and	and	and
also	An	and	and	and
also	an	and	and	and
also	an	and	and	and
also	an	and	and	and
also	an	and	and	and
also	an	and	and	and
also	an	and	and	and
altering	an	and	and	and
alternating	an	and	and	and
alternating	an	and	and	and
alternative	an	and	and	and
alternative	an	and	and	and
alternative	an	and	and	and
alternative	an	and	and	and
Although	an	and	and	and
Although	an	and	and	and
although	an	and	and	and
Although	an	and	and	and
Although	an	and	and	and
Although	an	and	and	and
altitudes	an	and	and	and
aluminium	an	and	and	and
aluminium	an	and	and	and
aluminium	an	and	and	and
aluminium	an	and	and	and
aluminium	an	and	and	and
aluminium	an	and	and	and
aluminium	an	and	and	and
aluminium	an	and	and	and
aluminium).	an	and	and	and
aluminium,	an	and	and	and
aluminium,	an	and	and	and
aluminium,	an	and	and	and
aluminium.	an	and	and	and
aluminium.	an	and	and	and
ambary	an	and	and	and
Ambient	an	and	and	and
ambitious	an	and	and	and
America,	an	and	and	and
American	an	and	and	and
Amoco	an	and	and	and
among	an	and	and	and
among	an	and	and	and
Among	An	and	and	and
among	an	and	and	and
among	an	and	and	and
among	an	and	and	and
among	an	and	and	and
among	An	and	and	and
amorphous	an	and	and	and
amorphous	an	and	and	and
amount	an	and	and	and
amount	an	and	and	and
amount	an	and	and	and
amplitude	an	and	and	and
amulets,	an	and	and	and
amusement	anatomical	and	and	and
an	and	and	and	and
an	and	and	and	and
an	and	and	and	and
an	and	and	and	and
an	and	and	and	and
an	and	and	and	and
an	and	and	and	and
an	and	and	and	and

Birkhäuser – Publishers for Architecture
Basel • Boston • Berlin

Material World 2

Innovative Materials for Architecture and Design

Frame Publishers
Amsterdam

Birkhäuser – Publishers for Architecture
Basel • Boston • Berlin

Legend

Air
Earth
Elastic
Extreme
Industrial
Know-How

Light

Optical

Smart

Surface

Sustainable

Temperature

Water

Contents

Used words *0 – a*	1
Picture index	3
Used words *a – and*	9
Title page	11
Legend	14
Contents	16
Used words *and – as*	19
Introduction	21
Used words *as – by-product*	27

Air
Introduction	29
Copper Foam	30
Eccosphere	32
FullBlown	34
Lége Béton	36
Metapor	38
Mikor	40
Nanogel	42
PluriGigaBall	44
SLP	46
Supracor / Stimulite Honeycomb	48
ThermoStack	50
Vulcarix	52
Wavecore	54

Used words *by-product – create*	57

Earth
Introduction	59
BarkCloth	60
Belly / Bullfrog Skin / Rumen	62
Cuoioarredo	64
MicaPaper	66
NaturAsphalt	68
Parchment	70
Riverstone	72
Synderme	74
Tagua	76
Tortoiseshell	78
Vegetable Paper	80

ZosteraMat	82
Used words *create – environmentally*	85

Elastic
Introduction	87
Avantige	88
Expando	90
ForMetal	92
Jelly Tile	94
Morphogenese	96
Niti Tubes	98
Plylin	100
Rebound	102
Stretch Leather	104
Synthetix	106
TexFlex	108

Used words *environmentally – ForMetal*	111

Extreme
Introduction	113
Absolute Zero	114
Basalt Fab	116
Fortadur	118
LiquidMetal	120
Nanotube	122
Spectra	124
Textreme	126
Turtleskin	128

Used words *ForMetal – in*	131

Industrial
Introduction	133
3-D Textile	134
3D-Tex	136
B-GON	138
Calme / Almute	140
Cascade Coil Drapery	142
Chainex 0.7	144
Chrome Waxed Leather	146
Cylindrical Filters	148

Cylindrical Spring 150
Felt Block 152
FiltroCell 154
Krütex 156
Pertinax 158
Pillow Plate 160
Road Surface 162
Sparoc 164
SpiraWave 166
Web Plate 168

Used words *in – is* 171

Know-How
Introduction 173
3-D Printed Textiles 174
3D Veneer 176
Appia 178
Cristal de Ravier 180
Curv 182
IronX 184
Metal Textile 186
PhotoGlas 188
Polsterflex 190
Reptile 192
TSP 194
VitroLux 196

Used words *is – made* 199

Light
Introduction 201
Brightness Enhancement Film 202
DualGlo 204
Duran Tube Filter 206
Elumin8 208
Holo-Color 210
iColor Tile FX 212
Kapipane 214
LCF 216
LightBlocks 218
Lightiss 220
LiTraCon 222

Louverscreen 224
Optic Mesh 226
Power Glass 228
powerLED 230
Radiant Color Film 232
Schott ICR 234
Solatube 236

Used words *made – nickel,* 239

Optical
Introduction 241
Alioscopy 242
Angelina 244
Deep 3D 246
Neoparies 248
Optical Lenses 250
Plexiglas Heatstop 252
Polarisant 254
Polispectral 256
Veluna 258

Used words *nickel-titanium – Opening:* 261

Smart
Introduction 263
Electric Plaid 264
EMFiT 266
Flexinol 268
IntegratedCircuit 270
PaperPC 272
Power Paper 274
Sensitive Carpet 276
Sensitive Object 278
SOFTswitch 280
SplashPad 282

Used words *Openings – Prize* 285

Surface
Introduction 287
Artema 288
Blow Print 290

Curious Collection 292
DigiMotifs 294
Ecosolution 296
MagnetPaint 298
Metallization 300
MirrorFloor 302
Sérilith 304
Silver 306
Thalweg 308

Used words *prized – seconds* 311

Sustainable

Introduction 313
BatiPlum 314
Canatex 316
Clean Green Packing 318
Fasal 320
Ingeo 322
Moniflex 324
Natural Fibre 326
Nettle 328
PanLin 330
Plasticana 332
Potato Plate 334
Soft and Squishy 336
Soybean Fibre 338
Zelfo 340

Used words *secret – surrounding* 343

Temperature

Introduction 345
Cast Basalt 346
Cooking Tiles 348
Glacé 350
Hapuflam 352
Micronal 354
Rubitherm GR / FB 356
SaniFriz 358
Thermo-Pad 360
Wx Film 362

Used words *suspended – the* 365

Water

Introduction 367
Living Floor 368
Oceanshell 370
OsmoFilm 372
Stockosorb 374
Vilene 376

Used words *The – to* 379
Glossary 381
Used words *to – walls* 395
Colophon 397
Used words *walls - Zosteramat* 399

and	and	and	and	and
and	and	and	and	and
and	and	and	and	and
and	and	and	and	and
and	and	and	and	and
and	and	and	and	and
and	and	and	and	and
and	and	and	and	and
and	and	and	and	and
and	and	and	and	and
and	and	and	and	and
and	and	and	and	and
and	and	and	and	and
and	and	and	and	And
and	and	and	and	and
and	and	and	and	and
and	and	and	and	and
and	and	and	and	and
and	and	and	and	and
and	and	and	and	and
and	and	and	and	and
and	and	and	and	and
and	and	and	and	and
and	and	and	and	and
and	and	and	and	and
and	and	and	and	and
and	and	and	and	and
and	and	and	and	and
and	and	and	and	and
and	and	and	and	and
and	and	and	and	and
and	and	and	and	and
and	and	and	and	and
and	and	and	and	and
and	and	and	and	and
and	and	and	and	and
and	and	and	and	and
and	and	and	and	and
and	and	and	and	and
and	and	and	and	and
and	and	and	and	and
and	and	and	and	and
and	and	and	and	and
and	and	and	and	and
and	and	and	and	and
and	and	and	and	and
and	and	and	and	and
and	and	and	and	and
and	and	and	and	and
and	and	and	and	and
and	and	and	and	and
and	and	and	and	and
and	and	and	and	and
and	and	and	and	and
and	and	and	and	and
and	and	and	and	and
and	and	and	and	and
and	and	and	and	and
and	and	and	and	and
and	and	and	and	and
and	and	and	and	and
and	and	and	and	and
and	and	and	and	and
and	and	and	and	and
and	and	and	and	and
and	and	and	and	and
and	and	and	and	and
and	and	and	and	and
and	and	and	and	and
and	and	and	and	and
and	and	and	and	and
and	and	and	and	and
and	and	and	and	and

and	Appia	applying	are	are
and	appliances	appreciate	are	are
and	application	approx.	are	are
and	application	approx.	are	are
and	application	approximately	are	are
and	application	approximately	are	are
and	Applications	aprons.	are	are
and,	applications	aquariums.	are	are
and,	applications	aramid,	are	are
and,	applications	arc	are	are
and,	applications	architect	are	are
and,	applications	architectonic	are	are
and,	applications	architectonic	are	are
and,	Applications	architects	are	are
and/or	applications	architects	are	are
and/or	Applications	architects	are	area
and/or	applications	architects,	are	area
Angelina	applications	Architects,	are	area
Angelina	applications	architectural	are	areas
Angelina	applications	architectural	are	areas
angels'	applications	architectural	are	areas
angle	applications	architecture	are	areas
angle	Applications	architecture	are	areas
angle	applications	architecture,	are	areas
angle	applications	architecture,	are	areas.
angle.	applications	architecture.	are	armrest
angles	applications	arctic	are	aromas
angles	applications	are	are	around
angles.	Applications	are	are	around
angles.	applications	are	are	around
angles.	Applications	are	are	arrangement,
angular	Applications	are	are	art
animal	Applications	are	are	art,
animals.	applications	are	are	art.
animated	Applications	are	are	Artema
animated	applications	are	are	Artema
animation	Applications	are	are	artificial
anisotropic	Applications	are	are	artificial
anodized	Applications	are	are	artificial
another	applications	are	are	artificial
another	applications	are	are	artisanal
Anticipated	applications	are	are	artistic
antifreeze	Applications	are	are	as
anti-reflection	applications	are	are	as
anti-shock	Applications	are	are	as
anti-stick	Applications	are	are	as
any	applications	are	are	as
any	applications	are	are	as
any	applications	are	are	as
Any	applications	are	are	as
any	applications,	are	are	as
any	applications,	are	are	as
any	applications,	are	are	as
Apart	applications,	are	are	As
apparel	applications,	are	are	as
apparent	applications,	are	are	as
apparently	applications,	are	are	as
appeal	applications,	are	are	as
appealing	applications,	are	are	as
appear	applications,	are	are	as
appear	applications,	are	are	as
appearance	applications.	are	are	as
appearance	applications.	are	are	as
appearance	applications.	are	are	as
appearance	applications.	are	are	as
appearance	applications.	are	are	as
appearance	applications.	are	are	as
appearance	applied	are	are	as
appearance	applied	are	are	as
Appia	applied,	are	are	as
Appia	applied,	are	are	as

Introduction

MatériO is taking up where Edwin van Onna and the editors of
Frame magazine, organizers of the first edition of *Material World*,
left off. Hence the title of this book: *Material World 2*, a somewhat
ironic reference to the generally accepted idea that we live in
a very material world that often neglects the spiritual aspect
of life. It's a reference to the eternal human struggle between
tangible and intangible, ordinary and extraordinary.

 The title reminds us that our everyday lives are dominated
by materials, even though our world is frequently qualified as
'virtual', populated as it is by video games, enhanced reality, the
Internet and new technologies – things that distance us from
the physical dimension of our existence while simultaneously
emphasizing our desire for that same materiality.

Material World 2 is, above all, concrete and straightforward.
The book describes 150 unique materials, techniques and
technologies carefully selected from among the thousands
referenced by matériO. We chose them not for their potential
applications in architecture and design, but because we see
them as emblematic of what can be achieved today. We believe
they offer a snapshot of our era: its future (smart), its prospects
(extreme), its history (earth), its magic (optical), its aspirations
(air) and its concerns (sustainable).

 Indeed, in the strictest sense of the word, 'material' is not
the best definition for every entry in this book, many of which

are semi-manufactured products (composites, honeycomb plastics, high-tech textiles and the like) or even techniques and technologies selected for their potential applications.

Why such a random selection of materials? One answer to that question lies in the brief history of a product known worldwide. At the beginning of the 20th century, the newly emerging electricity industry experienced a skyrocketing demand for insulation materials in all segments of the market (generation, distribution and electrical appliances). At the time, mica sheet was a highly popular material used to make insulators. Mica, a natural laminate, is a good insulator that remains stable at high temperatures, but it has several disadvantages: it's fragile, it can contain flaws, and it's fairly costly. Consequently, in 1913 two American researchers came up with a new, high-quality insulation material made by coating sheets of kraft paper with phenolic resin, in imitation of the stratified structure of mica. The resulting material provided insulation equal to that offered by mica; it was also stronger and easier to produce than the thin sheets of mica had been. Thus was born HPL (high pressure laminate), which eventually replaced mica and became known as 'for-mica'.

HPL's initial applications were for electrical appliances (circuit boards), mechanical components and shuttles for weaving looms. It took another 15 years before 'Formica' began to enjoy phenomenal success in the furniture industry following a chance meeting between the inventor of the new insulation material and designers working for furniture manufacturers.

This example is one of many hundreds that illustrate how the applications of a material can migrate. We believe there are three key points to be learned from it.

 - Every material, and the numbers are increasing, has applications not yet recognized.

 - Disseminating information extensively and beyond the scope of obvious applications is a precondition for discovering new applications.

 - Such dissemination requires a new approach on the part of manufacturers and designers

An explosion of materials

The story of how Formica migrated from one sector to another could be multiplied to infinity given the huge and growing number of materials, semimanufactured products and material-related technologies around today. The latter half of the 20th century saw explosive growth in innovation as regards 'classical' materials (complex glass, new metal alloys, wood derivatives and so on) and, more particularly, as regards the creation of composite materials, the incredible success story of polymers, the recent emergence of so-called 'intelligent' materials, nano-technologies, bio-materials – the list is endless. Manufacturers experiment with specific materials to solve specific problems: materials for a product that must be impermeable to water but not to certain gases, for a product that has to withstand high temperatures without losing rigidity or electrical insulation properties, for a product designed to deflect specific wave-

lengths of light at a specific angle, to be printable on one side or to resist UV light. Research and development laboratories are designing materials apparently originating in the realms of fantasy, and hundreds of new possibilities surface every day. Only a few will find relevant applications if their existence is not made known to a wide audience, however. After all, Formica could have remained the sole preserve of electrical insulation had it not been for its chance encounter with the world of furniture.

Communication is everything

Getting the word out may not seem like much of a problem in an era characterized by information technology, high-tech media and mass communication. It has become almost a cliché to say that globalization has opened borders, made us more interdependent and greatly increased the flow of goods, news and interaction. In certain areas, however, we see the continued existence of barriers, of hermetically sealed walls: industry, for instance, is dominated by a sector-based logic, a culture of segregated applications that hampers the migration of materials. It has to be said that the researchers and engineers who design new materials are not ideally placed to list all the potential applications of their creations; nor does the manufacturer who comes up with a semi-finished product for a specific purpose necessarily have the wherewithal to determine how it might otherwise be used. This is not their role. A company that manufactures filtration tubes for the food industry, for example, does not automatically see its product as a cladding for

concrete columns in interior design or as an effective sunshield for a high-tech building façade. And in all probability the inventors of a non-woven fabric for use in the nuclear industry and in hygiene products have no realization of the aesthetic qualities that might make the fabric an overnight success in the packaging industry.

Thinking out of the box

Another approach to this book may have been to list each and every newly invented material, allowing readers to fish out what they find interesting. Perhaps we should have created a supermarket of materials and semi-products, offering nothing exclusive and excluding nothing, a gigantic playground for the designer, the Luna Park of materials! Our responses to such a mountain of possibilities are 'too much choice means no choice' and 'profusion stifles creation'. The virtually unlimited range of materials available today tempts the designer to showcase the material rather than the design, to neglect vital aspects of the design process, to come up with something with no future, something frivolous and stripped of significance. At the opposite end of the spectrum is the equally dangerous temptation to design an object without giving a thought to materials. Better to consider the characteristics and constraints of a material and use that knowledge to add a new dimension to the project. A good design combines intelligence, a measured approach, and the ability to extrapolate, adapt and imagine. The future depends on improving our capacity to understand, to dig deeper and

study harder. We must reject preconceived notions and learn to think out of the box – to risk doing what no-one has done before. Innovation is often nothing more than adapting something that already exists, giving it a new role and a new context. 'Think different' was the slogan of a series of adverts a few years back. So think different. Be a nonconformist. Follow your instincts. Feel free. Create.

On the verge of a revolution?

Material World 2 is not a catalogue from the supermarket. It is a glimpse through a half-open door that invites you to enter a rich world still brimming with surprises. And this is just the beginning. Human curiosity will not be satisfied until we have a zillion polymorphous materials that together can be seen as a universal modelling clay for crafting everyday life. Science, and nanotechnology in particular, holds unlimited potential in this regard. We are doubtless on the verge of witnessing a veritable revolution, one that will lead to materials for every requirement imaginable. Nanomaterials are already revolutionizing our knowledge, our concept and our control of the elements, opening the door to an infinite store of new materials and new qualities. But more about all that in *Material World 3* ...

Quentin Hirsinger & Elodie Ternaux
matériO

as	as	attractively	available.	be
as	as	authentication,	available.	be
as	as	auto-cooling	available:	be
as	as	automated	available:	be
As	as	Automatic	Avantige	be
as	as	automatic	Avantige	be
as	as	automotive	averse	be
as	as	automotive	aviation	be
as	as	automotive	aviation),	be
as	as	automotive	away	be
as	as	automotive	B.Lab	be
as	as	automotive	backing	be
as	as	automotive	backing.	be
as	As	automotive	backings,	be
as	as	automotive	bags	be
as	as	automotive	bags	be
as	as	automotive,	bags,	be
as	as	automotive,	bags.	be
as	As	Available	baker.	be
as	as	available	Bal	be
as	as	available	ball	be
as	as	available	ballistic	be
as	as	available	bamboo,	be
as	as	available	bands.	be
as	as	available	banknotes	be
as	as	available	banned	be
as	as	available	barbed	be
as	as	available	Barcodes	be
as	asbestos	available	bark	be
as	asbestos	available	bark	be
as	asbestos.	available	BarkCloth	be
as	ash.	available	BarkCloth,	be
as	asphalt	available	BarkTex	be
as	asphalt.	available	barrier	be
as	assembly	available	bars).	be
as	asset	available	Bars,	be
as	asset	Available	Basalt	be
as	associated	Available	basalt	be
as	associated	available	Basalt	be
as	associated	Available	basalt	be
as	asymmetric,	available	Basalt	be
as	at	Available	Basalt	be
as	at	available	basalt	be
as	at	available	basalt	be
as	at	Available	basalt,	be
as	at	Available	base	be
as	at	available	base	be
as	at	available	based	be
as	at	available	based	be
as	at	available	based	be
as	At	available	based	be
as	at	available	based	be
as	at	available	based	be
as	at	available	BASF,	be
as	at	available	basic	be
as	at	Available	basic	be
as	at	available	basin	be
as	at	available	bath	be
as	at	Available	bath	be
as	at	Available	bathroom	be
as	at	Available	bathrooms,	be
as	Atelier	Available	BatiPlum	be
as	athletes	available	BatiPlum	be
as	athletic	available	BatiPlum	be
as	Athletics	Available	BatiPlum	be
as	atmospheric	available	batteries,	be
as	atomic	available	battery	be
as	atop	available	battery	be
as	attachments,	available.	Batyline	be
as	attractive	available.	be	be
as	attractive	available.	be	be
as	attractive	available.	be	be

be	being	black-and-white	boxes	but
be	being	blend	braided	but
be	being	blend	Braille	but
be	being	blend	Brazil,	but
be	being	blend	bread	but
be	Belly	blend	breakage	but
be	Belly	blends	breakage	but
be	Belly,	blends	breakaway	but
be	belts.	blends,	breaking.	butchers'
be	bends.	blends.	breathable	buttons
be	benefit	blink	breathable	buttons,
Beach	Benefits	block	breathable	buy
beaches	Benefits	block	breathable.	by
beaches),	beryllium)	Block	breathes	by
bearings	best-performing	block	breweries,	by
bearings,	Béton	block	Brick	by
beautiful,	Béton	block	bricks	by
beauty	Béton	block,	Brightness	by
became	Béton	blocks	brightness.	by
Because	better	blocks	brilliance	by
because	better	blocks	brilliant	by
Because	between	blocks	brilliant	by
Because	between	blocks	Britain.	by
because	between	blocks	brittle	by
because	between	blocks	broad	by
become	between	blocks	broad	by
become	between	blocks	broken	by
become	between	blocks	bronze,	by
becomes	between	blocks	bronze,	by
becomes	between	blocks,	bronze,	by
becomes	between	blocks.	brown	by
becoming	between	Blow	brown	By
becoming	between	Blue	brown,	by
bedding	between	blue	brown,	by
beds	between	blue	brown,	by
beds,	between	blue,	brush.	by
beech,	between	blue,	bubble	by
been	between	blue.	bubbly	by
been	beverages	Blue-Magenta-Gold	building	by
been	beyond	blue-tinged	building	by
been	B-GON	bluish	building	by
been	B-GON's	board	building	by
been	big	board,	building	by
been	big	boards,	building	by
been	bin.	boasts	building	by
been	bind	boasts	building	by
been	binder.	boiling	building	by
been	binders	bonding	building	by
beer,	binders,	Bonding	building	by
beetroots,	binding	book	building	by
BEF	binding,	bookbinding,	building.	by
BEF	biocompatible.	bookshelves,	buildings	By
BEF	biodegradable	boon	buildings,	by
Before	biodegradable	boot.	built-in	by
Before	biodegradable	boron	bulk	by
before	biodegradable,	Borrowed	bulletproof	by
before	biopsy	borrows	bulletproof.	by
before	birch.	both	Bullfrog	by
before	birds	both	Bullfrog	by
begin	bison	both	Bullfrog	by
begin	bit	Both	burial	by
beginning	bites,	both	business	by
behind	black	both	but	by
behind	black	both	but	by
behind	black	both	but	by
behind	black	Bottle	but	by
behind	black	bottle,	but	by
behind,	black	bottle,	but	by
beige	black	bottom	but	by
beige.	black,	bottom	but	By
being	black,	bowls,	but	by-product

Air

For today's designers and manufacturers, lightness is a key preoccupation. Materials are becoming both increasingly lightweight and increasingly robust. While weight may still be seen as a sign of quality and security in some quarters, its days are numbered. In an era of low-fat zero-sugar foods, people are no longer willing to hike around with tons of equipment on their backs, and it no longer takes a bodybuilder to lift a bicycle. Lighter materials are helping us achieve new goals. A huge explosion in the use of composite materials that incorporate honeycomb sandwich panels, for example, is the perfect illustration. Such air-filled products have form, bulk and structure. Indeed, air is taking over to the extent that often little of the actual material remains. Certain silicon gels (such as Nanogel) contain up to 99% air. Frequently considered irrelevant, air has immense strength. Pressurized air can be used to inflate an object until it explodes. Amusement parks are opening up new attractions that propel visitors several metres into the air on a cushion of compressed air. Air, an invisible and omnipresent material, has not said its final word.

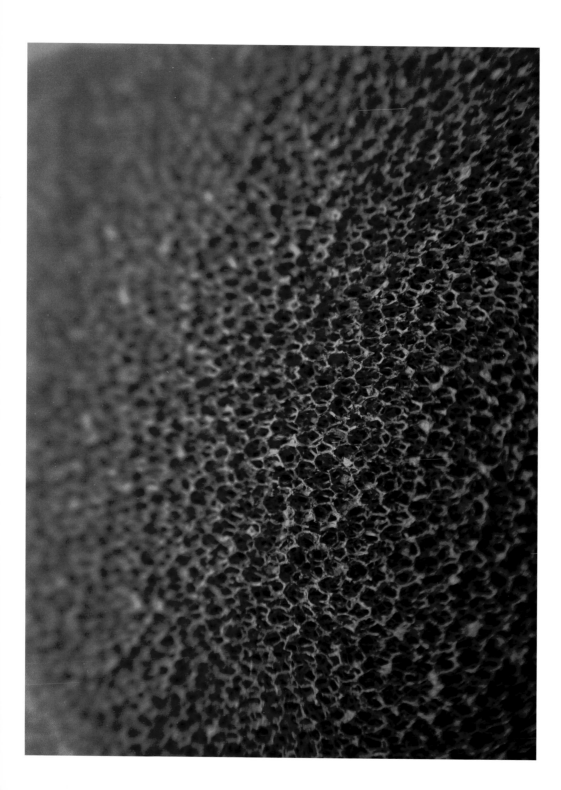

Manufacturer

SCPS
85-93 boulevard Alsace-Lorraine
93115 Rosny-sous-Bois
France

T +33 (0)1 4854 5636
F +33 (0)1 4854 5462
scps-group@wanadoo.fr
www.scps-group.com

Copper Foam

383, 385, 390, 385 — Copper-foam structures are made using polymer foam
383, 390, 385 — coated with a conductor substrate. A block of polymer foam
384 — is cut into rolls, which are placed into an electrolysis bath
388, 383 — to obtain a uniform deposit of metal throughout all cells of
385, 390 — the foam. A thermal treatment then destroys the polymer,
383 — leaving the copper deposit intact. The same technique can
388, 388, 387 — be used with other metals, including nickel, lead and even
388, 388 — precious metals. The weight of the metal deposit varies
388, 385 — from 0.3 to 1 kg per square metre. Metal-foam structures
388 — are widely employed in electrical engineering, the metal-
chemicals industry, and electromagnetic and thermal
insulation (catalyser support, alkaline batteries,
384, 388 — electrolysis-based metals recycling, thermal exchangers
and so forth).

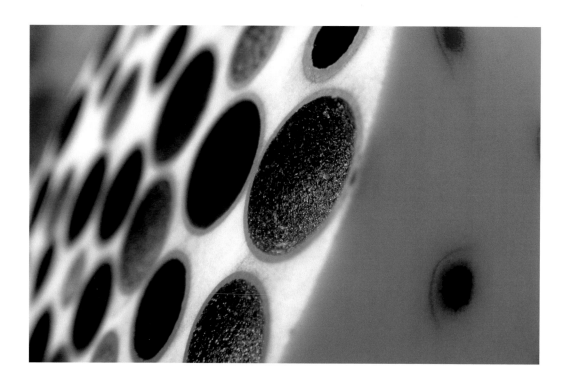

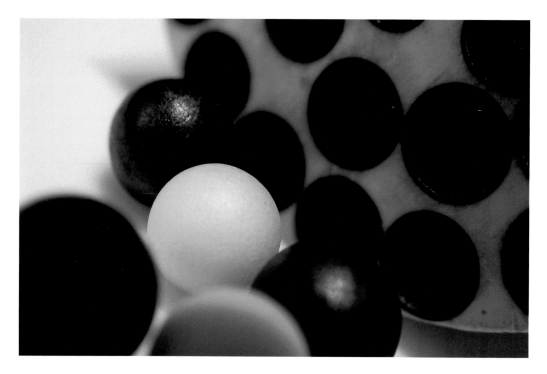

Manufacturer
Emerson & Cuming T +1 781 8214 250
59 Walpole Street F +1 781 8210 737
Canton, MA 02021-1838 micro@emerson.com
USA www.emerson.com

Eccosphere

Eccosphere macrospheres are miniature, hollow, composite spheres (Ø 10 to 54 mm) that are light and stable at temperatures up to 121°C. Used in conjunction with various resins, this material offers low-density thermal and sound insulation, control over mechanical properties, and lower resin-production costs. These macrospheres are pressure resistant and can withstand many highly aggressive industrial processes. Often used in conjunction with their microsphere cousins (10 to 200 microns), Eccosphere macrospheres were originally developed as a means of controlling the evaporation of volatile liquids. They also find wide application as a density-reduction agent in all kinds of structures.

387

391, 384

391

388

387

384

Manufacturer
Full Blown Metals
Unit 6, The Clocktower
Buildings
Haverthwaite
Ulverston
Cumbria LA12 8LY
England

T +44 (0)709 2126 874
info@fullblownmetals.com
www.fullblownmetals.com

FullBlown

392

384, 388

387

381

Sheet steel inflated under pressure: a successful marriage between the toughness and density of the metal and the apparent lightness of the inflated structure. After two sheets (from 0.3 to 2 mm thick) are arc welded together around the edges, air is injected under pressure to create a three-dimensional volume. Borrowed from industrial processes used to make certain types of reservoirs, this technique produces aesthetically unique cushions: no two alike. Applications include furniture, walls, windbreakers, accessories and sculpture. Sizes range from 5 to 250 cm.

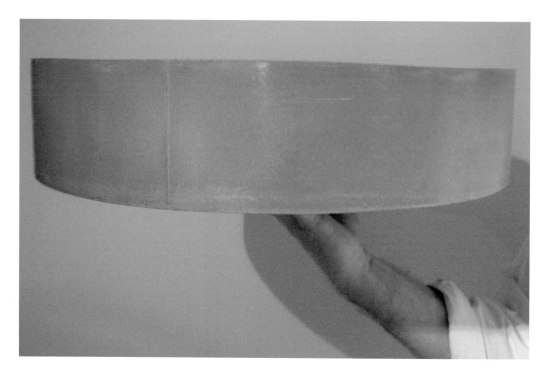

Manufacturer
La Compagnie Des Arts
1, rue Pierre Gourdault
75013 Paris
France

T +33 (0)1 4424 5001
ducancelle@tele2.fr
www.beton-lcda.com

Lége Béton

383

392, 383

385

To fully appreciate the potential of this unique composite material, you should hold a sample in your hands. Although it has the appearance and feel of ordinary concrete, Lége Béton is not nearly as heavy. Consisting mainly of concrete reinforced with synthetic fibres, Lége Béton is used to make hollow forms in a wide variety of colours and textures. Suitable for furniture and a range of interior-design applications, the material is watertight, waterproof and shockproof. The dye used to colour objects made of Lége Béton thoroughly penetrates the material.

384

Manufacturer
Portec
Barbara-Reinhart-
Strasse 22
8404 Winterthur
Switzerland

T +41 (0)52 2625 286
F +41 (0)52 2620 188
www.portec.ch

Metapor

381

387

381

384, 381

388

385

Metapor may look like ordinary aluminium, but it is much
lighter. A closer look reveals the product's microporous
structure. Metapor is comprised of 80% aluminium granules,
a small amount of epoxy resin for binding, and air, which
leaves the metal with a permeable surface. Available as
breathable blocks or panels that appear to be solid, Metapor
can be permeated by certain fluids. Industrial applications
include filtration and vacuum clamping. Dimensions:
50 x 50 cm. Thickness: 10 to 400 mm. Larger sizes available
on request.

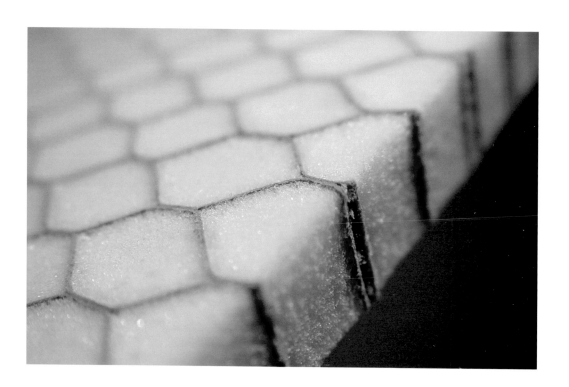

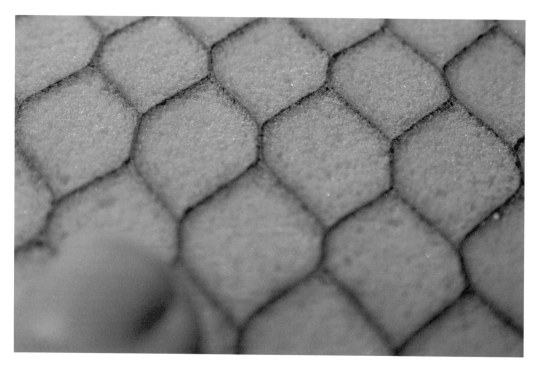

Manufacturer

MGi
511 Mercy Street
Selkirk, Manitoba
Canada R1A 2L3

T +1 204 4828 615
F +1 204 4828 625
info@mgicanada.com
www.mgicanada.com

Mikor

386

383, 385

384

385, 386

387

386

385

Honeycomb structures lend a high degree of rigidity to a wide range of materials. Filling the cells with foam adds to the shock and deformation resistance of the end product. Mikor is a revolutionary new material (foam-filled honeycomb or FFH) for the creation of ultra-light composites that have the physical properties of honeycomb and the convenience of foam panels. Chemical resistant and stable, Mikor also offers good sound insulation.

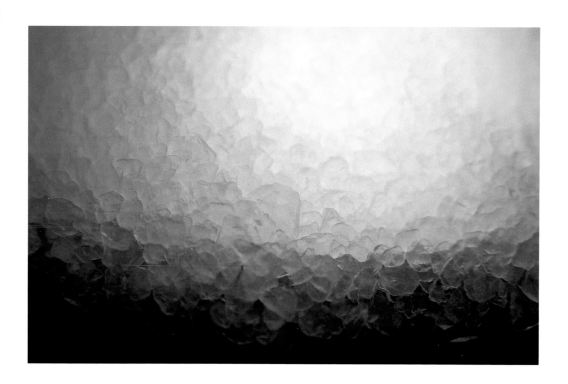

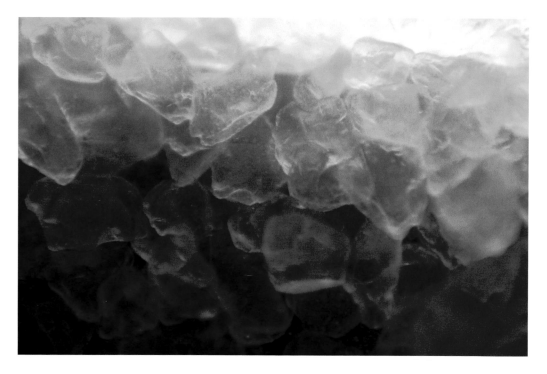

Manufacturer

Cabot
700 E. U.S. Highway 36
Tuscola, IL 61953-9643
USA

T +1 217 2533 370
F +1 217 2534 334
nanogel@cabot-corp.com
www.cabot-corp.com

Nanogel

Nanogel, also known as Blue Smoke, is a feather-light silicon aerogel. This solid, translucent, blue-tinged substance is 97% vacuum and 3% amorphous silicon. Initial, highly specialized applications limited the product mainly to the aerospace industry. Thanks to its exceptional heat- and sound-insulation properties, however, a granulated form of Nanogel is currently proving successful in the field of architecture. Sandwiching Nanogel between two panes of glass multiplies the degree of insulation offered by such double glazing by as much as four times. The light that filters through is soft and homogeneous, making the product particularly suited to museum settings. Nanogel is a stable, extremely fire-resistant substance that does not react to UV light or humidity. Density: 90 g/litre.

387, 391

381, 392

391

391

385

387

392

392

387, 384

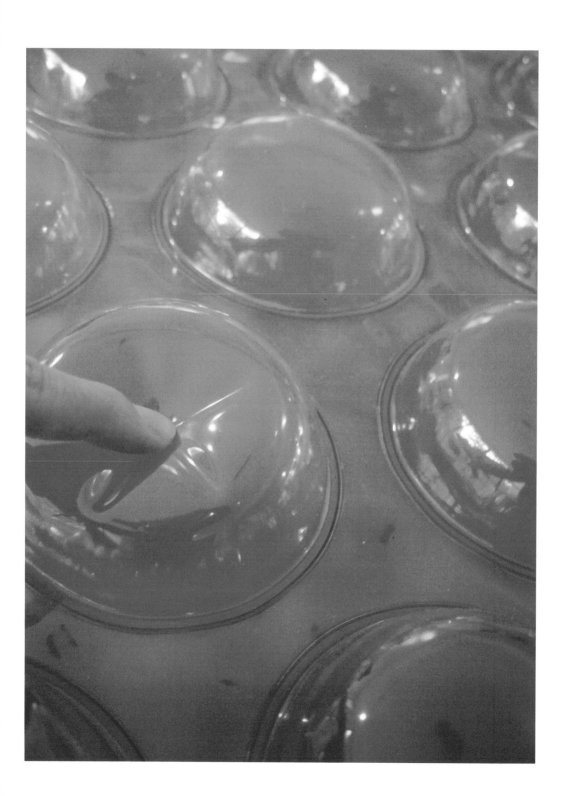

Manufacturer

Nucleo
Via Vittorio Andreis, 18/10
10152 Turin
Italy

T +39 011 5217 854
F +39 011 2475 066
nucleo@nucleo.to
www.nucleo.to

PluriGigaBall

Everyone is familiar with polythene bubble wrap, with its endless rows of miniature air cushions. PluriGigaBall is based on the same principle, but here the oversize pockets of air, each measuring Ø 25 cm, are encapsulated between two sheets of thermal-welded PVC. Lie down on this resilient cushion of air, and you're 'floating' 5 centimetres above floor level. PluriGigaBall is available for use as a mattress, a floor covering and a seating cushion. Colours are khaki, smoke, orange, strawberry and light yellow.

390
381
381
391
381, 392
392
387

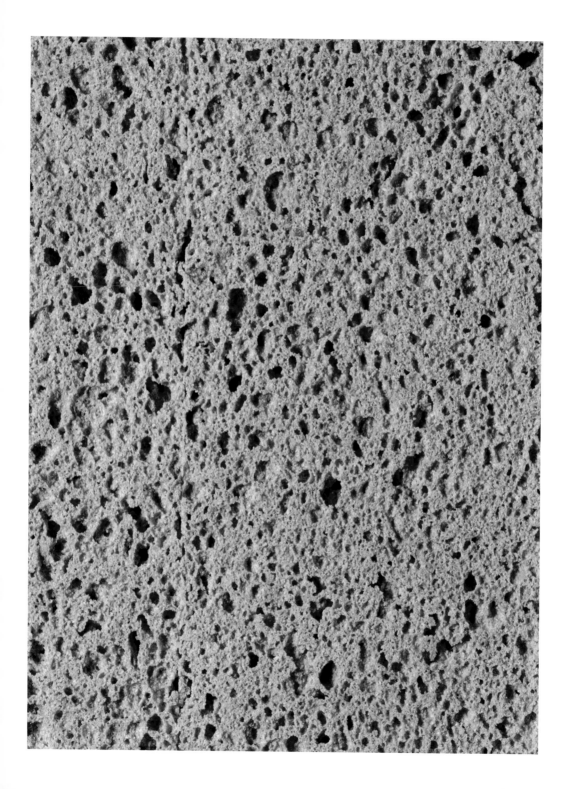

Manufacturer
Innovation Wood
PO Box 345
6301 Zug
Switzerland

T +41 (0)41 7609 080
F +41 (0)41 7609 081
info@iwood.ch
www.iwood.ch

SLP

384

SLP (starch-bound low-density wood-based panel) is environmentally friendly wood panelling composed of wood shavings and sawdust: a recipe that might have been invented by a baker. Having been mixed with yeast and fungal microorganisms, rolled out and allowed to begin drying, the shavings and sawdust rise like bread dough to form panels of hard, aerated wood foam. The panels are rigid, stable and ultra-light. Main applications include furniture and interior design. Like wood, SLP can be glued, sanded, pierced, sawed and screw mounted. Density: 250 kg/m³.

385

387

391

384

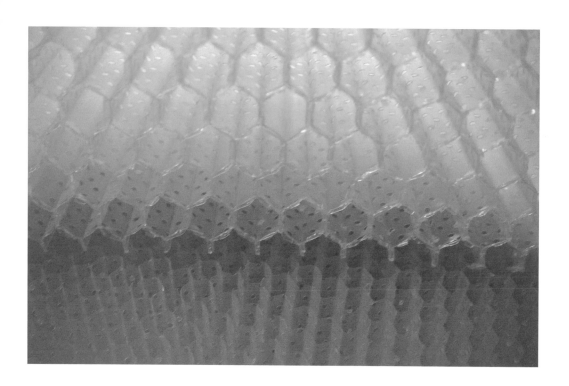

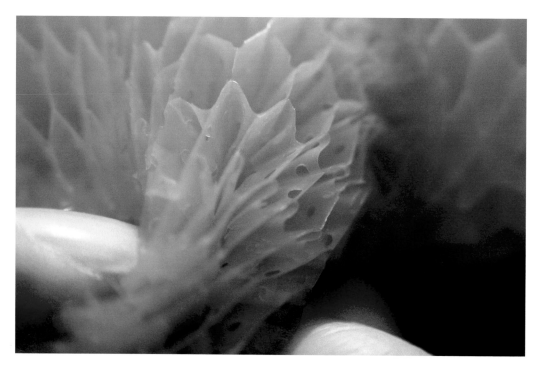

Manufacturer

Supracor
2050 Corporate Court
San Jose, CA 95131-1753
USA

T +1 408 4321 616
F +1 408 4321 975
webmaster@supracor.com
www.supracor.com

Supracor / Stimulite Honeycomb

386

387

386, 392, 384

383

392

392

In the past, honeycomb structures have been used primarily to create strong, lightweight products. Supracor aerospace honeycomb, made from thermoplastic elastomers, has a soft, flexible feel that makes it intriguing and fun. Highly versatile, Supracor combines a geometric structure with remarkable flexibility for good performance. A product with 'memory', it can return to its original shape; and it relies on anisotropic qualities for differing degrees of resistance and flexibility. Supracor can be manufactured in a variety of configurations, thicknesses and levels of compressive resistance. Excellent for applications requiring shock absorption and cushioning, such as footwear, sports and military protective gear, and seating (can be totally ventilated). Other uses include massage accessories, bathroom fittings and acoustic panelling.

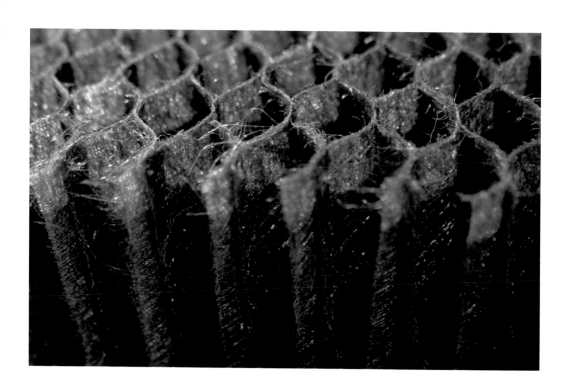

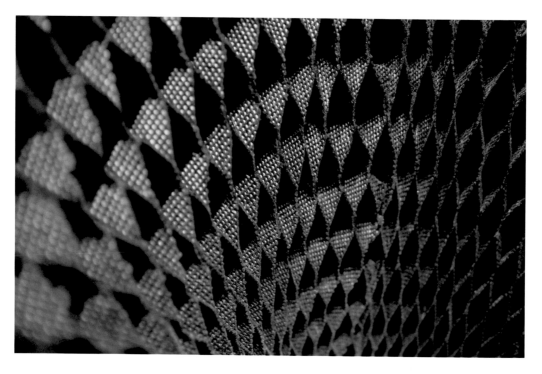

Manufacturer

VersaCore Industrial
Nieuwe Haven 67
1135 VM Edam
the Netherlands

T +31 (0)299 3712 47
F +31 (0)299 3714 94
versacore@wxs.nl
www.versacoreindustrial.com

ThermoStack

386

392, 387

392

387

383

ThermoStack, a new automated manufacturing process, produces flexible, three-dimensional honeycomb structures from thermoplastic roll goods. Lightweight and water-resistant, the product is widely used in interior design, seating, beds, cars and packaging. Openings can be incorporated into the structure (in applications where light is desired, for example). Cell dimensions: 8 to 55 mm. Maximum thickness: 100 mm. Maximum width: 1250 mm.

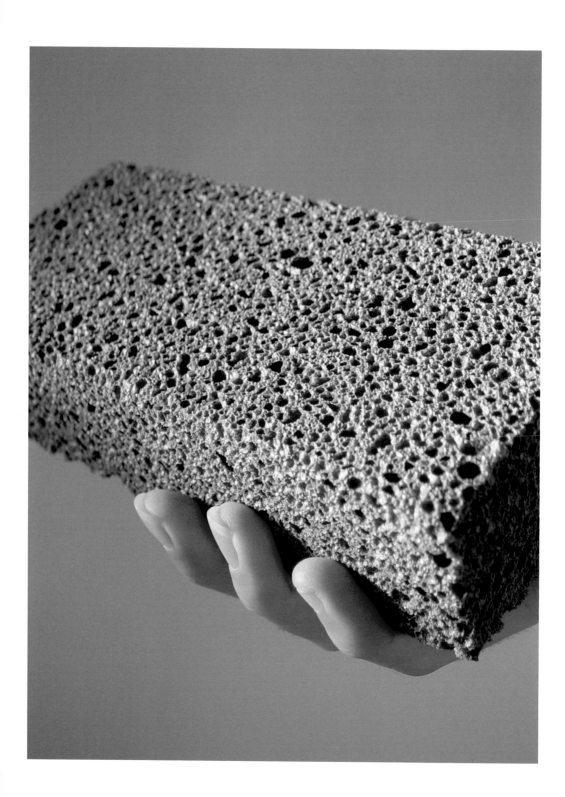

Manufacturer
Techwaste-Carmeuse
13, avenue Maurice
Destenay
4000 Liège
Belgium

T +32 (0)4 2219 889
F +32 (0)4 2219 837
jmaisse@sriw.be

Vulcarix

385 Made of recycled glass, sediment and a small amount of
381, 388 aluminium nitride, fused together at 900°C, this spongelike
insulator is less dense than water yet highly robust.
385 Twice as efficient as fibreglass in absorbing sound, the
385, 385 environmentally friendly glass foam withstands
385 temperatures up to 800°C. It emits no toxic gases, leaves
382, 382 no toxic residue and, unlike asbestos and asbestos
385 substitutes, contains no fibres (a potential cause of lung
383 cancer). Vulcarix is an all-in-one alternative to concrete
385, 388, 393, 382 block, fibreglass, mineral wool and asbestos.

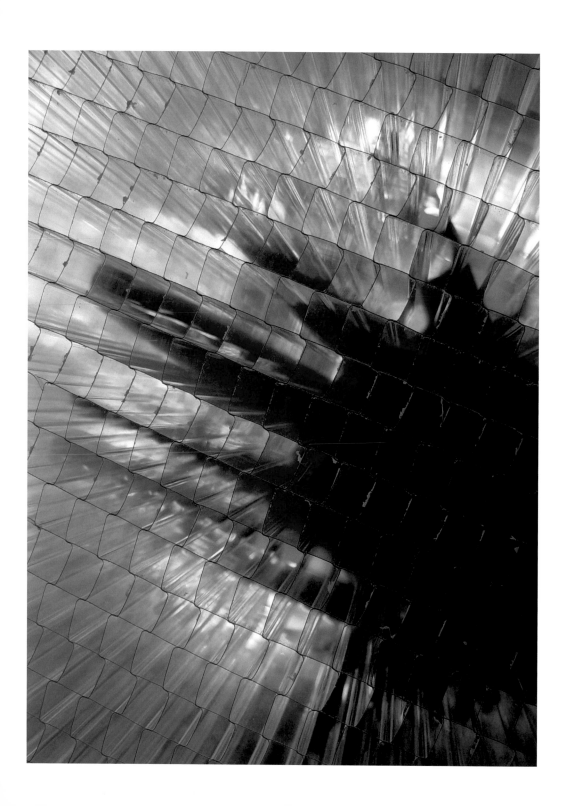

Manufacturer
Wacotech
Gewerbepark Brake,
Querstrasse 7
33729 Bielefeld-Brake
Germany

T +49 (0)521 9620 0-80
F +49 (0)521 9620 0-89
info@wacotech.de
www.wacotech.de

Wavecore

Wacotech's revolutionary process for making honeycomb structures is based on the continuous thermal welding of multiple sheets of polymer (mainly PET). Cell dimensions (4 to 50 mm) can be tailored to measure, and cell walls can be pierced. Grouped together, the three-dimensional honeycomb blocks are used as cores in low-density composite panels and shock absorbers. Other applications include shipbuilding, railways and road-haulage vehicles. Because most of the plastic sheets used to make these products are translucent, the optical effect of light passing through the structure is an attractive asset of rigid-walled Wavecore panels used in interior design. Standard dimensions (w x h x l): 1300 x 160 x unlimited. Density: 5 to 80 kg / m^3. Materials (among others): PE, PP, PS, PVC, EVA, PC and PET-reinforced fibreglass.

386
392
390, 389, 383
383
386, 384
390
387
384
389, 391, 391, 391
385, 389, 389, 385

by-product	can	cards,	Chainex	Clean
cables	can	carefully	Chainex	Clean
cabling,	can	carpet	chains,	clean,
cages)	can	Carpet	chain-saw	clean,
calcium	can	carpet	chair,	clean,
California	can	carpet	chairs	cleaned
called	can	carpet	chameleon-like	Cleaning
calls	can	carpeting	champagne	clear
Calme/Almute	can	carpeting.	champagne,	clear.
Calme/Almute	can	Carrara	change	clear-cut
camera.	can	carries	change	clearer
can	can	carrots,	change	cleavage
can	can	cars	change	clever
can	can	cars,	change	Clicking
can	can	Cascade	change	client's
can	can	Cascade	change.	clientele
can	can	cases,	changed	clients
can	can	cases,	changes	Clients
can	can	cashmere,	changes	clients
can	can	Cast	changes	climates.
can	can	cast	changes	climate-specific
can	can	catch	changes	clogs.
can	can	Cathode	changes	closely
can	can	cause	changing	closer
can	can	cause	changing	closer
can	can	cause	channels	cloth
can	Can	caused	characterised	cloth
can	can	causes	characteristic	clothing
can	can	causes	cheap,	clothing
can	can	causes	checkouts.	clothing
can	can	ceiling	Chemical	clothing
can	can	ceiling	chemical	clothing
can	can	ceiling)	chemical	clothing
can	can	ceilings	chemical	clothing
can	can	ceilings,	chemical-	clothing,
can	can	celebrate	chemical,	clubs.
can	Cell	Cell	chemicals	cm
can	Canatex	Cell	chemicals	cm
can	Canatex	cell	chemicals,	cm
can	Canatex	cell	chemicals.	cm
can	Canatex,	cells	chewing	cm
can	cancer).	cells	children's	cm
can	cannot)	cells	chilled	cm
can	canted-coil	cells	chilled	cm)
can	canted-coil-spring	cells	chills	cm).
can	capable	cellular	china	cm,
can	capable	cellulose	China?	cm,
can	capacity	cellulose	chipboard,	cm,
can	capacity	cellulose	chips.	cm.
can	capacity	cellulose,	chocolate,	cm.
can	capacity	centilitres.	choice	cm.
can	capacity	centimetres	choice	cm.
can	capacity	central,	choices	cm.
can	capacity	centuries	Choices	cm.
can	capacity	century	chromatic	cm.
can	caps	century,	chromatic	cm.
can	capturing	ceramic	Chrome	cm.
can	car	ceramic	chrome	cm.
can	carbon	ceramic,	chrome	cm.
can	carbon	ceramic.	chrome	cm.
can	carbon	certain	circuit,	cm.
can	carbon	certain	circular,	cm.
can	carbon	certain	circulating	cm.
can	carbon	certain	cite	cm.
can	carbon	certain	civil	cm.
can	carbon	certain	clad	cm.
can	carbon,	certain	clad	cm.
can	carbonates,	certain	clamping.	cm.
can	carbon-based	Certain	clarity	cm;
can	carbon-bonding	chafe-resistant,	Class-1)	coaches.
can	Cardboard	chain	classified	coastal
can	cards	chain	clean	
can	cards,	Chainex		

coat	colours,	complex	conjunction	converts
coated	colours,	complex.	conjunction	convey
coated	colours,	complicated	connecting	conveying
coated	colours,	component	connectors	convincing
coated	colours,	component	consist	Cooking
coated	colours,	components	consistent	cooking
coating	colours.	components.	Consisting	cool.
coating	colours.	composed	consists	cooler
coating	colours.	composed	consists	Copper
coating	colours.	composed	constant	copper
coating	colours.	composed	constant	copper
coats	Colours:	composed	constant.	copper
cobalt,	colours;	composed	constantly	copper,
cobweb	combination	composed	construction	copper,
Coil	combination	Composed	construction	copper,
Coil	combination	composed	construction	copper,
coil	combine	composite	construction	Copper-foam
coiling	combined	composite	construction,	copper-zinc
coils	combined	composite	construction,	core
coils	combines	composite	construction,	cores
coils.	combines	composite	construction,	corners
cold	combines	composite	consultants	cornstalk),
cold	combines	composite	consume	corrective
cold-moulded.	combines	composite	consumption,	corridors,
collect	combines	composite.	consumption.	corrode
Collection	combines	Composite's	contact	corrosion.
collection	combining	composites	contact	corrugated
Collection,	combining	composites	contain	corrugated,
Color	come	composites	container	corsets,
Color	come	composites.	containing	cosmetics
Color	come	composition	containing	cosmetics
colour	come	composition,	containing	cost
colour	come	composition.	contains	Cost:
colour	comes	compost	contains	Cost:
colour	comes	compress	contemporary	costly
Colour	comes	compressed	contemporary	costly
colour	comes	compressed	contemporary	costs.
colour	comes	compressed	Contemporary	cotton
colour	comes	compressed)	contemporary	cotton,
colour	comes	Compressing	content.	could
colour	comes	compressive	contents	could
colour),	comes	comprised	contents,	could
colour,	comes	comprised	contents.	could
colour.	comes	comprises	continuation	counters
colour-changing	comes	computer	continuous	countries
coloured	comes	computer	continuous-filament	coupling
coloured	comes	computer	contract	couplings,
coloured	comes	conceals	contract,	cousins
coloured	comes	conceivably	contributes	couture,
coloured,	comfort	concentrated	contributing	couture,
colourful	comfort,	concrete	control	cover
colouring	comfortable	concrete	control	covered
colourless	commercial	concrete	control	covered,
colourless.	compact	concrete	control	covering
colours	compact	concrete	control	covering
Colours	compact,	concrete	control	Covering
colours	companies	concrete,	control	covering,
Colours	companies	concrete,	control	covering,
colours	company	concrete.	control	coverings
colours	compare,	concrete.	control	coverings.
colours	compatible	conditioning,	control.	covers
colours	compatible.	conductive	controlled.	covers,
colours	competitions,	conductor	controlling	crack.
colours	competitive	conduits	convenience	cracking
colours	Completed	confectionery,	conventional	craft.
Colours	completely	configuration	conventional	crafted
colours	completely	configurations,	conventional	crafts
colours	complex	configured	conventional	create
colours	complex	conform	conventional	create
colours,	complex	conjunction	convert	create
colours,	complex	conjunction	converts	create
				create

Earth

Mother Earth has a rightful place in this book. Material, mater, matrix – the etymological proximity is in no way a coincidence: materials are the origin of all tangible things, and the earth is the mother of all materials. Granted, many of the materials found in this volume are so technologically complex that they bear little resemblance to their original state. Among them, however, are materials that conjure up our relationship with the earth in a natural way, sometimes to the point of caricature. The earth is mineral (pebbles, asphalt, mica), vegetable (tagua, wood cloth, seaweed) and animal (leather, shell). It is a precious, primeval resource that should be preserved and respected rather than exploited to the point of exhaustion. On the day the earth lies down in exhaustion, the human body will not be far behind.

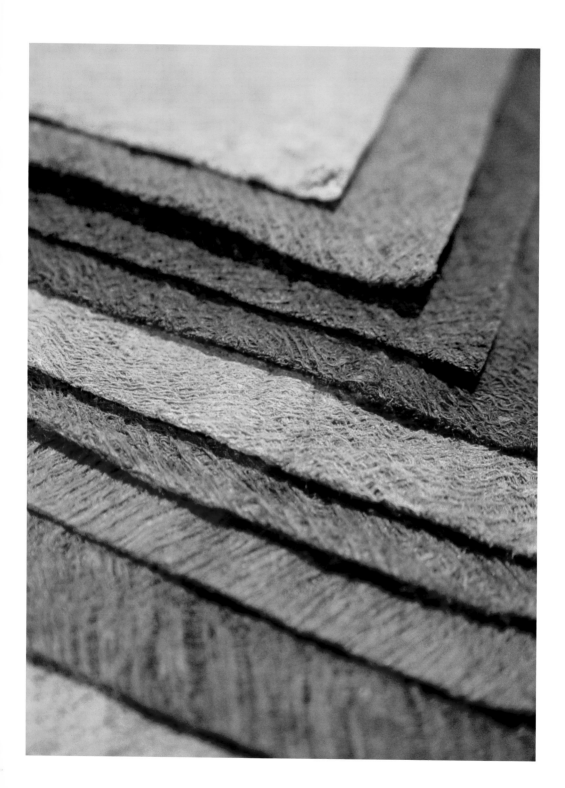

Manufacturer
Bark Cloth Europe
Talhauser Strasse 18
79285 Ebringen
Germany

T +49 700 BARKCLOTH
F +49 700 2275 2568
barkcloth@barkcloth.de
www.barkcloth.biz

BarkCloth

BarkCloth, an updated name for one of the oldest textiles known to man, represents the continuation of an almost forgotten African craft. Farmers collect the fibrous bark of the Ficus natalensis, which they crush, work and flatten into a non-woven textile. Originally used to make burial shrouds, bark cloth can now be dyed, fireproofed, coated in Teflon and laminated. Applications include furniture, lighting, interior design, fashion and accessories. The automotive industry uses certain fire- and friction-resistant versions of the product. The manufacturing process is environmentally friendly.

392

384

386

387, 392

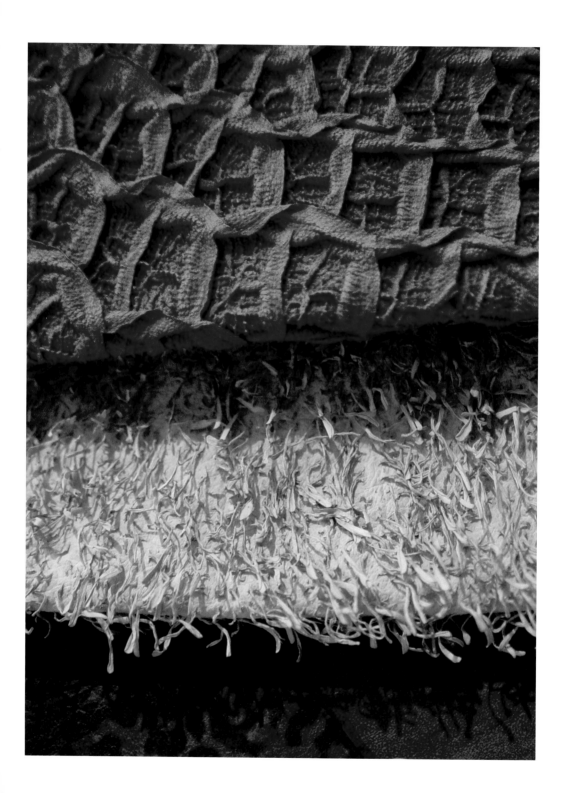

Manufacturer

Naturetouch
Av. das Américas 4200,
Bl. 8 Ed. Genéve,
Cob. 301a
Barra da Tijuca
Rio de Janeiro,
RJ 22640-102
Brazil

T +55 21 3150 2522
F +55 21 3385 4139
comercial@naturetouch.com.br
www.naturetouch.com.br

387

Belly / Bullfrog Skin / Rumen

Rumen. Belly leather. Bullfrog skin. Currently available in limited quantities only from Brazil, these intriguing skins are the result of an environmentally friendly tanning process. Their production, carefully refined over the years, is strictly controlled. Resistant to freshwater and saltwater stains, the skins are available in a range of colours and textures that look sensational when used for bags, shoes, clothing and fashion accessories. They are also suitable for furniture. Maximum sizes: Belly, 0.28 square metre; Rumen, 0.50 square metre; Bullfrog skin, 100 x 70 cm.

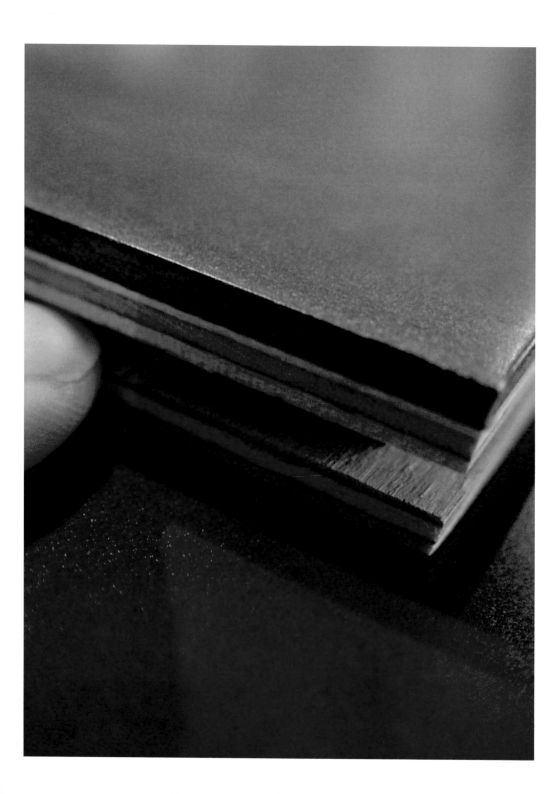

Manufacturer

Cuoificio Bisonte
Via Masini, 36
56029 Santa Croce
sull'Arno (Pisa)
Italy

T +39 0571 3003 6
F +39 0571 3389 4
info@cuoioarredo.it
www.cuoioarredo.it

Cuoioarredo

Used as a floor covering, Cuoioarredo tiles are made from the central, uniformly thick section of top-quality bison hides. The slow tanning and dyeing process, which takes place in drums, produces strong, cured leather that improves over time. Cut into squares and mounted on wood backings, the leather is transformed into floor tiles that are easy to lay and to maintain. As they age, the tiles acquire a distinctive patina. Marks and variations in colour are not defects, but proof of the natural origins of the product. Standard sizes range from 20 x 20 cm to 50 x 50 cm. Colours are natural, 5B, rust, brown, green, red, black and testa di moro. Fire-resistant tiles (certified Class-1) can be supplied on request.

384
387
387
392
389

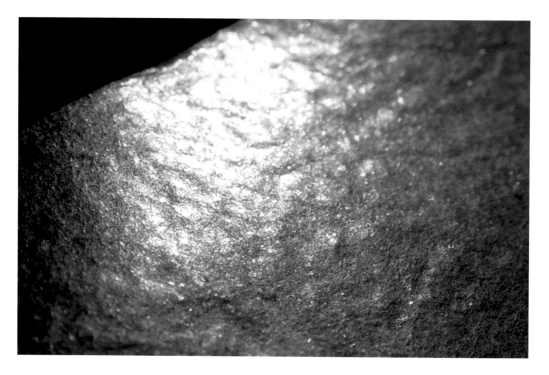

Manufacturer
Mica Manufacturing
3c, Camac Street
700016 Calcutta
India

T +91 33 2229 2277
F +91 33 2229 5216
micamafco@vsnl.net
www.micamafco.com

MicaPaper

388

386, 388

392

385

389

389

388

Mica, a mineral of the phyllosilicate family, is characterised by its laminate structure, metallic brilliance and resistance to high temperatures. Splitting mica along its cleavage yields thin, uniform, film-like layers that are flexible and translucent. Widely used in industry for its electrical-insulation properties, MicaPaper also provides thermal insulation in furnaces and has applications in the optics industry. MicaPaper is available in sheets (standard thicknesses: 0.3 / 0.4 x 0.5 mm) or blocks (1000 x 1000 mm and 1000 x 2000 mm). The blocks can be cold-moulded. The material can withstand temperatures up to 1200°C.

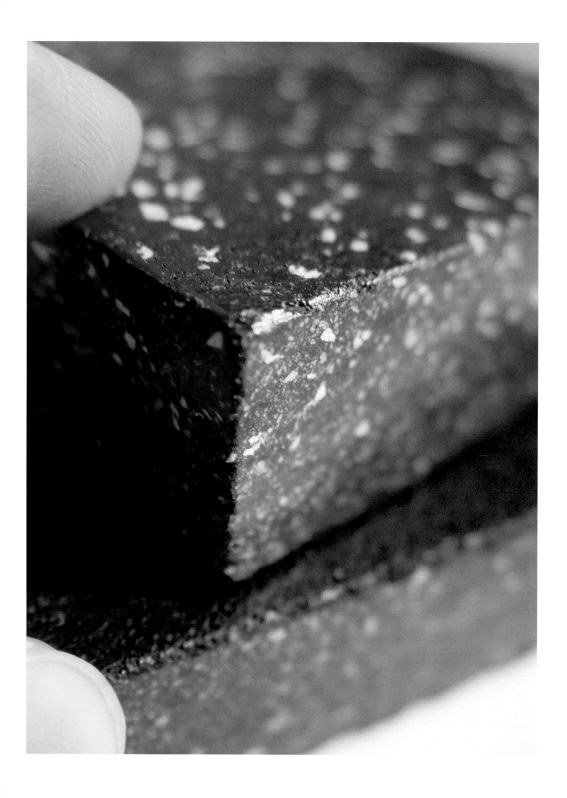

Manufacturer
Dasag
Homburgstrasse 8
37632 Eschershausen
Germany

T +49 (0)5534 916-0
F +49 (0)5534 916-194
info@dasag.de
www.dasag.de

NaturAsphalt

Not a by-product of the petrochemical industry, NaturAsphalt tiles are made from a dark, oily powder extracted from mines: natural asphalt. The substance is heated and compressed into compact, 25-x-25-cm tiles that are from 2 to 4 cm thick. Widely used in industry, the tiles are shock, abrasion and wear resistant. They can withstand heavy loads and are impervious to certain chemicals. NaturAsphalt offers sound, thermal and electrical insulation. The tiles are laid joint-free indoors, are available in uniform mat or marble finishes and in four colours, and have a smooth, non-slip surface.

382, 389

382

381

382

387

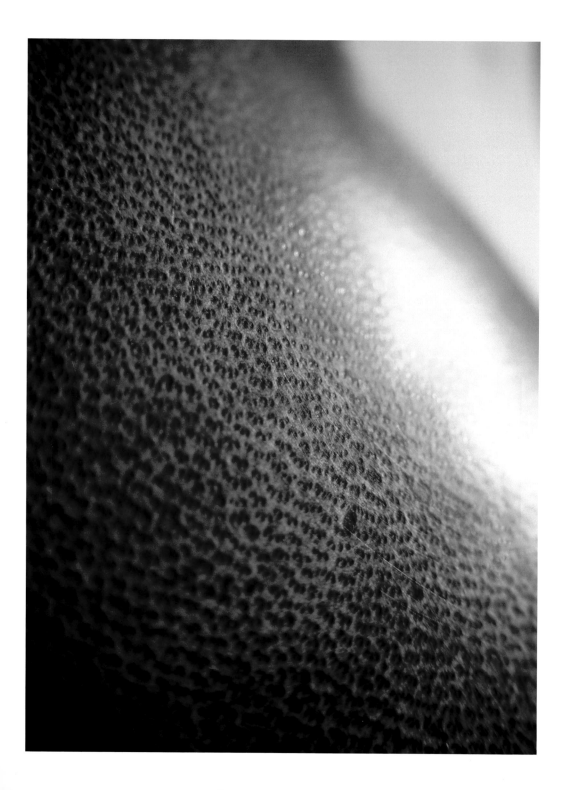

Manufacturer

Parchemin
Contemporain
4, rue Saint Maurille
49410 Saint-Florent-
Le-Vieil
France

T/F +33 (0)2 4139 7124
a.bretagnolle@tiscali.fr
www.parchemin-contemporain.com

Parchment

389

387

387

393

To make parchment, goat or sheep hides are soaked in a bath of lime, stretched over a frame and scraped to achieve an extremely fine but durable material. Only a few tenths of a millimetre thick, the dried skin is completely translucent. Originally used for manuscripts and bookbinding, parchment was rediscovered in the 20th century as a highly aesthetic material suitable for interior design, notably for wall and furniture coverings. Parchment can be waxed, polished and varnished. Maximum hide dimensions: 70 x 55 cm.

Manufacturer

Effepi Marmi
Via del Commercio, 69
56034 Casciana Terme
(Pisa)
Italy

T +39 0587 6464 04
F +39 0587 6463 50
info@effepimarmi.it
www.riverstone.it

Riverstone

390, 391

387

391

392, 387, 391

387, 393

Riverstone panels are composed of graded river-bed pebbles encased in a transparent, polymerized resin. This highly durable material gives the illusion of depth, and certain Riverstone products (light colours, thin slices) have a translucent quality. The resin is available in three colours, the pebbles in three grades (small, medium, large) and the panels in three thicknesses (10, 14 and 22 mm). Owing to the product's UV sensitivity (sunlight can cause the resin to change colour), it is for indoor use only. Riverstone is suitable for a wide range of surfaces, such as floors, walls, water features and furniture. Polish it with marble wax to maintain an optimal finish. Maximum dimensions: 80 x 180 cm.

Manufacturer
Prodotti Alfa
Via Garlasco, 29-33
27020 Tromello
Italy

T +39 0382 8090 82
F +39 0382 8097 94
alfaprod@prodottialfa.com
www.prodottialfa.com

Synderme

387

387

386

387, 387

Manufacturers of shoes, bags and other leather goods generate huge quantities of offcuts. For years, Prodotti Alfa has been recycling leather offcuts by shredding them and transforming them into sheets with, in most cases, the use of natural latex as a binding agent. The product is used to make insoles, toe caps and stiffeners for shoes, bags and leather pouches. Not simply a form of artificial leather, Synderme is a flexible, durable material that does not fade and that can be polished to a high sheen. Applications include book covers, handbags and belts.

Manufacturer

Tagua RainForest
USA

T +1 800 4524 287
mail@tagua.com
www.tagua.com

Tagua World
PO Box 3066
97079 Saint Martin cedex
France

T/F +33 590 2758 18
taguitos@taguaworld.com
www.taguaworld.com

Tagua

386

389, 386

386

386, 387

Tagua, a hard nut just over Ø 5 cm, is also known as ivory nut: it has the same colour, texture and patina as elephant ivory and is worked in the same way. It comes from a palm tree found in the dense forests of South America, at altitudes from 300 to 1200 metres. Before it ripens, the double-shelled seed of the ivory palm contains sweet milk that eventually solidifies to become tagua. The inner shell covers the nut itself, which can be crafted into amulets, buttons, figurines and desk accessories. Ivory nut is also used in marquetry.

Manufacturer

Maison Bonnet
8, rue Tiphaine
75015 Paris
France

T +33 (0)1 4059 4514
F +33 (0)1 4059 4341
www.art-ecaille.com

Tortoiseshell

Tortoiseshell with a twist. A product of the hawksbill turtle, this tortoiseshell fuses spontaneously – layer upon layer – when hot water is applied, according to an age-old procedure, to the horny shields of the shell. Fusion yields a block of tortoiseshell that can be sculpted, shaped and, when needed, repaired seamlessly. Suitable as a laminate, this light nonallergenic product is used for marquetry and panelling, as well as in the leather trade. Other applications are jewellery, spectacles, lamps and fashion accessories.

381, 386

387, 387

387

Manufacturer
Sandrine Paumelle
86, rue de Belleville
75020 Paris
France

T + 33 (0)1 4636 0681
paumelles@aol.com

Vegetable Paper

391

389

389

387, 391

385, 390

Some people prepare meals with the ingredients they buy at the market. Others, like Sandrine Paumelle of Paris, slice carrots, beetroots, cucumbers and leeks to make paper. Say goodbye to stews and soups and hello to delicate sheets of vegetable paper whose translucence plays a magical game with available light. This fragile product can be sandwiched between panels of glass or plastic and used in interior design and furniture-making, as well as for dozens of other design-related applications.

Manufacturer

SydTek
Råhavegård, Maribovej 9
4960 Holeby
Denmark

T +45 (0)54 6916 00
F +45 (0)54 6916 01
syd-tek@syd-tek.dk
www.syd-tek.dk

ZosteraMat

Zostera marina (grass weed or grass wrack) is a better thermal insulator than synthetic materials such as fibreglass. In addition, zostera is nonflammable, readily available (it is found in abundance on European beaches), environmentally friendly and, unlike fibreglass and similar insulating materials, unhazardous to the health of those exposed to it. Before processing, zostera must be separated from the detritus picked up during the gathering process. Used in the construction industry, ZosteraMat contributes to buildings that consume less energy.

385

385

392

390

create	curved).	deformation	devices.
create	curvilinear,	degree	devices.
create	cushion	degree	dew-coated
create	cushion.	degree	Dhè
create	cushioning,	degree	di
create	cushions.	degree	diameter
create	cushions:	degree	diameter
create	customize	degrees	diameter,
create	Custom-made	dehydrated	Diameter:
created	cut	dehydration,	diameter:
created	Cut	delicate	diameters
created	cut	deliciously	diameters
creates	cut	delivers	diameters.
creates	cut	demands	diameters.
creates,	cut	dense	diameters:
creating	cut	dense	diameters:
creation	cut,	Densities	diamonds,
creation	cut,	densities	dichroic
creation	cut-proof	densities	dichroic
creation	cut-proof,	density	dichroic
creation	cutting-edge	Density:	differences
creations	Cyan-Blue-Magenta	Density:	differences
creative	Cylinder	Density:	different
crisp	cylinders,	Density:	Different
Cristal	Cylindrical	density-reduction	different
Cristal	cylindrical	dental	Different
crops,	Cylindrical	departure	different
cross-linked	cylindrical,	Depending	different
crosswise	dairy	Depending	different
crosswise	damage	depending	different,
crosswise,	damage,	depending	differentiate
Crozet	damaging	Depending	differing
crumpled	damp	depending	diffracts
crush,	dampened	depending	diffuse
crystal	dark	depending	diffuser.
crystalline	dark	Depending	diffusion,
crystallization	dark,	deposit	DigiMotifs
crystallized	dark,	deposit	digital
cubes.	dark.	deposit	digital
cucumbers	darker	deposited	digital
cue	dark-grey	depositing	dimension
culminating	data	deposits	dimension.
cultivation	data,	depth	dimensions
Cuoioarredo	data-compression	depth	dimensions
Cuoioarredo	date,	depth	dimensions
cupboard?	date;	depth,	Dimensions
cured	dawn	depth.	dimensions,
Curious	day	depth.	dimensions.
Curious	daylight	depths	dimensions.
Curious	day-to-day	derived	Dimensions:
Current	de	desiccation	dimensions:
current	de	design	dimensions:
current	death	design	dimensions:
Current	decorated	design	Dimensions:
current	decoration	design	Dimensions:
current).	decorative	design	dimensions:
current,	decorative	design	dimensions:
current.	decorative	design	dimensions:
currently	decorative	design	dimensions:
Currently	decreases	design	dimensions:
currently	Deep	design	dimensions:
currently	Deep	design	Dimensions:
Currently	deep	design	dimensions:
Currently	deep	design	Dimensions:
currently	deeper	design	dimensions:
curtains	defects,	design,	dimensions:
curtains	defence,	design,	dimensions:
curtains,	defies	design,	dinner
Curv	definition	design,	Diodes
Curv	deflect	design,	diodes
Curv	deflected,	design,	Diodes
curved	deformation	design,	diodes

dioxide	Drapery	eco-friendly	electrical	emit
dioxide	draw	eco-friendly	electrical	emits
direct	drawings	economical	electrical	emits
direct	dresses	Ecosolution	electrical	emits
direct	dried	Ecosolution	electrical	employed
direction	dries,	Ecosolution	electrical	employed
directly	drilling	edges	electrical	employed
directly	driver's	edges,	electrical	employing
directly	droplets	edgings	electrical	empty
dirt	drops.	education,	electrical	enable
disappearing	drums,	effect	electrical-insulation	enable
disc	dry	effect	electrical-insulation	enables
disc	dry-conservation	effect	electrically	enabling
disc,	drying,	effect	electricity	enamelled
discarded	DualGlo	effect	electricity	encapsulate
discarded	DualGlo	effect	electricity	encapsulated
discovered.	DualGlo	effect	electricity.	encapsulated
display	Dupont	effect	electricity.	encased
display	durability	effect	electrochemical	enchanting
display	durability	effect	electrodes	enclosed
display	durable	effect,	electroluminescent	enclosure
displays	durable	effect.	electrolysis	end
displays,	durable	effect.	electrolysis-based	end
displays,	durable	effect'),	electromagnetic	end
disposable	durable	effective	electromagnetic-induction	endless
disposal,	durable	effective	electron-emission	endless
dissipate	durable	effective	electronic	endless
dissolves	durable	effects	electronic	endless,
dissolves	durable,	effects	electronic	ends
distance	durable,	effects	electronic	energizes
distance	Duran	effects.	electronic	energy
distinctive	Duran	effects.	electronic	energy
distinctive	during	effects.	electronic	energy
distortion,	During	effects.	electronics	energy
disturbing	during	effects.	electronics	energy
diverse	dye	effects.	electronics	energy
diverse	dyed,	effects.	electronics,	energy
dividers,	dyeing	effects:	electrons	energy
dividers,	dyes,	efficient	elegant	energy
DIY	dyes.	efficient	element.	energy
do.	dyes.	efficiently	elements	energy.
does	dynamic	efficiently.	elements,	engineering,
does	dynamically	effort.	elephant	engineering,
does	each	eight	eliminate	engrave
does	each	eight	elliptical	engraved
does	Each	either	elongated	engraved
does	each	either	Elumin8	engraved
does	each	elaborate	Elumin8	enhance
does	Each	elastic	Elumin8	enhance
does	Each	elastic	embed	enhanced
does.	each	elastic	embedded	enhanced
dome,	each	elastic	embedded	enhanced
Donati	each	elastic	embedded	enhanced
done	each	Elasticity	embedded	Enhancement
doors	early	elasticity	embedded	enhancement
doors	earthlings.	elasticity	Embossing	enough
doors).	easily	elasticity	embroidering	ensure
doors,	easily	elastomer.	embroidery	ensure
doors,	easing	elastomeric	embroidery,	entering
double	easy	elastomers,	embroidery'.	entertainment.
doubles	easy	electric	emerge	enthusiasts,
double-shelled	Electric	emerged.	entire	
double-sided	easy	Electric	emergence	Entirely
double-walled	Easy	Electric	emergency	entirely
dough	easy	electric	EMFiT	entrap
down	easy	electric	EMFiT	envelope
down	easy	electric	EMFiT	envelope.
down	easy-to-clean	electric	EMFiT	environmentally
dozens	easy-to-handle	electric	emission.	environmentally
drains,	Eccosphere	electric	emit	environmentally
drape.	Eccosphere	electrical	emit	environmentally
Drapery	Eccosphere	electrical	emit	environmentally

Elastic

What could be simpler than putting an elastic band around a package to keep it shut or securing a ponytail with a colourful scrunchie? In terms of shape, it's never been easier to make materials conform to our desires. The commercial success of rubber in the mid-19th century went a long way towards making materials more elastic. Elasticized fabrics like Lycra and Spandex have revolutionized the textile industry. 'Stretch' is a much sought-after quality in clothes, as well as in fabrics used to cover furniture, lamps and countless other objects. Subtle and astonishing ways of weaving non-elastic materials can also lead to products that feature extreme stretchability.

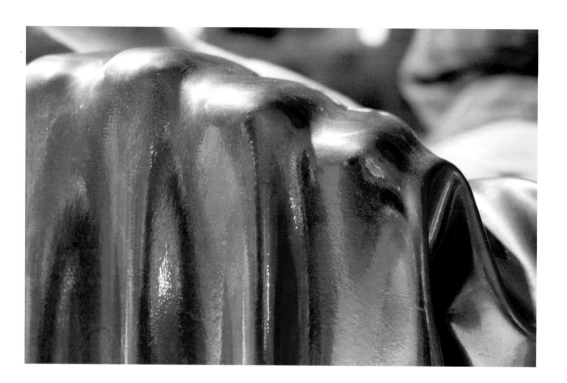

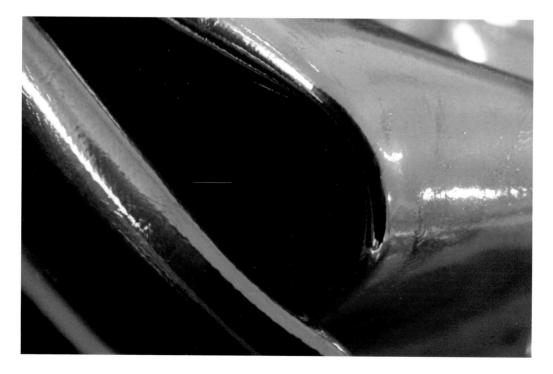

Manufacturer
Arteca
Viale del Lavoro, 2
37036 Martino
Italy

T +39 045 8871 711
italconv@tin.it

Avantige

390, 387

392, 386

This material – a high-tech polyester-and-Lycra blend impregnated with silver – is the first laminated stretch fabric that does not crack. Made according to a new technology developed by Invista (formerly Dupont Textiles & Interior),

381, 392

388

Avantige can be stretched over all manner of frames, including chairs and other seating objects, giving them a metallic appearance while remaining flexible and impermeable yet breathable. Other uses include weatherproof outerwear, protective clothing and shoes, and industrial applications.

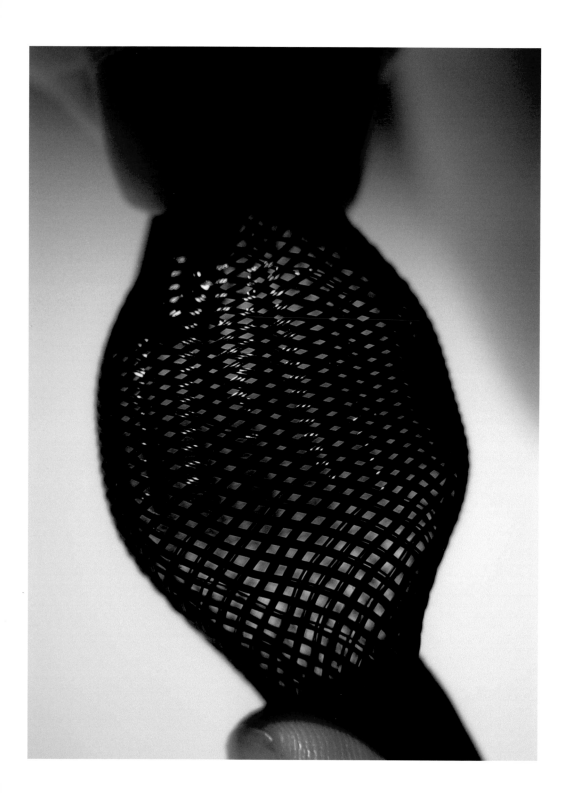

Manufacturer
Federal-Mogul
26555 Northwestern
Highway
Southfield, MI 48034
USA

T +1 248 3547 700
F +1 248 3548 950
www.federal-mogul.com

390, 388

Expando

Expando is an expandable, chafe-resistant, braided oversleeve made from polyester monofilament. Thanks to the open-weave construction of the material, Expando products can be fitted over objects that are long and thin or short and wide. This high-performance, easy-to-handle product is normally used for the protection of electrical and electronic systems, such as those in the rail-transport sector. Expando comes in many diameters and lengths, all with an expansion ratio of 1:2. Expando oversleeves withstand temperatures ranging from -50° to +125°C.

384

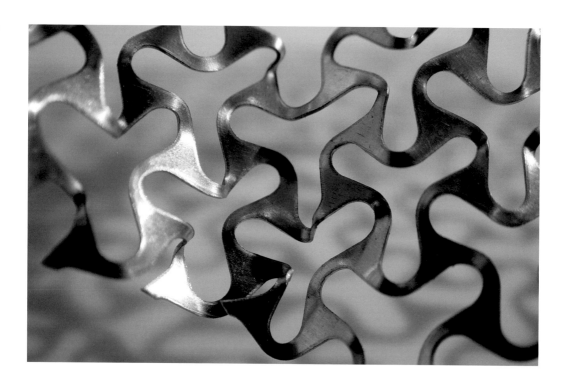

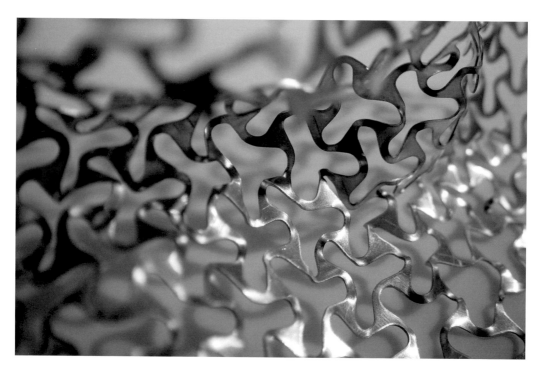

Manufacturer
Design for Metal
Damaschkestrasse 4
10711 Berlin
Germany

T +49 (0)30 3270 5680
F +49 (0)30 3270 5550
office@formetal.de
www.formetal.de

ForMetal

388
381, 392

Providing a great opportunity for DIY enthusiasts, ForMetal is aluminium sheeting marked with perforated patterns that allow the designer or hobbyist to transform a two-

388

dimensional piece of metal into a 3-D object with a smooth, attractive surface. Completed objects can be covered, if

388

desired, with various materials, including ForMetal Flexorit. Extremely flexible, the material can be shaped and reshaped (stretched or compressed) by hand or with the use of simple tools. Virtually no material is lost in the manufacturing

388

process, which causes no pollution. ForMetal is fully recyclable. A wide range of applications includes areas as diverse as architecture, education, design, industry, art,

392, 388

marketing and modelling. Two types are available: ForMetal

388

Varius and ForMetal Ypsilon.

Manufacturer

Keiko Oyabu
7-30-14
Tamagawagakuen,
Machidashi
194-0041 Tokyo
Japan

T +81 (0)42 7259 655
F +81 (0)42 7255 769
keoyabu@attglobal.net

Jelly Tile

Soft, supple and viscous, Jelly Tiles adhere to all flat, smooth surfaces. The design of a wall decorated with Jelly Tiles can be changed every day if desired, as the tiles are quite easy to remove and rearrange. To restore their sheen and adhesive properties, simply immerse them in a basin of warm water. Thanks to the translucence of the polyurethane gel used to make the product, Jelly Tiles can be combined with lighting to create any number of unique visual effects. Dimensions: 125 x 125 x 11 mm.

390

387, 392

Manufacturer
Morphogenese
Hagenauerstrasse 16
10435 Berlin
Germany

T +49 (0)30 4405 3745
info@morphogenese.com
www.morphogenese.com

Morphogenese

Morphogenese is perceived primarily as an extremely smooth fabric knitted from nylon and viscose. Depending on the diameter of the thread and the amplitude of the knit, however, the fabric can be either soft and fluid or rough and rigid. What makes it so special, though, is that movement and volume are permanently imprinted into the textile, giving it a kind of shape memory. Morphogenese is available in a range of colours; gold, copper and silver tones are added to produce magical metallic effects.

386, 388, 393

386

385

391

385, 383, 392

388

Manufacturer

Euroflex G. Rau
Kaiser-Friedrich-Stasse 7
75172 Pforzheim
Germany

T +49 (0)7231 2082 10
F +49 (0)7231 2087 599
info@euroflex-gmbh.de
www.euroflex-gmbh.de

Niti Tubes

These extremely fine tubes are components of the precision instruments used in ophthalmology, neurosurgery, biopsy procedures and so forth. Other applications target the electrical and automotive industries. Depending on their composition and / or the thermo-mechanical treatment they have undergone, alloys of nickel and titanium offer shape memory and are super-elastic at different temperatures. Diameter: 0.13 to 13 mm. Maximum length: 300 cm. Melting temperature: 1310°C. Density: 6.5 g / cm³. Elasticity module: 41,000-75,000 MPa. Maximum tension: 1070 MPa. Niti Tubes have a total stretch capacity of 10%.

381, 388, 392

391

392, 384

384

Manufacturer

Plymouth
21, Allée du Rhône - BP 1
69551 Feyzin cedex
Lyon
France

T +33 (0)4 7209 2929
F +33 (0)4 7209 2930
contact@plymouth.fr
www.plymouth.fr

Plylin

391

Plylin is a thin, vulcanized rubber tape with a stretch capacity of more than 600%. The material resists tears and perforations, is extremely durable and watertight. It can be washed (and sterilized) at 100°C. These properties make it suitable for various applications, such as membranes for sealing joints, protective sheets for hospital beds and operating theatres, nappies and elastic undergarments.

392

Manufacturer
Conwed Plastics
Marcel Habetslaan 20
3600 Genk
Belgium

T +32 (0)89 8483 10
F +32 (0)89 8483 20
info@conwedplastics.com
www.conwedplastics.com

Rebound

Rebound, which looks like a uniformly woven spider's web, is soft and highly elastic (300% extension). It is the first elastomeric netting made from PP combined with an elastomer. Used as a waist elastic in both nappies and lumbar-support corsets, and as a stiffener in shoe soles, Rebound offers elasticity to the material – textile or non-textile – to which it is laminated. Mesh sizes range from 1.7 to 6.3 mm, and the product is available in rolls as wide as 1.07 m. Densities vary from 16 to 100 g/m². Stretch capacity can be limited to one direction only (length or width).

384, 392, 391

384

384

386

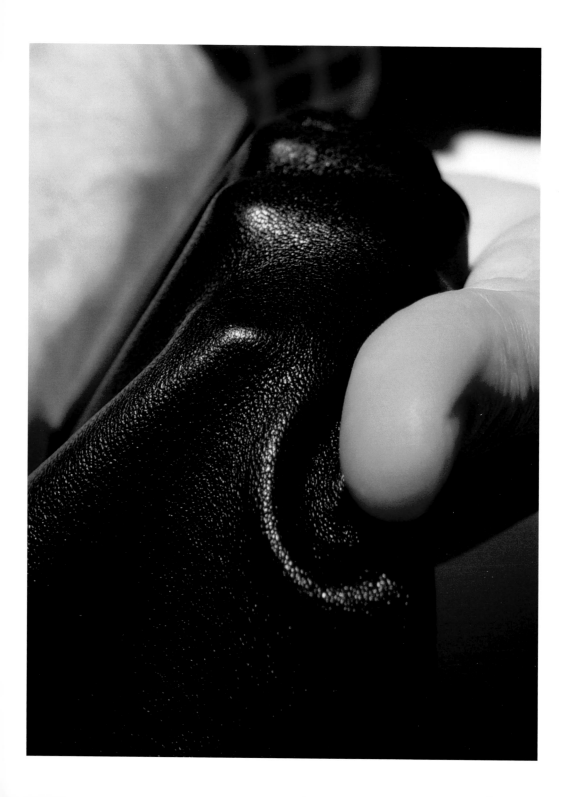

Manufacturer
J.M.Marthens
Le Métropole 19
138-140, rue
d'Aubervilliers
75019 Paris
France

T +33 (0)1 4209 9280
F +33 (0)1 4209 9290
info@marthens-stretch.com
www.marthens-stretch.com

Stretch Leather

Henri Guenoun's process for bonding sub-layers of leather at a high temperature (120°C) with a material less elastic than leather led to the creation of stretch leather, a supple, tear-resistant material with long-lasting elasticity that became an immediate success among makers of clothing, footwear, accessories, furniture and automotive seating. Stretch leather withstands water temperatures of up to 70°C and air temperatures of up to 190°C. After it has been stretched, it returns to its original shape. It can be worked, stitched, glued, cleaned and so forth using the same methods that are applied to traditional leather.

387

387, 387

392, 384

392

387

381

387

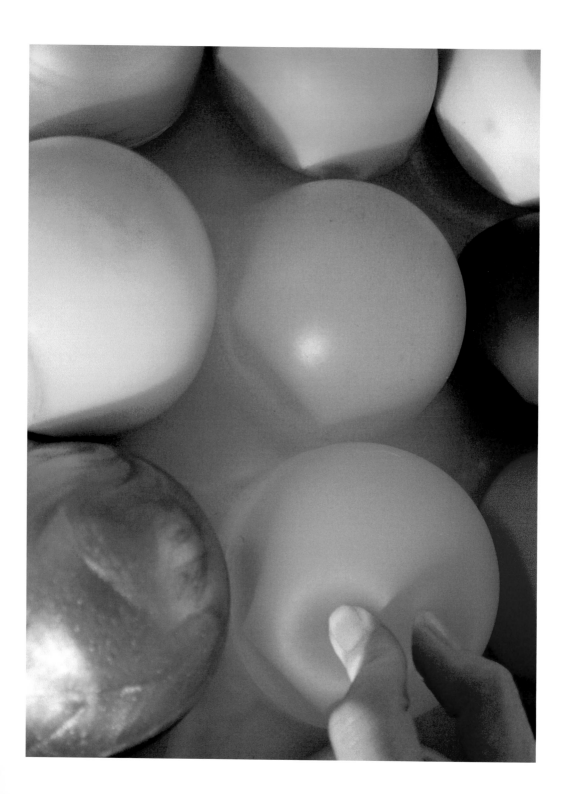

Manufacturer
Synthetix
11, rue des Grandes
Cultures
93100 Montreuil
France

T +33 (0)1 4870 7298
F +33 (0)1 4870 7446
info@synthetix.fr
www.synthetix.fr

Synthetix

As a manufacturer specializing in new plastic fabrics, foams and gels, Synthetix and its various consultants focus on materials well suited to the needs of architects and designers. Current favourites are silicone and polyurethane, plastics from which Synthetix crafts products such as foam membranes, innovative gels, silky fabrics and transformative materials. Synthetix offers clients advice and prototyping services, beginning with the simplest of ideas and culminating in the integration of a mass-produced object into today's complex markets.

390

385

391, 390

390, 385

391

392

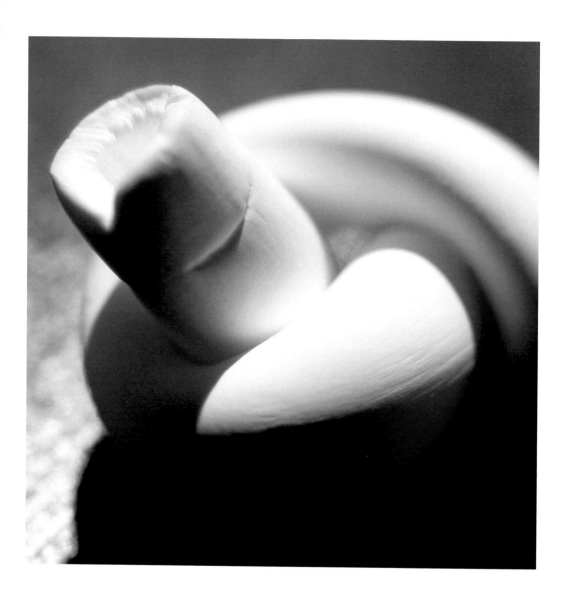

Manufacturer

IFK-Isofluor
Borsigstrasse 13-15
41469 Neuss
Germany

T +49 (0)2137 9178 9-0
F +49 (0)2137 1266 7
service@isofluor.de
www.isofluor.de

391, 390

386

TexFlex

TexFlex is flexible tubing made from specially treated expanded PTFE. Thanks to the properties of this plastic, it can be preshaped to create a kink-resistant product. Used mainly as an electrical and thermal insulator, TexFlex has numerous applications in laboratories and the medical industry. The product, which withstands temperatures of up to 260°C, is available in a range of colours and diameters.

environmentally	excellent	fabric	features	fibres.
environmentally	exceptional	fabric	features	fibres.
environmentally	exceptional	fabric	features	fibres.
environmentally	exceptional	fabric	featuring	fibres.
environmentally	exceptional	fabric	featuring	fibres.
environmentally	exceptional	fabric	featuring	fibrous
environmentally	exceptionally	fabric	featuring	Ficus
environmentally	excess	fabric.	fed	field
environments.	excessively	fabric.	fed	field
environments.	exchangers	fabric.	Federation	field
epoxy	exciting	fabric-like	feeds	field.
epoxy	exclusively	fabrics	feedstock	fields
equally	exerted,	fabrics	feel	Fielitz's
equally	exhaust	fabrics	feel	figure.
equals	exhibition	fabrics	feels	figures
equipment	exhibits,	fabrics	feels	figures
equipment,	exhibits,	fabrics	feels,	figurines
equipment.	expand	fabrics	Felt	files
equipped	expand	fabrics	Felt	fill
equipped	expandable,	fabrics	Felt	fill
equipped	expanded	fabrics,	felt,	filled
era,	expanding	Fabrics'	fencing.	Filling
especially	Expando	façades)	fertilizer-saturated	film
especially	Expando	façades,	few	Film
Europe.	Expando	façades,	few	film
European	Expando	façades.	few	film
Euroslot's	Expando	façades.	few	film
eutectic	expansion	face	few	film
Eutit	experiments	facets,	few	film
EVA,	explorers	facial	FFH)	film
evaporation	explosion	facilitate	fibre	Film
evaporation	exposed	facilitates	fibre	film
evaporation	exposed	factories	fibre	film
even	exposure	factory,	fibre	Film
even	expressed	factory-sealed	fibre	film
even	extension).	facts	Fibre	film
even	exterior	fade	Fibre	film
even	exterior	fade,	fibre	film
even	exterior	Fair)	fibre,	film
even	exterior	familiar	fibre,	film
even	extra	family	fibre.	Film
even	extracted	family	fibre.	film
even	Extra-large	family,	fibre-free.	film
even	extraordinarily	Farmers	fibreglass	film),
even	extraordinary	Fasal	fibreglass	film,
even	extreme	Fasal,	fibreglass	film,
even	extreme	fashion	fibreglass	film,
even	extreme	fashion	fibreglass,	film,
events,	extreme	fashion	fibreglass,	film-like
eventually	extreme	fashion	fibreglass.	films
ever-improving	extremely	fashion	fibreglass.	films
every	extremely	fashion	fibre-reinforced	films.
Everyone	Extremely	fashion	fibres	filter
everything	extremely	fashion	fibres	filter
everything	extremely	fashion	fibres	Filter
evokes	extremely	fashion	fibres	filter
evokes	extremely	fashion	fibres	filter,
evolution	extremely	fashion.	fibres	filtered,
exaggerated	extruded	fashion-related	fibres	filtering
example	extrusion	fast	fibres	filters
example)	eye)	faster	fibres	Filters
example).	eye.	faux	fibres	filters
example);	eyewear.	favourites	fibres	filters
example,	Fab	feather-light	fibres)	filters
example,	Fab	Feathers	fibres,	filters
example,	fabric	Feathers	fibres,	filters
example,	fabric	feathers,	fibres,	filters.
example.	fabric	feature	fibres,	filtration
example.	fabric	feature	fibres,	filtration
Examples	fabric	feature	fibres,	filtration,
Excellent	fabric	features	fibres,	filtration,
excellent	fabric	features	fibres,	FiltroCell
excellent	fabric	features	fibres.	Filtrocell

Filtrocell	flattened	foam	for	for
Filzfabriken	flax,	foam	for	for
find	flex	foam	for	for
fine	flexes	foam,	for	for
fine	Flexi,	foam.	for	for
fine	flexibility	foam.	for	for
fine	flexibility	foams	for	For
fine	flexibility	focus	for	for
fine	flexibility.	focused	for	for
Fine	flexible	foil	for	for
fine,	flexible	folded	for	for
fine-grained	flexible	folds,	for	for
finely	flexible	food	for	for
fineness	flexible	food	for	for
finer	flexible	food	for	For
finer	flexible	food	for	for
fine-tuned	flexible	food-compatible,	for	for
finish.	flexible	footprints	for	for
finished	flexible	footsteps.	for	for
finishes	flexible	footwear	for	for
finishes	flexible	footwear	for	for
Finishes	flexible	footwear	for	for
finishes	flexible	footwear,	for	for
finishes	flexible	footwear,	for	for
finishes,	flexible	for	for	for
finishes.	flexible	for	for	for
fire	flexible	for	for	for
fire	flexible	for	for	for
Fire	flexible,	for	for	for
fire	flexible,	for	for	for
fire	flexible,	for	for	for
fire	flexible,	for	for	for
fire	flexible,	for	for	for
fire-	flexible,	for	for	for
fireplace	flexible,	for	for	for
fireproof	flexible,	for	for	for
fireproofed,	flexible,	for	for	for
fire-protection	Flexinol	for	for	for
fire-resistant	Flexinol	for	for	for
Fire-resistant	Flexorit.	for	for	for
fire-resistant	flexure,	for	for	for
fire-resistant	float,	for	for	for
fire-resistant.	floor	for	For	for
firm	floor	For	for	for
firm	floor	for	for	for
firm's	floor	for	for	for
first	floor	for	for	force
first	Floor	for	for	force
first	Floor	for	For	force
first	floor	for	for	force
first	floor.	for	for	force.
first	floor-heating	for	for	forests
fish-eye	flooring	for	for	forgotten
fitted	floors	for	for	form
fittings	floors	for	for	form
five	floors	for	for	form
five	floors,	for	for	form
five	flowing	for	for	form
five	flows	for	for	form
fixed	fluid	for	for	form
flame	fluidity	for	for	form
flame	fluids	for	for	form
flame-retardant	fluids.	for	for	form
flaps,	fluorescent	for	for	form
Flat	fluoro-polymers.	for	for	formaldehyde
flat	Foam	for	for	format.
flat	foam	for	for	formed
flat	foam	for	for	formed
flat	foam	for	for	formerly
flat,	foam	for	for	ForMetal
flat,	foam	for	for	ForMetal
flatten	foam	for	for	ForMetal

Extreme

Ever lighter, ever stronger, ever more amazing. Scientific research and technological innovations are taking us into unknown realms and beyond boundaries we once considered inaccessible. Mankind's ability to work materials on an increasingly smaller scale (think 'nanometre') – and thus to alter the atomic structure of an element – is revolutionizing the properties of materials and changing our understanding of how they are created. Today's highly sophisticated materials meet extreme requirements and, in some cases, defy logic. From the tear-resistant fabric and the bullet-proof vest to the unbreakable window and the fire-resistant overall, many of these products do more than amaze us. They protect us from a dangerous world.

Manufacturer
Grado Zero Espace
Via 8 Marzo, 8
50053 Empoli (FI)
Italy

T +39 0571 8036 8
F +39 0571 8036 8
contact@gzespace.com
www.gzespace.com

Absolute Zero

The use of aerogel in textiles and clothing marks a step forward in the area of thermal protection. The Absolute Zero and Absolute Frontier clothing lines were developed for explorers of regions with extreme climates. Aerogel-crystal mattresses are ideal for bedding down in arctic temperatures, and aerogel has been used with success by NASA for the Pathfinder mission to Mars. An exceptional material with the same structure as silicon sponge, aerogel is 99.8% vacuum and resembles ultra-light snow. It is not only the best-performing thermal insulator to date, but also the world's lightest artificial material.

381
381
381
391, 381
387
387

Manufacturer
Masureel Group
Zuidstraat 18
8560 Wevelgem
Belgium

T +32 (0)56 4254 27
F +32 (0)56 4255 84
info@masureel.be
www.masureel-group.com

Basalt Fab

In the 1920s, Frenchman Paul Dhè developed a fabric made from basalt, a dark volcanic rock. It was not until the '70s, however, that well-funded Soviet researchers studied basalt textile and recommended it for industrial use: initially for military purposes and, ultimately, for the aerospace industry. Today, the continuous-filament textile is available for commercial and private use. Basalt Fab is a natural, inert, nontoxic, environmentally friendly material with a melting point of 1450°C. Less costly to manufacture than the silicate- and carbon-based textiles used in industry, basalt textile lends itself to fire protection (construction, rail transport, aviation), thermal insulation (industrial kilns) and composite materials (automotive).

382
382
392
382
392
382, 382

Manufacturer
Schott AG
Hattenbergstrasse 10
55122 Mainz
Germany

T +49 (0)6131 66-0
F +49 (0)6131 66-2000
info@schott.com
www.schott.com

Fortadur

383

385, 382, 391, 385

385, 385

392, 385, 385

385

385

This opaque black material, which looks like ceramic, is glass reinforced with carbon and silicon-carbide fibres. The fibres are coated with powdered glass, cut and heated to more than 1000°C at more than 100 times atmospheric pressure. The resulting composite (60% glass, 40% fibres) has properties normally not associated with glass, such as flexure, strong resistance to breakage and ultra-strong resistance to thermal shock. These properties make Fortadur suitable for use in mechanical parts that are subjected to high temperatures. Work is currently under way to develop a version of Fortadur featuring transparent fibres. Potential applications, particularly in construction, are manifold.

Manufacturer
LiquidMetal
Technologies
25800 Commercentre
Drive, suite 100
Lake Forest, CA 92630
USA

T +1 949 2068 000
F +1 949 2068 008
information@liquidmetal.com
www.liquidmetal.com

LiquidMetal

387, 388, 388, 381 LiquidMetal, a patented family of revolutionary metal alloys, was developed 12 years ago at the California Institute 381 of Technology. It is the first bulk alloy with an amorphous atomic structure (unlike the crystalline structure of 388 conventional metals). Two and a half times stronger than 392, 387, 388, 388 titanium, LiquidMetal combines the advantages of metal and 390 plastic. It is exceptionally hard, elastic (while maintaining 387 its shape), lightweight, wear- and scratch-proof, and biocompatible. It absorbs vibrations, does not corrode and, 390, 388 like plastic, can be moulded into clean, clear-cut shapes. Users include the aerospace, defence, medical and 384 electronic industries. A more recent application is sports equipment, such as tennis racquets, skis and golf clubs. 387, 388 LiquidMetal Technologies has also developed a number 387, 388, 381 of LiquidMetal alloys for specific applications, the latest 387, 388, 392 being LiquidMetal Platinum for the jewellery industry.

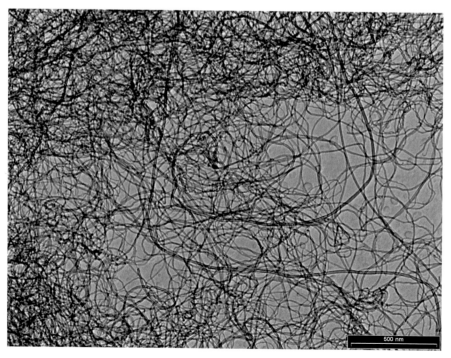

Manufacturer
Nanocyl
4, rue de l'Essor
5060 Sambreville
Belgium

T +32 (0)71 7503 80
F +32 (0)71 7503 90
info@nanocyl.com
www.nanocyl.com

Nanotube

The use of carbon nanotubes for televisions of the future will be the death knell for LCD and plasma screens. Nanotubes are elongated structures one thousand times finer than a human hair, which emit electrons from either end when placed in an electric field. Cathode screens currently feature this electron-emission phenomenon; in the future, nano-components will make it possible to achieve extreme miniaturization easily and relatively inexpensively, thus revolutionizing – while becoming an integral part of – our day-to-day lives. In addition to television, carbon nanotubes target a wide range of applications, including composite materials, high-tech fibres and electrodes for fuel cells and artificial muscles.

382
386
391
381, 384
384, 388
382
385, 384, 383

Manufacturer
Honeywell
101 Columbia Road
Morristown, NJ 07962
USA

T +1 973 4552 000
F +1 973 4554 807
www.honeywell.com

Spectra

390

385, 381

387, 388

385

384

Spectra is an extraordinarily strong, resilient, polyethylene fibre. A cut-proof, abrasion-resistant material with a pleasant texture, it is ideal for making protective sleeves and lining leather gloves. Patented blends of Spectra and nylon are used in apparel and accessories for chain-saw operators; similar blends appear in protective gear for practitioners of fencing. Spectra and fibreglass – a hybrid combination marketed as Spectra Guard – produce an even more rugged cut-proof fabric. Added flexibility and elasticity are provided by a Spectra-spandex blend called Spectra Stretch. Different types of Spectra can be used to make bulletproof vests and other resources for civil and military protection. Additional applications are marine use and composites.

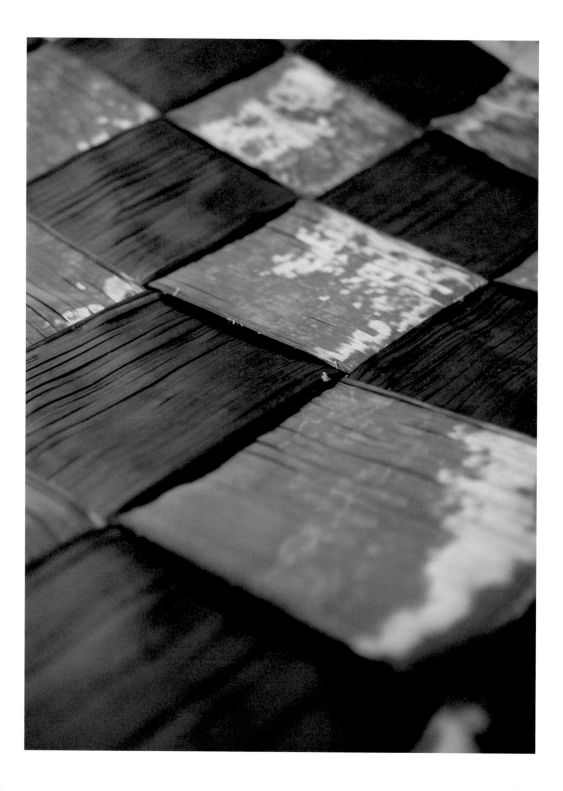

Manufacturer

Oxeon
Fältspatsgatan 2
42130 Västra Frölunda
Sweden

T +46 (0)31 7093 380
F +46 (0)31 7093 389
contact@oxeon.se
www.oxeon.se

385

385, 381, 382

382, 383

Textreme

Oxeon has developed a weaving technology for the manufacture of tapes composed of fibres made from all types of materials, including glass, aramid, carbon and extremely brittle materials such as boron and ceramic. The product can be used by the makers of advanced composites in the aerospace, sports, automotive and marine industries, where improvements in product performance (smoother surface, faster output) are valued highly. Tapes come in widths from 20 to 50 mm. Custom-made tape-woven products are available upon request.

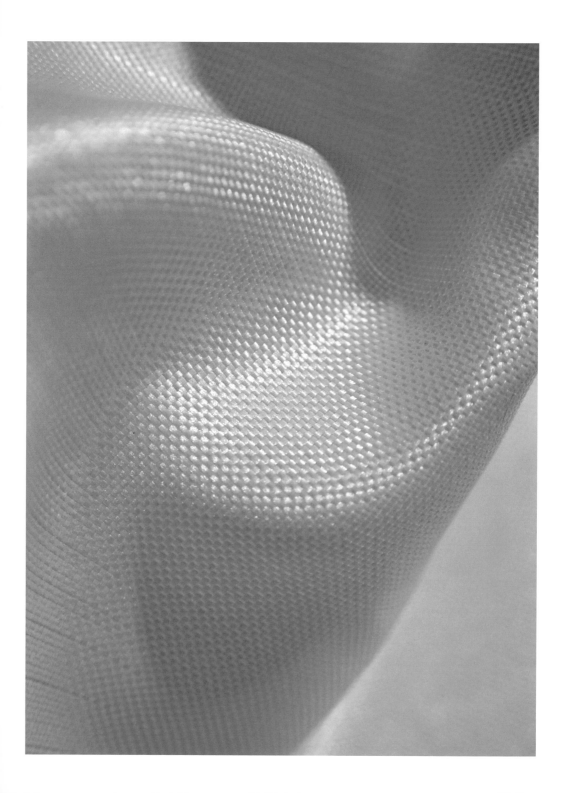

Manufacturer
Warwick Mills
301 Turnpike Road
PO Box 409
New Ipswich, NH 03071
USA

T +1 603 8781 565
F +1 603 8784 306
inquiries@warwickmills.com
www.warwickmills.com

Turtleskin

387

Light, flexible and comfortable to wear, Turtleskin offers ideal protection against bites, thorns, barbed wire and sharp

385

objects. Thanks to the use of ultra-tough ballistic fibres, the fabric boasts the tightest weave achieved to date; stronger

392

than steel thread of the same diameter, it is impenetrable, even by a needle. NASA used Turtleskin in its missions to Mars, but the product is equally suitable for the protective clothing of earthlings. Turtleskin is available in a number of grades and blends.

ForMetal	from	fuel	garments	glass
ForMetal	from	full	garments	glass,
ForMetal	from	full	garments.	glass,
forms	from	full	garments.	glass,
forms	from	FullBlown	gaseous	glass,
forms	from	fully	gases,	glass,
Forsnäs	from	fully	gases,	glass,
Fortadur	from	fully	gasoline	glass,
Fortadur	from	fully	gathering	glass.
Fortadur	from	fun.	Gaultier's	glass.
forth	from	function	gave	glass.
forth	from	function,	gear	glass.
forth)	from	functional	gear,	glass.
forth)	from	functions	gears	glass.
forth).	from	fungal	gel	glasses
forth).	from	furnaces	gel.	Glasses
forth).	from	furniture	gels,	glass-fibre
forth).	from	furniture	gels,	glazing
forth).	from	furniture	gemstones,	glimpse
forth);	from	furniture	generate	glossy
forth.	from	furniture	generate	gloves
forth.	from	Furniture	generated	gloves.
forth.	from	furniture	generated	glow-in-the-dark
forward	from	furniture	generation	glued
found	from	furniture	generation	glued
found	from	furniture	genuine	Glued
found	from	furniture	geometric	glued,
found	from	furniture	geometry.	glued,
four	from	furniture	Get	glued,
four	from	furniture	giant,	goat
four	from	furniture	give	goes
four	from	furniture	give	gold
four-colour	from	furniture	given	gold,
fragile	from	furniture	given	gold,
fragile	from	furniture	given	golf
fragility	from	furniture),	given	good
frame	from	furniture,	gives	good
frames	from	furniture,	gives	good
frames,	from	furniture,	gives	good
frames,	from	furniture,	gives	good
Frédérick	from	furniture,	gives	good
free,	from	furniture,	giving	good
free,	from	furniture,	giving	good
free.	from	furniture,	giving	goodbye
freezing	from	furniture.	Glacé	goods
freezing	from	furniture.	glass	goods.
Frenchman	from	furniture.	glass	goods.
fresh	from	furniture.	glass	gr/dm2.
freshly	from	furniture.	glass	GR/FB
freshwater	from	furniture-making,	glass	GR/FB
friction-resistant	from	further	glass	graded
friendly	from	fuse	glass	grades
friendly	from	fuse	glass	grades
friendly	from	fused	glass	grades
friendly	from	fused,	glass	grades
friendly	from	fuses	glass	grades.
friendly	from	Fusion	glass	gradual
friendly	from	fusion	glass	gradually
friendly)	from	future	glass	grain
friendly,	from	future,	glass	grains
friendly,	from	FX	Glass	grains,
friendly.	from	g/cm3.	Glass	grams
friendly.	from	g/litre.	glass	granite.
from	from	g/m2	glass	granulated
from	from	g/m2.	glass	granulated
from	from	g/m2.	glass	granules
from	from	galvanized	glass	granules
from	from	game	glass	granules
from	from	games,	glass	granules,
from	front	garages,	Glass	graphic
from	Frontier	gardens,	glass	grass
from	frost	garments	glass	gravestones
from	frost-,			

grease	has	helicoid)	hold	ideal
grease	has	hello	hollow	ideal
great	has	hemispheres	hollow	ideal
great	has	hemp	hollow,	Ideal
Great	has	hemp	Holo-Color	ideal
great	has	hemp	Holo-Color	Ideal
greater	has	hemp,	Holograms	Ideal
greater	has	hemp,	holographic	ideal
greater).	has	Hemp,	homogeneity	ideas
green	has	hemp,	homogeneity.	ideas,
green	has	hemp,	homogeneous,	identical
Green	has	hemp.	Honeycomb	identification,
Green	has	hemp.)	honeycomb	identity
green,	has	hemp-reinforced	honeycomb	if
green,	has	Henri	Honeycomb	if
green,	hats,	herald	honeycomb	illumination
greenhouse	haute	heralds	honeycomb	illumination
greenhouse	haute	here	honeycomb	illumination,
grey	have	hide	honeycomb	illusion
grid	have	hides	honeycomb	illusion
grid	have	hides.	honeycomb,	illusion
grooves	have	high	horny	illusion
ground	have	high	hose	image
Group.	have	high	hospital	image
Grouped	have	high	host	image
grow	have	high	host	image
grow,	have	high	host	image
Guard	have	high	hot	image
GUBI	have	high	hot	image,
Guenoun's	have	High	hot	image-mastering
Gueta	have	high	hot	images
guidance	Having	high	hour	images
guide	having	high	hours),	images
gum),	having	high	hours.	images
h	hawksbill	high-definition	however,	Imagine
hair,	he	high-density	however,	imaging.
hair,	health	higher	however,	immediate
half	health-care	highly	however,	immerse
half-millimetre	heat	highly	however,	immiscible
halls,	heat	Highly	however,	impenetrable,
hand	heat	highly	however,	impermeable
hand	heat	highly	HQE	impervious
handbags	heat	highly	huge	important
hands.	heat	highly	human	importantly,
hand-woven	heat	highly	human	impossible
Hapuflam	heat	highly	human	impregnated
Hapuflam	heat	highly	human	impregnated
Hapuflam	heat	highly	humidity,	impregnated
Hapuflam	heat	highly	humidity,	impregnated
hard	heat	highly	humidity.	impregnating
hard	heat	highly	hundreds	impression
hard,	heat	highly	hundreds	impressive
hard,	heat-	Highly	hybrid	Imprimerie
hard,	heat,	highly	hydrates	imprinted
hardboard	heat,	highly	hydraulic	improve
hardy	heat-compression	highly	hydraulic	improvements
has	heated	highly	hydraulic	improves
has	heated	Highly	hydrocarbon-	improving
has	heated	highly	hydrocarbon-,	in
has	heated	highly.	hydrogel.	in
has	heating	high-performance	hydrophobic,	in
has	heat-moulded	high-performance	hydrothermal	in
has	Heat-pressing	high-performance,	ice.	in
has	heat-proof.	high-performance,	iColor	in
has	heats	high-quality	iColor	in
has	heats	high-reflection	ICR	in
has	Heatstop	high-tech	idea	In
has	Heatstop	high-tech	idea	in
has	heavy	high-tech	ideal	in
has	heavy,	high-volume	ideal	in
has	heavy.	his	ideal	in
has	height	hobbyist	ideal	in

Industrial

Chromed panelling resembling elegantly embossed partitions
is used as a cooling element in refrigerated areas. Chain mail
provides meat-industry workers with total body protection.
A stainless-steel, micro-filtration textile feels like sheer silk,
and industrial springs look pretty enough to grace a jewellery
display. Every day modern industry gives birth to materials
with incredible properties, aesthetic qualities and exotic
applications. Their beauty often inspires designers to find new
uses for these highly industrial, little-known materials: a car
filter becomes a lampshade (Masayo Ave, designer), food-
industry conveyor belts pop up as sunshades on the façade of
a building, hospital gel adds comfort to an upholstered chaise
longue (Christian Ghion, designer) and a lenticular film intended
for computer screens was seen recently on the display windows
of Issey Miyake boutiques.

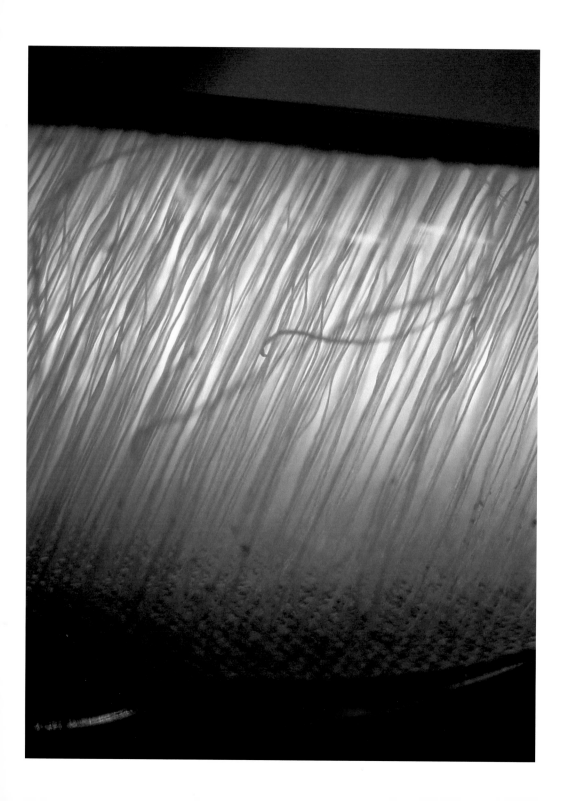

Manufacturer

Tissavel
Zone Industrielle - BP 33
59531 Neuville-en-Ferrain
France

T +33 (0)3 2028 9010
F +33 (0)3 2028 9011
tissavel@tissavel.fr
www.tissavel.fr

3-D Textile

390, 390
390, 390
392
387
391, 383

Tissavel's 3-D textile (made from polyester, polyamide and polypropylene) features two slay and pick fabrics joined by connecting threads. The distance between the two fabrics (from a few millimetres to 45 cm) can be tailored to measure and the mechanical resistance of the textile adapted to individual needs. The product is used for inflatables (boat keels, pontoons and so forth); for the protection of receptacles (filled with sand or concrete, for example); for composite structures used in the building industry; and for heat, fire and mechanical damage protection. Potential applications are legion, given the high level of interest expressed in inflatable structures by furniture makers and interior designers.

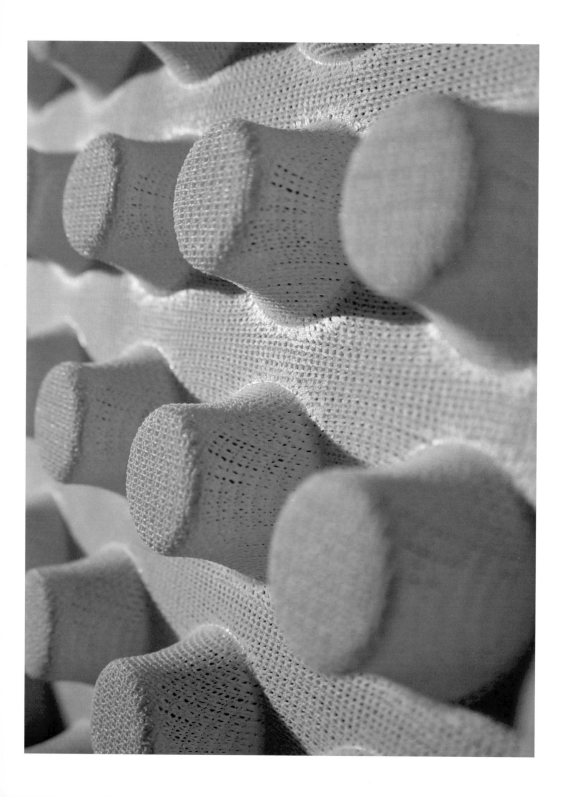

Manufacturer

Mayser
Bismarckstrasse 2
88161 Lindenberg
Germany

T +49 (0)8381 507-0
F +49 (0)8381 507-101
info@mayser.de
www.mayser.de

3D-Tex

Produced in sheets and rolls, this fireproof textile is
impregnated with a stabilizing polymer blend of
thermosetting and thermoplastic resins and moulded to
produce a three-dimensional pattern. Two of the products
available are a basic white polyester textile and a less
costly brown textile composed of 50% polypropylene and
50% hemp. Aesthetically intriguing, this highly stable
and flexible product can be used as is, as a support for
other materials and as a component of sandwich panels.
Its permeable structure allows gaseous and viscous
substances to pass through. Users are the automotive and
aviation industries, construction companies (roofing
materials, building façades) and manufacturers of sports
shoes. 3D-Tex is 14 mm thick and comes in 50-metre rolls.

390

392, 392, 391, 388

390

390

386

391

385

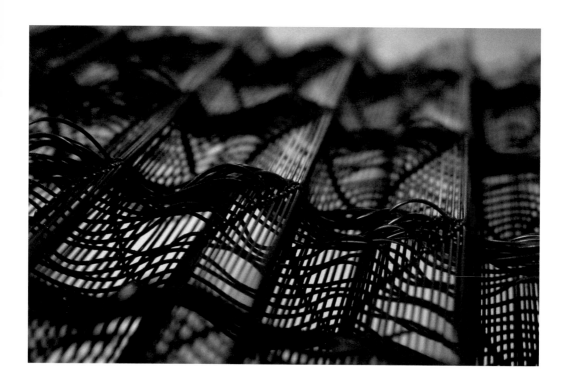

Manufacturer

Kimre
16201 SW 95 Avenue,
suite 303
Miami, FL 33157
USA

T +1 305 2334 249
F +1 305 2338 687
sales@kimre.com
www.kimre.com

Kimre Europe
Koolmijnlaan 201
3582 Beringen
Belgium

T +32 (0)11 4507 50
F +32 (0)11 4507 59
sales@kimre.com
www.kimre.com

B-GON

390

These 100% polypropylene structures, which look a bit like elaborate fashion accessories, are actually highly effective filter pads. Available in a variety of mesh sizes, the layered pads are used to trap droplets produced by all sorts of

387

liquids. B-GON's primary application is industrial filtration, but a clever designer will spot the aesthetic potential of

386

this product in the blink of an eye.

Manufacturer
NDC Sales
2-39-1 Mimomi,
Narashino-Shi
Chiba 275-0002
Japan

T +81 (0)47 4771 133
F +81 (0)47 4771 156
export@ndc-sales.co.jp
www.ndc-sales.co.jp (Japanese only)

Calme / Almute

Calme / Almute is a high-performance sound-absorption product. In a unique manufacturing process, fine grains of aluminium are heated to just under their fusion temperature. At this point, only partially fused, the aluminium is formed into panels that are more than 40% porous. Permeable to air and liquid, the panels are used mainly for filtration and for highly varied sound-absorption applications, even in damp environments. Available in various finishes and colours, the 100%-recyclable product is suitable for both indoor and outdoor use.

381
381
381
387

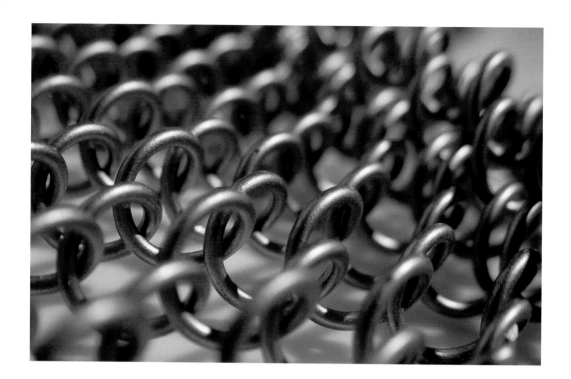

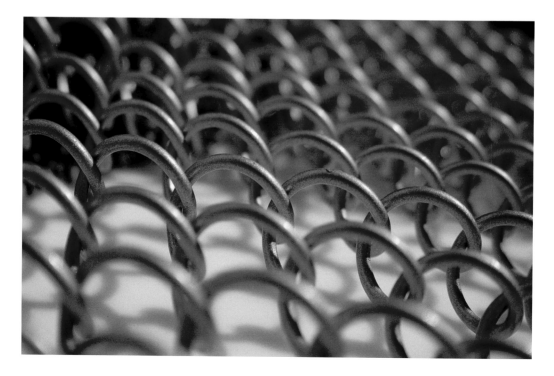

143

Manufacturer

Cascade Coil Drapery
PO Box 14602
Portland, OR 97293
USA

T +1 800 9992 645
T +1 503 2331 530
F +1 503 2331 398
sales@cascadecoil.com
www.cascadecoil.com

Cascade Coil Drapery

Cascade Coil Drapery is an innovative, functional material that allows the architect to play with and direct light without influencing ventilation or acoustics. It can take the place of conventional dividers, curtains, and other ceiling and window treatments. Fire resistant, lightweight, flexible, aesthetically pleasing, and easy to install and maintain, the product is suitable for all types of interior design. It can be used as fireplace mesh, as explosion protection, and as an enclosure for birds and animals. The fabric-like aluminium coils are available in various sizes and with a choice of finishes.

383
387
387
381
383

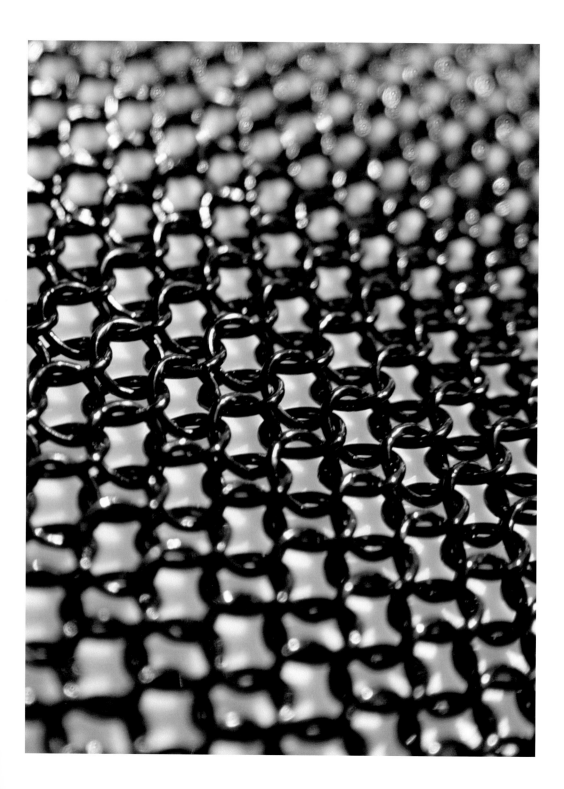

Manufacturer
Foin groupe Bacou-
Dalloz
33, rue des Vanesses
ZI de Paris Nord 2
PO Box 50288
95958 Roissy CDG
France

T +33 (0)1 4996 6170
F +33 (0)1 4996 6171
information@groupe-foin.com
www.groupe-foin.com

Chainex 0.7

392

387

A flowing cloth comprised of individually welded stainless-steel rings, Chainex is a contemporary version of the protective chain mail once worn by knights and used, even today, as a protective material for butchers' gloves and aprons. This flexible material, with its unique texture and light-catching facets, is prized by architects, as well as by interior and fashion designers. Available in several versions and finishes, Chainex has a wide range of applications, from curtains and wall and ceiling coverings to Paco Rabanne dresses and accessories.

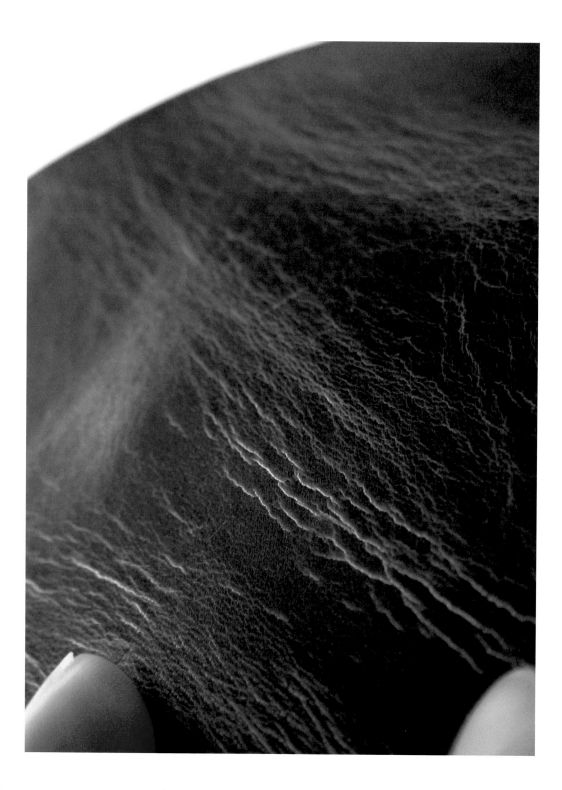

Manufacturer
Clayton of Chesterfield
Clayton Street Tannery
Derbyshire S41 0DU
Chesterfield
England

T +44 (0)1246 2328 63
F +44 (0)1246 2078 07
office@claytonleather.com
www.claytonleather.com

Chrome Waxed Leather

383, 393, 387
No other material tops the ability of chrome waxed leather
to meet and to adapt to the demands of extreme industrial
applications, such as hydraulic systems. Its resistance
389, 385
to oil, exhaust gases, antifreeze agents and temperature
387, 392
variations make this leather the ideal solution for protecting
381
hydraulic seals on aircraft flaps, to cite one example. Other
387
leather treatments – such as special vegetable tanning,
383, 389
chrome tanning and oiling – are available for multiple
industrial applications of a material that all too often is
misperceived as 'traditional'.

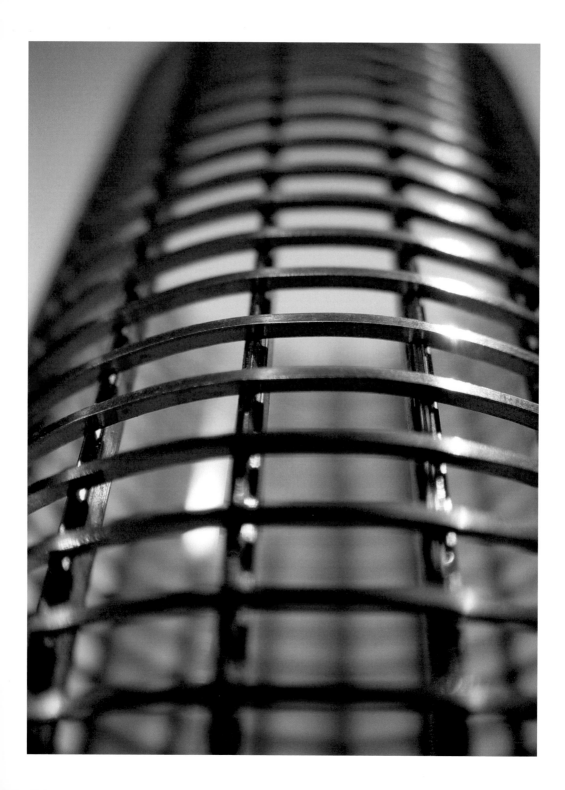

Manufacturer

Euroslot
ZA Les Priédons
86140 Scorbé Clairvaux
France

T +33 (0)5 4993 9393
F +33 (0)5 4993 8671
info@euroslot-screens.com
www.euroslot-architecture.com

Cylindrical Filters

389
392, 382, 385
392
389

Euroslot's cylindrical filters are used mainly in water and oil wells. Available in stainless steel, carbon steel or galvanized steel, they are made by machines designed especially for the resistance welding of triangular wire onto transverse supports. Well filters come in four depth levels: 100, 200, 350 and 600 metres. Benefits are lower energy consumption, higher well flows and longer well operation. The same type of filter is used in nuclear-power plants and in the chemical, paper and pulp, and food industries. Its aesthetic appeal even makes it suitable for architecture and interior design. Flat panels can be made from flattened cylinders, as well as with the use of a special machine. Cylinder diameter: 21 to 956 mm. Opening: 0 to 50 mm (maximum).

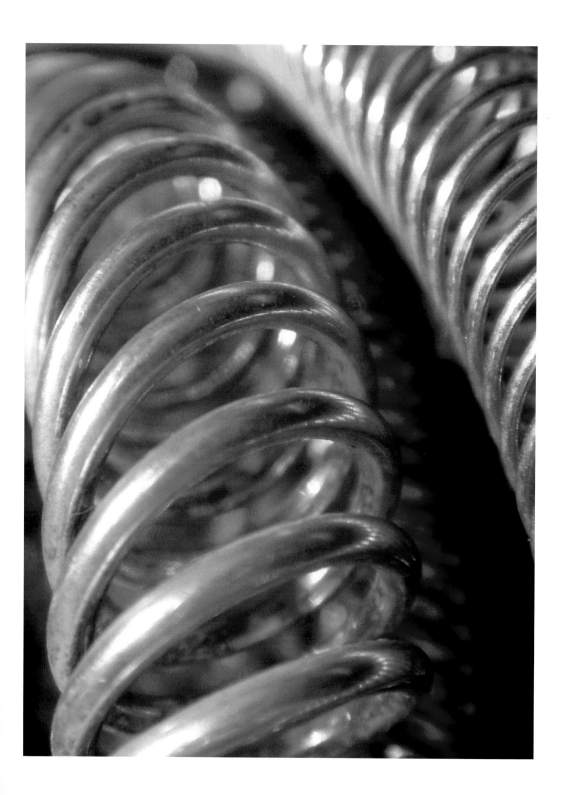

Manufacturer

Bal Seal Engineering
19650 Pauling
Foothill Ranch,
CA 92610-2610
USA

T +1 949 4602 100
F +1 949 4602 300
sales@balseal.com
www.balseal.com

Bal Seal Engineering
Europe
Spinozastraat 1
1018 HD Amsterdam
the Netherlands

T +31 (0)20 6386 523
F +31 (0)20 6256 018
info@balseal.nl
www.balseal.nl

Cylindrical Spring

383, 383

The elliptical coils of a cylindrical, canted-coil spring deflect
independently. The entire spring responds when any part

383

of a coil is deflected, producing consistent spring force
(uniform loading) at each contact point. By welding the ends
of such springs together, Bal Seal makes coupling rings
for surgical and dental devices, other drilling attachments,

385

swivels and breakaway gasoline hose couplings, to mention

383

only a few applications. The canted-coil-spring technology

384

is used, for example, in medical electronics and to make
industrial connectors and optical devices. A broad range of

381

alloys are used to make the springs, which are available in
various sizes and diameters.

Manufacturer

Vereinigte Filzfabriken
Giengener Weg 66
89537 Giengen
Germany

T +49 (0)7322 144-0
F +49 (0)7322 144-144
info@vfg.de
www.vfg.de

Felt Block

385 Felt has long been associated with slippers, hats, coats and other garments. Today, however, the material is used (often out of sight) in cars, musical instruments, electrical

385
393 appliances and the building trade The success of felt, especially that made from wool, lies in its softness and in its

387, 389 ability to absorb liquids and oils, to insulate, and to absorb

385 shocks. Felt comes in many sizes and shapes, including seamless tubes of quite large dimensions. Vereinigte

392 Filzfabriken serves a clientele representing more than 80 business sectors. In development are new manufacturing methods for an even better product.

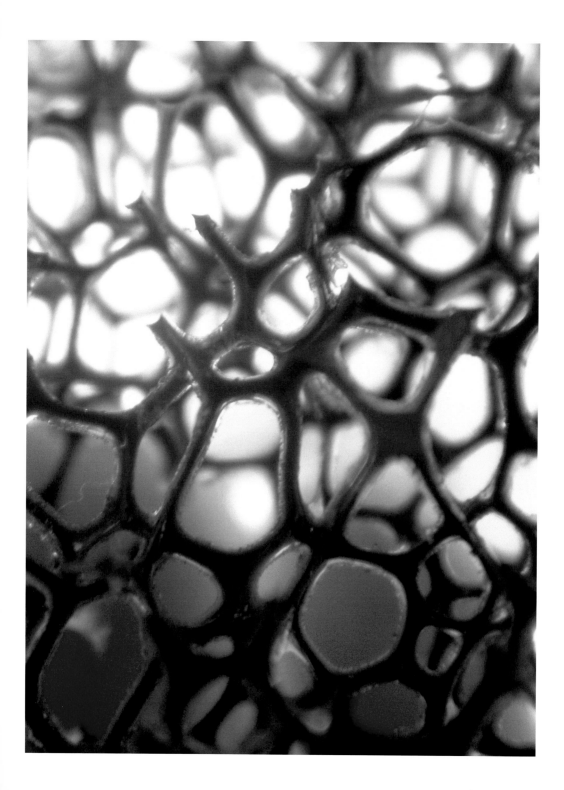

Manufacturer
Eurofoam
Via C. Colombo, 12
20020 Lainate
Italy

T +39 02 9379 6660
F +39 02 9379 6700
info@eurofoam.com
www.eurofoam.com

FiltroCell

383, 390, 385
383, 381
386, 383
383

Made from open-cell polyurethane foam, as its name suggests, Filtrocell is used for air and water filtration, in the automotive industry and as a host surface for micro-organisms in aquariums. Its cross-linked cells (available in various sizes) display differences in appearance and degree of transparency when viewed from different angles. Filtrocell is a breathable material. It can be washed in water. The product is available in blocks and sheets in a range of colours and grades.

Manufacturer
Krüger & Sohn
Robert-Bosch-
Strasse 1-3
84030 Landshut
Germany

T +49 (0)871 7004-0
F +49 (0)871 7004-11
info@krueger-und-sohn.de
www.krueger-und-sohn.de

Krütex

389, 383
385, 389
392

Bars, tubes and blocks are among the products Krüger &
Sohn makes from various materials – such as paper, cotton
and fibreglass – that are impregnated with phenolic resin.
Each of the firm's product ranges (Krüpex, Krüpax, Krülit)
has a specific composition. Applications include hydraulic
systems, ball bearings (for cages) and guide rings. The
product is even used in the health-care sector. The wood-like
appearance and sturdy structure of this material make it an
interesting option for architects and interior designers.

Distributor

Isolants de l'Est
Zone Industrielle Ouest
28, avenue des Erables
54182 Heillecourt cedex
France

T +33 (0)3 8353 1818
F +33 (0)3 8353 1333
info@isolants.com
www.isolants.com

Pertinax

392, 389, 389

Pertinax is paper impregnated with phenolic resin. Its electrical-insulation properties offer a solution to problems

383

caused by heat and corrosion. Industrial applications include electrical engineering, chemicals and automotive products. Dimensions: 200 x 100 cm. Minimum thickness:

392

0.5 mm. Pertinax withstands temperatures of up to 120°C.

Manufacturer
Omega
PO Box 10013
7504 PA Enschede
the Netherlands

T +31 (0)53 4281 818
F +31 (0)53 4281 819
info@omegaengineering.nl
www.omegaengineering.nl

Pillow Plate

Pillow Plate is the name given to double-sided metal panels
which are laser welded on the surface and sides before
being pumped full of compressed air (400 bars). The result is
quilted metal. The panels are used in the chemical industry
and, even more widely, as insulation units in the food sector
(for the insulation of refrigerated items like dairy products,
beer, chocolate, wine and so forth) and in the production
of ice. Different metals, including steel and titanium, are
available. Pillow Plate comes in a variety of thicknesses.

388
386
381
388

381

388, 392, 392

Manufacturer

SPV
Rue Sainte Reine
43500 Craponne sur
Arzon
France

T +33 (0)4 7103 3040
F +33 (0)4 7103 3334
moquette.routiere@ wanadoo.fr

Road Surface

A roll-up road surface? SVP delivers a fully sealed, non-slip road carpet for surfacing any area in record time. Available in rolls of varying dimensions, thicknesses (5 to 12 mm), colours and grains, the product is hydrocarbon-, oil-, chemical- and fire-resistant. Laid with the use of cold or hot adhesion, it is an ideal solution for surfacing terraces, garages, stairways, gardens, car parks, access ramps, road markings and emergency stop lanes.

386, 389

381

381

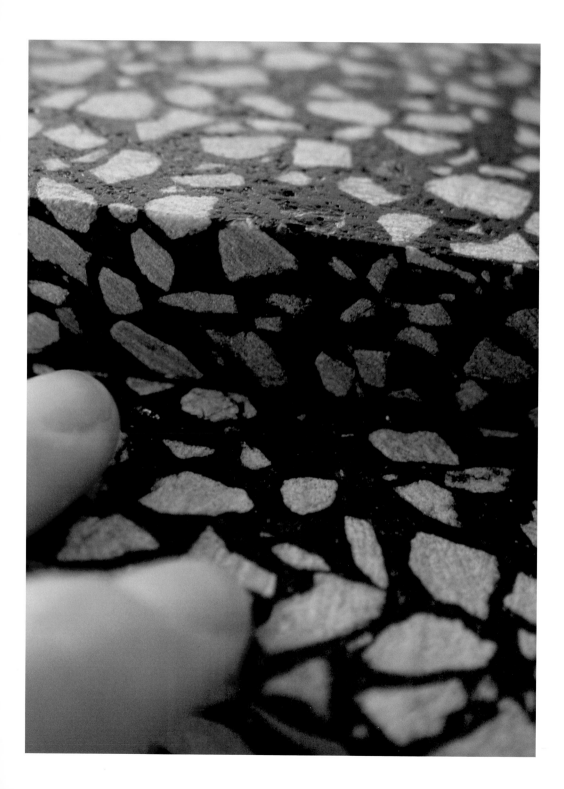

Manufacturer
ASTEN
66, rue Jean-Jacques
Rousseau
94207 Ivry-sur-Seine
France

T +33 (0)1 5891 2900
dir.technique@astengroup.com

382

Sparoc

A floor covering with the look of nougat, Sparoc is an asphalt paving material affixed to the underlying surface with a water-based adhesive. It is suitable for pedestrian-frequented areas like walkways, halls, corridors, lobbies and so forth. The attractively pebbled flooring resists dirt and stains (such as grease and discarded chewing gum), which are all but invisible on its seamless, granulated surface. Available in several colours.

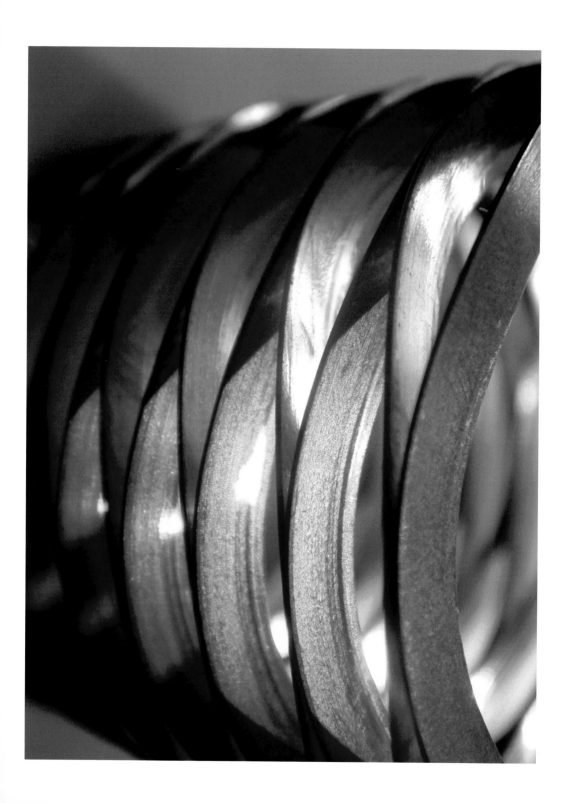

Manufacturer
Smalley Steel Ring
555 Oakwood Road
Lake Zurich, IL 60047
USA

T +1 847 7195 900
F +1 847 7195 999
info@smalley.com
www.smalley.com

SpiraWave

383

Wave springs are made using a flat wire. During the coiling process, the wire is shaped to obtain a series of nested,

392, 383

interlaced, undulating coils. Wave springs are used for industrial applications that require both space saving (30 to 50%) and the same flexibility and force as a standard spring. Smalley's Spirawave is so effective that the American Athletics Federation recently banned one manufacturer's athletic footwear from competitions, because springs in

381

the soles gave athletes wearing these shoes an unfair

381

advantage. The SpiraWave is available in various alloys

382, 392, 381

(including carbon steel, stainless steel, super alloy and

383, 382

copper beryllium) and in diameters ranging from 10 to 3500 mm.

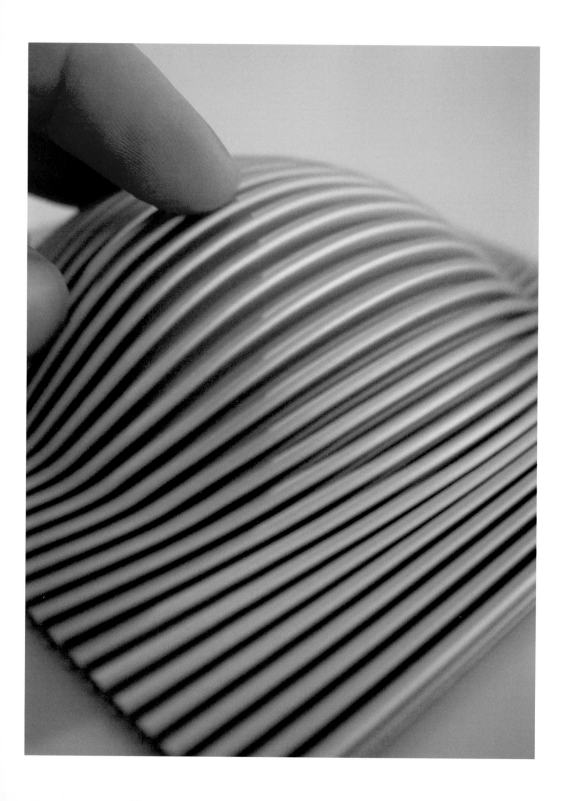

Manufacturer
Fielitz
Brunnhausgasse 3
85049 Ingolstadt
Germany

T +49 (0)841 9351 4-0
F +49 (0)841 9351 4-13
info@fielitz.de
www.fielitz.de

Web Plate

392, 381

387

381

387, 392

Web Plate is the name of an undulating aluminium product that defies geometry. Truly wavelike, Fielitz's lightweight, high-performance, anodized panels are available in your choice of perforated or non-perforated models. Use them to create 3-D shapes for innovative and aesthetic applications in interior architecture and design (furniture, architectonic elements, special lighting effects and so forth). The manufacturer will customize the product to meet the client's needs. Web Plate comes in various designs and dimensions.

in	in	in	in	including
in	in	in	In	including
in	in	in	In	including
in	in	in	in	including
in	in	in	in	including
in	in	in	in	including
in	In	in	in	including
in	in	in	in	incorporated
in	in	in	in	incorporated
in	in	in	in	increasing
in	in	in	In	increasingly
in	in	in	In	incredibly
in	in	in	in	indelible
in	in	in	in	independently.
in	in	in	in	indestructible.
in	in	in	in	individual
in	in	in	in	individually
in	in	in	in	individually
in	in	in	in	individually
in	in	in	in	individually.
in	in	in	in	indoor
in	in	in	in	indoor
in	in	in	in	indoor
In	in	in	in	indoors
in	in	in	in	indoors
in	in	in	in	indoors,
in	in	in	in	industrial
in	in	in	in	industrial
in	in	in	in	Industrial
in	in	in	in	industrial
in	in	in	in	industrial
in	in	in	in	industrial
in	in	in	incidence,	industrial
in	in	in	include	industrial
in	in	in	include	industrial
in	in	in	include	Industrial
in	in	in	include	industrial
in	in	in	include	industrial
in	in	in	include	industrial
in	in	in	include	industrial
in	in	in	include	industrial
in	in	in	include	industrial
In	in	in	include	industrial
in	in	in	include	industrialization
in	in	in	include	industries,
in	in	in	include	industries,
in	in	in	include	industries,
in	in	in	include	industries,
In	in	in	include	industries.
in	in	in	include	industries.
in	in	in	include	industries.
in	in	in	include	industries.
in	in	in	include	industries.
in	in	in	include	industries.
in	in	in	include	industries.
in	in	in	include	industries.
in	in	in	include	industry
in	in	in	include	industry
in	in	in	include	industry
in	in	in	include	industry
in	in	in	include	industry
in	in	in	include	industry
In	in	in	include	industry
in	in	in	includes	industry,
in	in	in	includes	industry,
in	in	in	includes	industry,
in	in	in	includes	industry,
in	in	in	including	industry,
in	in	in	including	industry,
in	in	in	including	industry,
in	in	in	including	industry.
in	in	in	including	industry.

industry.	insulation	interior	IR	is
industry.	insulation	interior	IR	is
industry.	insulation	Interior),	iridescence	is
industry.	insulation	interior.	iridescent	is
industry.	insulation	interior.	iridescent	is
industry.	insulation	interior-design	iridescent	is
industry:	insulation	interlaced,	Iriodin	is
industry:	insulation	interlining	IronX	is
industry;	insulation	interlinings,	irregular	is
inert	insulation,	internal	irrigation,	is
inert,	insulation,	interwoven	irritate	is
inexpensive.	insulation.	interwoven	is	is
inexpensively,	insulation.	interwoven	is	is
inflatable	insulation.	into	is	is
inflatables	insulation.	into	is	is
inflated	insulation.	into	is	is
inflated	insulation.	into	is	is
influencing	insulation.	into	is	is
information	insulation.	into	is	is
infrastructure	insulator	into	is	is
Ingeo	insulator	into	is	is
Ingeo	insulator	into	is	is
Ingeo	insulator	into	is	is
Ingeo,	insulator,	into	is	is
ingredients	intact.	into	is	is
Initial,	integral	into	is	is
initially	integrate	into	is	is
initially	integrated	into	is	is
injected	integrated	into	is	is
injection	IntegratedCircuit	into	is	is
injects	integration	into	is	is
ink	intended	into	is	is
ink	Intended	into	is	is
inner	intensity	into	is	is
inner	intensity	into	is	is
innovation	intensity,	into	is	is
innovation	interest	into	is	is
innovation	interesting	into	is	is
innovative	interesting	into	is	is
innovative	interesting	into	is	is
innovative	interesting	into	is	is
innovative	interesting	into	is	is
innovative,	interesting	into	is	is
inscriptions	interfaces	into	is	is
insects	interfaces	into	is	is
inserted	interior	into	is	is
insertion	interior	into	is	is
inside	interior	into	is	is
inside	interior	into	is	is
inside	interior	into	is	is
inside	interior	into	is	is
inside	interior	into	is	is
inside,	interior	intricate	is	is
insoles,	interior	intriguing	is	is
inspire	interior	intriguing	is	is
install	interior	intriguing	is	is
installed	interior	intriguing	is	is
instance).	interior	intriguing	is	is
instant	interior	intriguing,	is	is
instead	interior	intumescent	is	is
Institute	interior	invented	is	is
instruments	interior	Invented	is	is
instruments	interior	inventory	is	is
instruments	interior	investment	is	is
instruments,	interior	invisible	is	is
instruments,	interior	invisible	is	is
insulate,	interior	invisible	is	is
insulates	interior	invisibly	is	is
insulating	interior	Invista	is	is
insulating	interior	inviting	is	is
insulating	interior	involved.	is	is
insulation	interior	involves	is	is

Know-How

Materials often hold surprises just waiting to be discovered
by those who use them – creatives with experience, talent and
know-how. It's up to them to push the envelope, to see where and
how far a material can go. Selecting a material is the first step.
The processes that follow run the gamut from cutting, piercing
and polishing to shaping, assembling and declaring the project
completed. Each essential operation – the designer with know-
how often treads a long, complex and delicate path – is geared
to the composition of the material in question. Specialized
knowledge that brings out the full potential of a material is rare
and prized. Not everything in this section of the book can be
called innovative, but the items featured certainly illustrate a
number of intriguing ways to deal with materials.

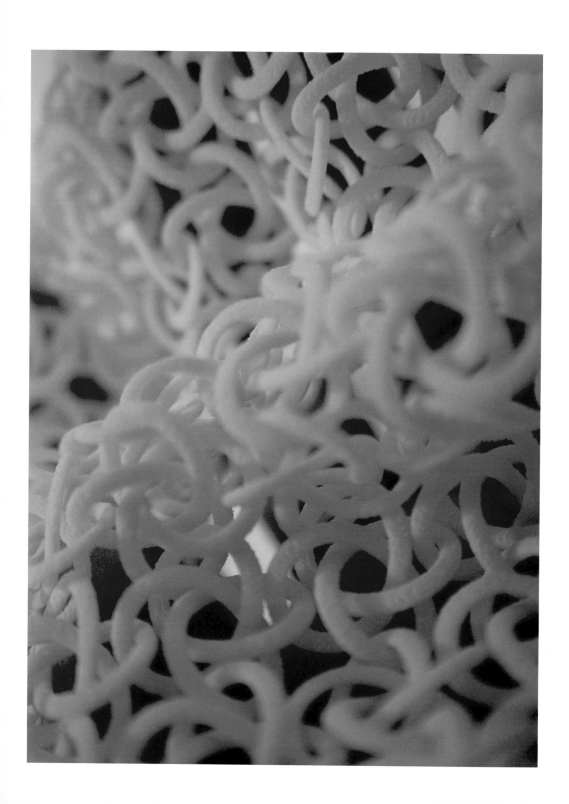

Manufacturer
Freedom of Creation
Hobbemakade 85hs
1017 XP Amsterdam
the Netherlands

T +31 (0)20 4271 575
F +31 (0)20 6758 415
info@freedomofcreation.com
www.freedomofcreation.com

3-D Printed Textiles

392, 386

This patented 3-D printing technology produces laser-created textiles without the need for complex stitching. It marks a radical departure from the traditional notion of fabric sold by the metre and sewed to make garments and bags. The flexible manufacturing process that turns out these fabrics works equally well for certain metals, as well as for a limited range of plastics, such as nylon and epoxy resin. It heralds a new way of looking at textiles and a promise of innovation to come in haute couture, fashion accessories and even interior design.

388

390, 388

384

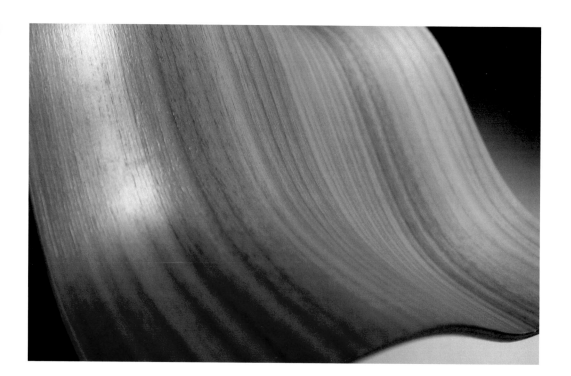

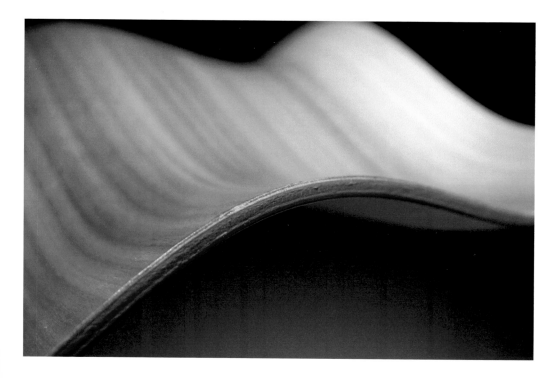

Manufacturer

Reholz
Sachsenallee 11
01723 Kesselsdorf
Germany

T +49 (0)35204 7804-30
F +49 (0)35204 7804-50
info@reholz.de
www.reholz.de

3D Veneer

387

382, 387, 389, 393

381

381

388

Reholz's fine wood veneer can be shaped into three-dimensional forms (waves, hemispheres and so forth) without cracking or breaking. This incredibly flexible, lightweight veneer is available in several varieties, including beech, maple, oak and walnut. The 2004 Forsnäs Prize (Stockholm Furniture Fair) went to Komplot Design's elegant GUBI chair, the first industrial product featuring Reholz 3-D Veneer. Although the possibilities seem endless, current applications target the design of furniture, mouldings and dinner trays, as well as diverse edgings and surfaces. Maximum dimensions of the panels: 980 x 2000 mm.

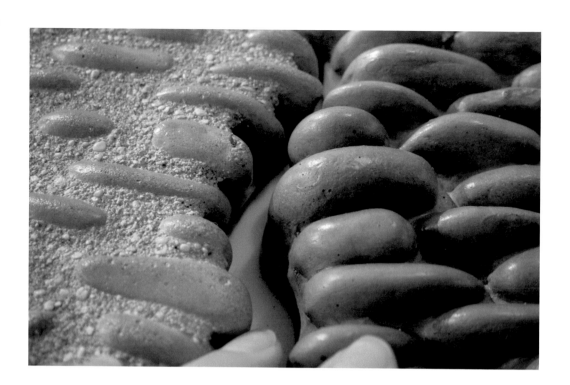

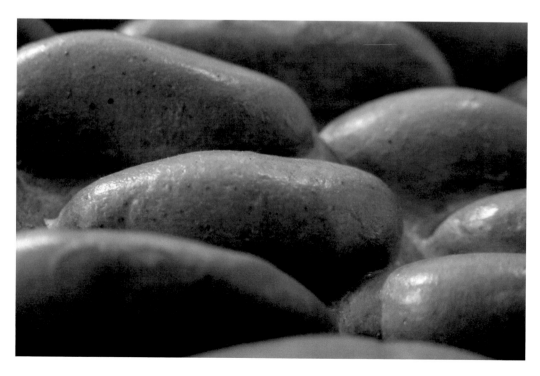

Manufacturer

Artbéton
58, rue du Professeur
Calmette
42700 Firminy
France

T +33 (0)4 7740 0101
F +33 (0)4 7740 0105
info@artbeton.fr
www.artbeton.fr

Appia

383

388

388

Many floors in Mediterranean countries feature smooth pebbles embedded in concrete. Appia is an artificial pebble made of a subtle blend of minerals and natural pigments. It is used in the manufacture of prefabricated, stackable tiles. Once laid, the tiles create a pebbled mosaic that evokes the beaches and aromas of southern Europe. Appia is suitable for floors and walls, indoors and out. Currently in development is a version intended for public roads. Pebbles come in five colours. Tile size: 50 x 50 cm. Thickness: 4 cm.

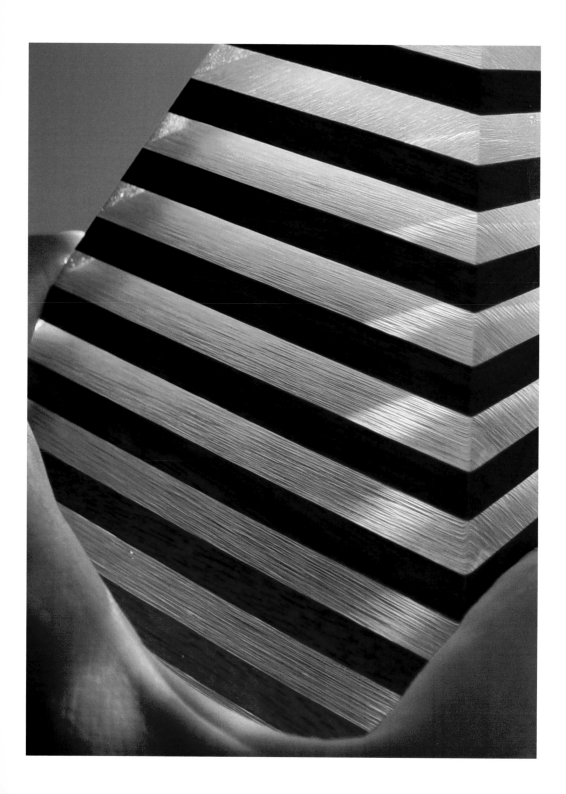

Manufacturer
Ravier
39210 Domblans
France

T +33 (0)3 8444 6108
F +33 (0)3 8444 6329
info@ravier.fr
www.ravier.fr

Cristal de Ravier

390
381

Bonding two materials as different as wood and PMMA is no easy matter. Any wood-and-acrylic assembly has to respect major structural differences between the two. Cristal de Ravier comes in made-to-measure panels and blocks that conform to the unique specifications of the space involved. It is an ideal material for interior design, displays, furniture, point-of-purchase advertising and decorative

389, 392, 381

381, 393, 382, 392

381

objects. Wood choices include oak, sycamore, alder, red alder, walnut and yellow birch. Both colourless and tinted acrylic are available. Finishes are polished or unpolished.

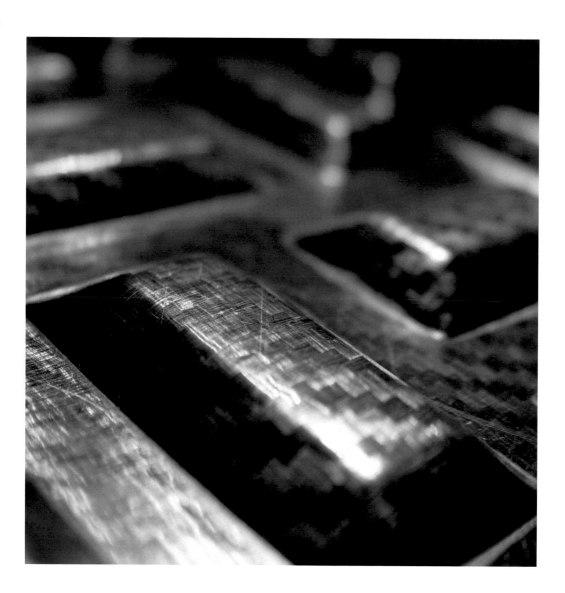

Manufacturer
Amoco Fabrics
Düppelstrasse 16
48599 Gronau
Germany

T +49 (0)2562 7746 5
F +49 (0)2562 7746 7
info@curvonline.com
www.curvonline.com

Curv

Curv is opening the way for a new generation of 100% polypropylene materials whose performance equals that of a fibre-reinforced composite. Amoco Fabrics' unique, patented process turns out a high-quality polypropylene ribbon in a self-reinforcing polypropylene matrix. This very hard, traction- and shock-resistant product can be used to make items with smooth, low-density surfaces that look like woven carbon fibre. Easy to thermoform, Curv is an abrasion-resistant, totally hydrophobic, recyclable thermoplastic. It can be used in conjunction with honeycomb and foam structures, and offers a serious alternative to materials traditionally employed in the construction, automotive and furniture industries.

390
385
390
390
384
382, 385, 392
381
392, 386
385

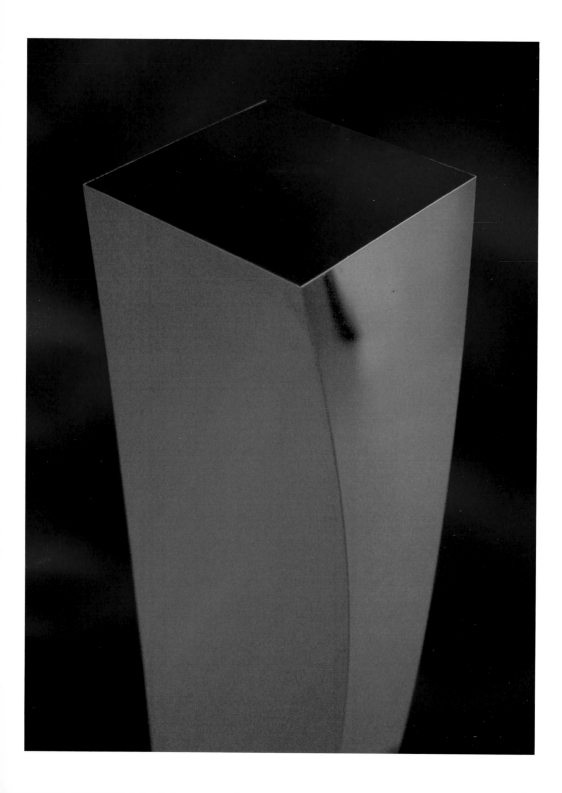

Manufacturer

Donati Group
Via Lombardia
24030 Medolago (BG)
Italy

T +39 035 4936 411
F +39 035 4931 028
doluflex@donatigroup.com
www.donatigroup.com

IronX

388, 387

388, 388

388

388

388

392, 381, 383, 392

Twisted metal shapes and ultra-light, monolithic elements that surely were moulded…? No, they are not moulded, but formed from metal sheets invisibly welded according to an exceptional method developed by the Donati Group. The company relies on this technology to make all sorts of shapes (polyhedral, curvilinear, asymmetric, helicoid) from nothing more than rolled sheet metal. No major investment in equipment is required. A wide range of metals can be used (steel, aluminium, copper, titanium and so on), and the potential applications are manifold: furniture, doors, bookshelves, work boards, dividers, partitions, street furniture, architecture, and the list goes on.

Manufacturer
Sophie Mallebranche
14, rue Abel
75012 Paris
France

T/F +33 (0)1 4252 4206
sophie@sophiemallebranche.com
www.sophiemallebranche.com

Metal Textile

388, 393 These top-quality woven textiles feature metallic yarns –

392, 383, 384, 383 containing stainless-steel, copper, enamelled copper,

382, 392, 385, 393 bronze, tin, gold and so forth – interwoven with yarns of

391, 387, 393, 385 silicone, linen, wool and other fibres. The result is a

388 stunningly luxurious material. Made-to-order metal textiles are highly prized in the worlds of fashion and interior design.

393, 393 Weft yarns make the fabrics truly flexible crosswise, while

393, 393, 391 warp yarns, running lengthways, give them shape memory. Maximum width: 3 metres.

Manufacturer

PhotoGlas
Wollzeile 9/1/30
1010 Vienna
Austria

T +43 (0)1 5852 610
F +43 (0)1 5852 610-20
info@photoglas.com
www.photoglas.com

PhotoGlas

391

391, 390, 385, 391

386, 385, 392

PhotoGlas is a sandwich panel that adds a new dimension to the well-known technique of sandwiching plastic film (PVB) between sheets of laminated glass to produce interesting and often colourful visual effects. Architects, as well as the designers of displays for museums and events, for example, can use PhotoGlas to create giant, high-definition slides. The special lamination technique used to make PhotoGlas, which took years to develop, relies on the use of stable

384, 392

and highly transparent dyes, as well as on cutting-edge information technologies and data-compression programs. Extra-large picture files can be transferred in ultra-high definition to PhotoGlas panels up to several square metres

392, 387

in size. The result is an exciting 'sculptural' display of light and colour.

Manufacturer
Brangs+Heinrich
Felderstrasse 79
42651 Solingen
Germany

T +49 (0)212 2403-0
F +49 (0)212 2403-188
www.brangs-heinrich.com

Polsterflex

Cardboard it is, but Polsterflex also provides flexible, corrugated, anti-shock protection that looks good to boot. The product comes in various colours and finishes (such as aluminium). It can be glued to chipboard, hardboard and the like. Applications include packaging and graphic design. Sizes: 3 x 5 cm to 210 x 350 cm; rolls have a maximum width of 210 cm. Embossing and scored lines can be made on request.

381, 383, 386

384

Manufacturer
GuetaTzuri
137, rue Pelleport
75020 Paris
France

T/F +33 (0)1 4358 5603
tzurit@free.fr
www.design-textile.com

Reptile

381

381

A true virtuoso, GuetaTzuri researches, experiments with and creates unlikely marriages of materials, textures and colours. She makes Reptile, an airy fabric with a reptilian texture, by pressing the material and then reworking it by hand with an airbrush. Clients include trendwatchers in the field of haute couture, as well as designers of prêt-à-porter and accessories. Reptile is available in a range of colours.

Manufacturer

Albeflex
Strada delle Paludi, 1/a
31010 Francenigo di
Gaiarine (TV)
Italy

T +39 0434 7684 92
F +39 0434 7677 52
info@albeflex.it
www.albeflex.it

TSP

Wood as soft to the touch as textile – that's TSP by Albeflex, a firm whose flexible wood veneer, glued to a foam support, results in composite panels with interesting acoustic qualities. The product, which is available in a fire-resistant version, is perfect for insulating doors and for use in furniture. The technology behind TSP can also be used to make composites of wood and leather, wood and textile, and wood and metal. Albeflex's broad range of products is sure to inspire even the most ambitious of designers.

385
392

392

387

388

Manufacturer

VitroLaser
Gewerbepark Meissen 10
32423 Minden
Germany

T +49 (0)571 3873 3-0
F +49 (0)571 3873 3-44
info@vitro.de
www.vitro.de

VitroLux

384

385, 386

385

386, 391

388

383

384, 385

386, 385

384, 390

388

Thanks to a technology developed during the Soviet era, it is possible to engrave all sorts of three-dimensional figures inside a block of glass without altering the surface. A laser focused on a point inside the block carries enough concentrated energy to change the structure of the glass. This laser creates, one by one, the hundreds of thousands of 'pinpoints' that form the figure. The technique was long reserved for classified military applications, such as the indelible marking of strategic objects. Later it was used to embed three-dimensional logos, portraits and small scenes in crystal cubes. The industrialization of the technology and the permanence and fineness of the motifs produced make it an excellent tool for architects and designers whose work requires the crosswise illumination of engraved glass or the projection of images onto otherwise transparent surfaces. All types of float, laminated and tempered glass can be engraved using the technique, as can plastic. Maximum size of three-dimensional figures and motifs: 150 x 220 cm.

is	is	it	it	it	jute
is	is	it	It	It	kaleidoscopic
is	is	It	it	it	Kapipane
is	is	it	It	it	Kapipane
is	is	It	It	it	Kapipane's
is	is	It	it	it	keels,
is	is	it	It	It	keep
is	is	It	It	IT,	Key
is	is	It	It	it.	Key
is	is	It	It	it.	keyboard,
is	is	it	It	it.	keyboards,
is	is	it	it	it.	keypads,
is	is	it	it	It's	kg
is	is	It	it	items	kg.
is	is	It	It	items	kg/m2).
is	is	it	It	items	kg/m3
is	is	It	it	items	kg/m3.
is	is	it	It	items	kg/m3.
is	is	It	it	its	kg/m3.
is	is	It	It	its	khaki,
is	is	It	It	its	kilns)
is	is	It	It	its	kind
is	is	It	It	its	kinds
is	is	It	It	its	kinds
is	is	It	it	its	kinds
is	is	it	It	its	kinetic,
is	is	It	it	its	kink-resistant
is	is	it	it	its	kitchens
is	is	it	it	its	knell
is	is	it	it	Its	knights
is	is	it	it	its	knit,
is	is	it	it	Its	knitted
is	is	it	It	Its	knobs
is	is	it	It	its	know
is	is	it	it	its	known
is	is	it	it	its	known
is	is	it	it	Its	known
is	is	it	it	Its	known
is	is	it	it	its	Komplot
is	is	it	it	its	kraft
is	is	It	it	its	Krüger
is	is	is	It	its	Krülit)
is	is	It	It	its	Krüpax,
is	is	is	it	Its	Krütex
is	is	it	it	its	l):
is	is	it	it	its	labels
is	is	it	it	its	labels,
is	is	it	It	its	labels.
is	is	it	It	its	laboratories
is	is	it	it	its	laboratories
is	is	it	it	its	lack
is	is	it	it	its	laid
is	is	it	it	itself	Laid
is	is	It	It	itself,	laid,
is	is,	It	it	ivory	laminate
is	is,	It	it	ivory	laminate
is	it	it	it	ivory	laminate,
is	it	it	it	Ivory	laminate,
is	it	it	it	jacket	laminated
is	it	it	it	Jean-Paul	laminated
is	It	It	it	Jelly	laminated
is	it	it	It	Jelly	laminated
is	it	it	It	Jelly	laminated
is	it	it	it	Jelly	laminated.
is	It	It	it	jewellery	laminated.
is	it	it	it	jewellery,	laminates
is	it	it	it	joined	laminates
is	it	it	It	joint-free	laminates,
is	It	It	It	joints,	lamination
is	it	it	it	journey	lamination,
is	It	it	it	just	lamps
is	it	it	it	just	lamps

lanes.	led	Light	like	look
large	LEDs	light	like	look
large	LEDs	light	like	look
large	LEDs	light	like	look
large)	leeks	light	like	look
large,	leftover	light	like	Look
large-format	Lége	light	like.	look,
Larger	Lége	light	like.	look.
Large-scale	Lége	light	lime,	looking
laser	Lége	light	limited	Looking
laser	legion,	light	limited	looks
laser	lend	light	limited	looks
laser	lends	Light,	limited	looks
laser-created	length	light,	limiting	looks
last	length:	light,	limits	looks
lasts	length:	light,	line:	looks,
Later	lengths	light,	linen	losing
later	lengths,	light.	linen,	losing
latest	lengthways,	light.	Linen,	lost
latest	Lenses	light.	lines	loudspeakers
latex	lenses	light.	lines	Louverscreen
latex	lenticular	light.	lining	Louverscreen
lattice	Lenticular	LightBlocks	liquid	louvre
latticed	less	LightBlocks	liquid	louvred
laundry	less	light-catching	liquid	love
Laville	less	Light-control	liquid	low
lay	Less	light-diffusing	liquid	low-density
layer	less	lighter	liquid,	low-density
layer	less	lighter.	liquid,	low-density
layer	lessen	lightest	LiquidMetal	low-density
layer	letters,	light-generation	LiquidMetal	lower
layer	level	lighting	LiquidMetal	lower
layer	level	lighting	LiquidMetal	lukewarm
layer	level.	lighting	LiquidMetal,	lumbar-support
layer	levels	lighting	liquids	luminescent
layered	levels:	lighting	liquids.	luminosity
layers	licence	lighting	liquids.	luminosity.
layers	Lie	lighting	list	luminosity.
layers	lie	lighting	list	luminous
layers.	lies	lighting	list	luminous
LCD	lies	lighting	lit	luminous
LCDs	lies	lighting	LiTraCon	lung
LCF	life	lighting,	LiTraCon	luxurious
LCF	life	lighting,	LiTraCon	m.
LCF	life	lighting.	LiTraCon	m.
lead	lift	Lightiss	little	m.
Leas	light	Lightiss	little	m.
lease	light	lightness	little	m;
leather	light	lightweight	lives	m;
leather	light	Lightweight	lives.	m;
leather	light	lightweight	Living	machine
leather	light	lightweight,	Living	machine.
leather	light	lightweight,	loading)	machines
Leather	light	lightweight,	loads	machines
leather	light	lightweight,	lobbies	machines)
leather	light	lightweight,	located,	machines.
leather	light	like	locates	macrospheres
leather	light	like	logos	macrospheres
leather	light	Like	logos,	macrospheres
leather	light	like	long	made
Leather	light	like	long	made
leather	light	like	long	made
leather	light	like	long	Made
leather	Light	like	long	made
leather,	light	like	long,	made
leather,	light	like	longer	Made
leather,	light	like	longer	made
leather.	light	like	long-lasting	made
leather.	light	like	look	made
leaves	light	Like	look	made
leaves	light	Like	look	made
leaves	light	like		made
leaving	light	like		made
leaving	light			made

Light

Is light a material? Whether composed of waves or photons, light
is an intangible, mysterious phenomenon. And whether it plays
with a material, revealing and caressing it, or forms an integral
part of the material, light is an omnipresent element of design.
Optical fibre, phosphorescence, electroluminous ink, LEDs –
technology offers ever-more sophisticated and durable sources
of light in ever-smaller dimensions. The rear lights of our cars
feature practically unbreakable LEDs made to last two or three
times longer than the car itself. And light goes beyond mere
illumination; think of laser technology, in which a sharp blade
of concentrated light cuts and engraves with unprecedented
surgical precision. Light is a source of constant inspiration for
designers, most of whom would answer our opening question in
the affirmative.

Brightness Enhancement Film

390, 385

Currently on the market is a range of high-tech plastic films designed to optimize the image clarity and luminosity of flat screens (computer and television screens, mobile-phone

390

and PDA screens, control screens and so forth). Plastic

385, 385

films manufactured by 3M include polarization film, micro-

386, 385, 385

laminate film and BEF (brightness enhancement film), whose main purpose is to improve screen luminosity. Traditionally

384, 387

used in the electronics industry, BEF diffracts light, making

387, 392

it suitable for use in a variety of lighting products. BEF is available in three standard sizes: 280 x 280 cm, 355 x 355 cm and 432 x 432 cm.

Manufacturer
DualGlo
PO Box 206
Hereford HR1 3YG
England

T +44 (0)1432 8209 99
sales@dualglo.co.uk
www.dualglo.co.uk

DualGlo

Phosphorescent materials store up photons and release them over time in the dark. Their phosphorescent capacity decreases rapidly, however, and until recently only two colours were available. DualGlo phosphorescent pigments herald the dawn of a new generation of luminous plastics and paints. These pigments enable greater and longer luminosity. DualGlo is available in yellow, red, blue, green and brilliant white. It is nonradioactive and suitable for use in children's toys. It takes only a few minutes to recharge and, once recharged, emits light for about 20 hours.

390
390
390
390
387

Manufacturer
Prinz Optics
Simmerner Strasse 7
55442 Stromberg
Germany

T +49 (0)6724 6071 65
F +49 (0)6724 6071 00
info@prinzoptics.de
www.prinzoptics.de

Duran Tube Filter

Multi-layered metallic deposits on glass create intriguing optical effects. A good example is the Duran dichroic tube filter, which, depending on the angle of incidence, allows certain wavelengths of colour to pass through and refracts rather than absorbs rays of coloured light. A tile treated with Prinz's metallic coating changes from red to green to blue to yellow along with a shift in the angle from which it is viewed. Apart from this interesting optical effect, the main advantages of the tube filter over ordinary coloured glass are a high degree of transparency, fine-tuned control of colour temperature, and resistance to UV light and high temperatures. Key applications include photography, museum exhibits, artistic illumination of buildings, airport lighting systems and UV filters.

388, 385
387
388, 392
392
385
392, 387
381
387, 392, 392

Manufacturer
Elumin8 Systems
1 Nimrod Way
Ferndown BH21 7SH
England

T +44 (0)1202 8651 38
F +44 (0)1202 8651 01
enquiries@elumin8.com
www.elumin8.com

Elumin8

For several years, Elumin8 has been making
electroluminescent panels for architects and designers.
The precision, durability and reliability of the technology –
initially used for the built-in lighting of computer screens,
mobile telephones and control panels – was welcomed
by professional in the world of design. A recent innovation
based on this technology is a flexible light that can be cut,
folded and twisted to create what the firm calls 'luminescent
embroidery'. Requiring a minimum of power, the product
comes in various colours. Elumin8 is constantly improving
its luminescent dyes.

387

387, 392

387

384

387, 384

Manufacturer

GLB
Heinrich-Hertz-Strasse 2
44227 Dortmund
Germany

T +49 (0)231 7254 780-30
F +49 (0)231 7978 509
sekretariat@glbau.de
www.glbau.de

Holo-Color

Holo-Color is made of ordinary laminated glass, but instead of having a PVB film sandwiched between the plies, it has a holographic grid that refracts light in the manner of a prism. Ambient white light refracted by the grid is transformed into a full spectrum for an aesthetic rainbow effect. The viewer sees a surface that looks like conventional clear glass until he reaches the angle of refraction (a number of angles of refraction are possible). Holograms can be laminated into all sorts of glass (flat or curved). The product is suitable for indoor or outdoor use.

Manufacturer

Color Kinetics
10 Milk Street, suite 1100
Boston, MA 02108
USA

T +1 617 4239 999
F +1 617 4239 998
info@colorkinetics.com
www.colorkinetics.com

iColor Tile FX

LEDs are changing the face of lighting as we know it. Among the advantages of LEDs over traditional lighting techniques are durability (LEDs last as long as 100,000 hours), size (increasingly smaller) and power (increasingly greater). They are vibration-proof and energy efficient and emit neither UV nor IR rays. Colour control is a major asset of iColor tiles: each tile conceals 432 individually addressable, tri-colour nodes behind a sheet of translucent plastic, enabling precision operability and the creation of images based on a mix of red-green-blue. Tile size: 61 x 61 cm.

387, 387, 392
387, 387, 392
387
392, 386
390

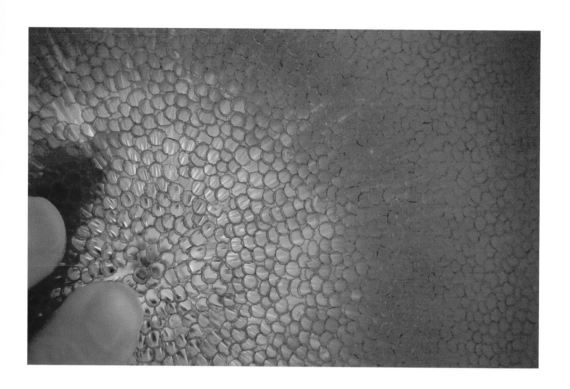

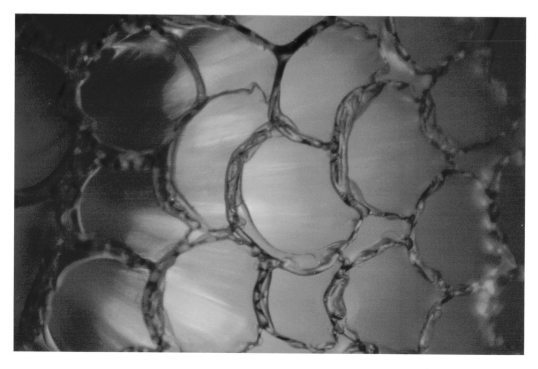

Manufacturer

Okalux
Am Jösphecklein 1
97828 Marktheidenfeld
Germany

T +49 (0)9391 900-0
F +49 (0)9391 900-100
info@okalux.de
www.okalux.de

Kapipane

Kapipane panels begin as large blocks composed of thin, extruded acrylic or polycarbonate tubes welded side by side, in parallel. Panels cut from these blocks and inserted between two panes of glass diffuse light and provide thermal insulation. Kapipane's cellular structure efficiently channels light into a building. Benefits are uniform illumination, a greater penetration of light, enhanced comfort and energy savings. Applications include construction, museum exhibits, set design and entertainment. The product withstands temperatures up to 120°C. Panels are tinted or colourless. Tube diameters: 1.5 and 3.5 mm. Thickness: 20 to 200 mm. Panel dimensions: 100 x 140 cm.

381, 390

385, 387

383

387

387

392

LCF

387, 385, 390

Light-control film (LCF) is a thin polycarbonate material containing closely spaced micro-louvres, which make it transparent when the user stands directly in front of a screen treated with it and opaque black when viewed from other angles. This privacy film is used mainly for computer screens. Automatic teller machines are usually equipped with LCF to ensure a clearer screen display and to prevent off-axis viewing of screen content. LCF is used in IT, security and the automotive industry. The film is available in sheets of 250 x 300 mm (maximum size) and comes in various grades with various louvre angles. Cost: approximately € 100 per 10 sheets.

Manufacturer
M.B. Wellington Studio
141 Canal Street
Nashua, NH 03064
USA

T +1 603 8891 115
F +1 603 8890 970
info@lightblocks.com
www.lightblocks.com

LightBlocks

392, 387

390

386, 385, 390

385, 391

390

388

Looking tender but acting tough, LightBlocks are large,
coloured plastic panels based on the technique used to
laminate glass. All polymers are suitable, including types
that are environmentally friendly, fire resistant and / or
bulletproof. A purpose-designed chromatic film sandwiched
between two sheets of mat or glossy plastic provides
the product with colour and gives it a high degree of
translucence, which can be adapted to the project in
question. Panels can be made and heat-moulded on site.
For use in interior design (partitions, suspended ceilings,
furniture and so on).

Manufacturer

Prestige Visual
International
Roissypole
BP 13918
95731 Roissy CDG cedex
France

T +33 (0)1 7437 2626
F +33 (0)1 7437 2726
info@lightiss.com
www.holographing.com

Lightiss

A product in which ordinary textile fibres are interwoven with optic fibres, Lightiss relies on a patented machine that abrades the core of the PMMA optic fibre used, thus creating a product whose light intensity can be modulated according to its distance from the light source and / or the configuration desired. Light intensity is constant throughout the length of the fibre, giving the fabric exceptional luminous homogeneity and brightness. Applications include interior design, exhibition design, fashion design and advertising.

385
385, 387
390, 385
392, 387
387
387
385

Manufacturer
LiTraCon
Brabantstrasse 30
52070 Aachen
Germany

T +49 (0)241 5332 58
F +49 (0)241 5332 13
info@andreabittis.com
www.litracon.com

LiTraCon

This apparently simple idea took years of development before a marketable product emerged. LiTraCon is finely structured concrete pierced by thousands of glass or plastic fibres. The material is both hard and translucent. The fibres, which are embedded crosswise in concrete blocks, allow light to pass through any structure made of these blocks – even one that is several metres thick. Because fibres make up only about 5% of the building material, LiTraCon blocks are quite similar, technically and structurally, to traditional concrete blocks. LiTraCon walls are ideal for filtering natural light into windowless spaces. The diameter of the fibres varies from 2 microns to 2 mm. Designs, inscriptions and logos can be incorporated into the product.

383, 391, 385, 390

385, 385

383

387

385

383

387, 385

388

Manufacturer
Louverdrape Italia
Via Laurentina Km. 24
00040 Pomezia (Roma)
Italy

T +39 06 9160 1553
F +39 06 9120 028
mbox@louverdrapeitalia.it
www.louverdrapeitalia.it

Louverscreen

Intended for outdoor use, this louvred screen features 2-cm-wide slats cut and moulded from a semirigid sheet of aluminium. The angle of the slats is designed to maximize visibility, minimize exposure to the sun and ensure good ventilation. Louverscreen is available in black and aluminium. Maximum dimensions: 240 x 350 cm.

388
381

381

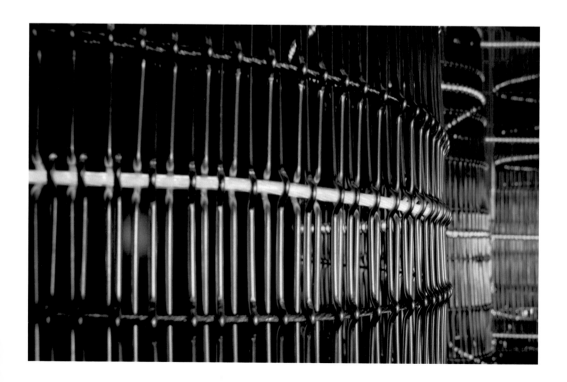

Manufacturer
Philips Eclairage

www.eur.lighting.
philips.com

GKD
Metallweberstrasse 46
52353 Düren
Germany

T +49 (0)2421 8030
F +49 (0)2421 8032 11
info@gkd.de
www.creativeweave.de

Optic Mesh

Optic mesh is a translucent woven material that combines plastic with light-diffusing glass fibres and stranded stainless-steel wire. Thanks to light-generation programming, the light achieved can be stationary, kinetic, soft, coloured, rhythmic (pulsating) or a combination thereof. Optic mesh can be used both indoors and out. Various woven patterns and densities are available. Maximum dimensions: 8 x 40 m.

390, 387, 385, 385

392, 387

387

392

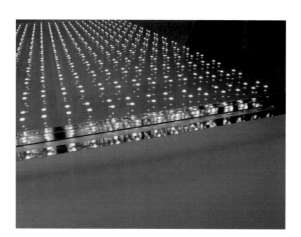

Manufacturer

Glas Platz
Auf den Pühlen 5
51674 Wiehl-Bomig
Germany

T +49 (0)2261 7890 0
F +49 (0)2261 7890 10
info@glas-platz.de
www.glas-platz.de

Power Glass

385

387, 385, 392

384

385

384

387

387

392, 385

387, 392

Power Glass successfully combines small, flat, powerful LEDs with the technique of glass lamination, thus inviting the insertion of small items and images of various thicknesses between the panes. Diodes encapsulated between two plies of glass are powered by an invisible source of electricity that allows the user to control each point of light individually. The technology can be used to display a name or message on a transparent window, to control light intensity, and to change the colours of an image without affecting the transparency of the glass. Applications include lighting, decoration and signalling, as well as architectonic and automotive components. Maximum dimensions: 210 x 75 cm.

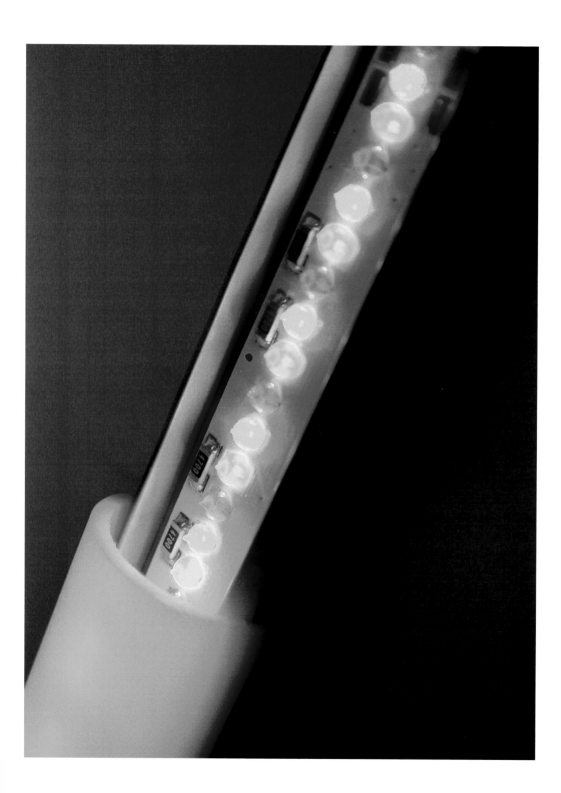

Manufacturer
Tridonic.Atco
Färbergasse 15
6850 Dornbirn
Austria

T +43 (0)5572 395-0
F +43 (0)5572 2017 6
sales@tridonicatco.com
www.tridonicatco.com

powerLED

384, 384

387, 392

387, 392, 384

392, 386

387

387, 392

Once used mainly for electronics, diodes are becoming an increasingly important part of the lighting world thanks to their polyvalence and the advantages they offer over traditional lighting. Diodes are extremely durable and virtually maintenance free. They withstand vibrations, emit no UV or IR radiation, take up very little space, and provide ever-improving light emission. They can be mounted in multiples – spots, chains, strip modules and so on – to create a wide range of monochromic and multicoloured lighting effects.

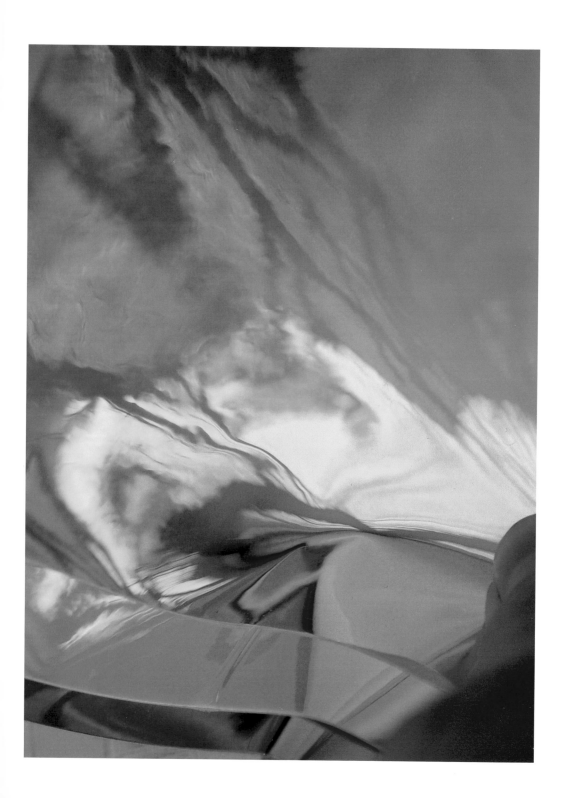

Radiant Color Film



392, 388, 385

390, 385

388, 385

392, 390, 390

387

385

385, 392

386

385

387, 392

385



The technique of depositing metal particles on glass in a vacuum to obtain a dichroic effect is not new. More recent is the appearance of a dichroic effect on flexible plastic film, which requires a highly accurate and complex procedure. Radiant Color is 46-micron film composed of more than 100 alternating layers of polyester and PMMA. Each superimposed layer filters a particular wavelength of light. The film changes colour as the observer changes his viewing angle. Radiant Color Film is non-corrosive, non-conducting, shrink resistant, and easy to cut and tear. The product withstands temperatures up to 125°C. Two products are available: Blue-Magenta-Gold (CM500) and Cyan-Blue-Magenta (CM590). Key applications include lighting products, interior design, packaging and signal films.

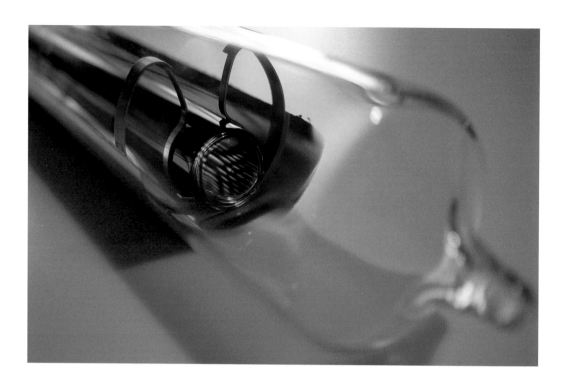

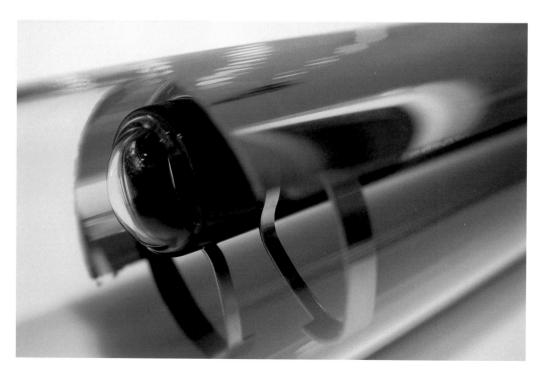

Manufacturer
Schott-Rohrglas
Erich-Schott-Strasse 14
95666 Mitterteich
Germany

T +49 (0)96 3380-0
F +49 (0)96 3380-757
info.solarthermie@schott.com
www.schott.com/solarthermal

Schott ICR

392

383

392, 385

392

Ideal for mounting on roofs, this double-walled vacuum-tube solar cell borrows energy from the sun to heat water. While circulating in the glass absorption tube, which is coated with pure silver on the inside, water absorbs the heat of the sun. Schott-Rohrglas's patented system relies on the insulation provided by a near-perfect vacuum to produce large quantities of clean hot water, while remaining within reasonable size and weight limits (20 kg / m²).

Manufacturer
Solatube
2210 Oak Ridge Way
Vista, CA 92071
USA

T +1 800 9667 652
F +1 760 5995 181
sgm@solaglobal.com
www.solatube.com

Solatube

387

387

384

387

A great way to draw natural light into a building is by capturing daylight on the roof and piping it inside through tubes with highly reflective inner surfaces. Solatube consists of a roof-mounted dome, a high-reflection tube and a prismatic diffuser. It can even fill windowless rooms with a profusion of natural light. Available in three diameters: 25, 35 and 53 cm. Maximum tube length: 12 m.

made	make	maple,	material	meals
made	make	marble	material)	means
Made	make	marble	material)	means
made	make	marble	material,	means
made	make	marina	material,	measure
made	make	marine	material,	measure,
made	make	marine	material,	measure.
made	make	mark,	material,	measuring
made	make	marked	material,	mechanical
made	make	market	material,	mechanical
Made	make	market.	material,	mechanical
made	make	marketable	material,	mechanical
made	make	marketed	material,	mechanical
made	make	marketed;	material.	mechanical
made	make	marketing	material.	mechanical
made	make	markets.	material.	medical
made	make,	marking	material.	medical
made	makers	markings	material.	medical
Made	makers	Marks	Materials	medical
made	makers	marks	materials	medical
made	makes	marks	materials	medical
made-to-measure	makes	marquetry	materials	medical,
Made-to-order	makes	marquetry.	materials	medicine
magical	makes	marriage	materials	Mediterranean
magical	makes	marriage	materials	medium,
magnetic	makes	marriages	materials	meet
magnetic	makes	Mars,	materials	meet
magnetic	makes	Mars.	materials	meets
magnetic	making	mask;	materials	Mello
magnetized.	making	massage	materials	Mellow
MagnetPaint	making	mass-produced	materials,	Mellow.
magnification,	making	mat	materials,	melted
mail	making	mat	materials,	Melting
Main	making	mat	materials,	melting
main	making	material	materials,	melts
main	making	material	materials,	membranes
Main	man,	material	materials,	membranes,
mainly	managed	material	materials.	memorable
mainly	management,	material	materials.	memory
mainly	manifold.	material	materials.	memory.
mainly	manifold:	material	materials.	memory.
mainly	manner	material	matrices	mention
mainly	manner	material	matrix.	Mesh
mainly	manner	material	matter.	mesh
mainly	manufacture	material	mattress,	Mesh
mainly	manufacture	material	mattresses	mesh
maintain	manufacture	material	maximize	mesh
maintain,	manufacture	material	Maximum	mesh,
maintain.	manufactured	material	Maximum	message
maintaining	manufactured	material	Maximum	messages.
maintains	manufactured	material	Maximum	metal
maintenance	manufactured	material	Maximum	metal
maintenance	manufacturer	material	Maximum	metal
maize,	manufacturer	material	Maximum	metal
major	manufacturer's	material	Maximum	metal
major	Manufacturers	material	maximum	metal
major	manufacturers	material	Maximum	metal
make	manufacturers	material	Maximum	metal
make	manufacturers	material	Maximum	metal
make	manufacturers.	material	Maximum	Metal
make	manufacturing	material	Maximum	metal
make	manufacturing	material	Maximum	metal
make	manufacturing	material	Maximum	metal
make	manufacturing	material	Maximum	metal
make	manufacturing	material	may	Metal
make	manufacturing	material	may	metal
make	manuscripts	material	may	metal
make	many	material	MDF	metal
make	many	material	MDF,	metal.
make	many	material	MDF,	metal.
make	Many	material	meals	metal.

metal-chemicals	millennia.	mm.	moulded	natural
Metal-foam	millimetre	mm.	moulded,	natural
metallic	millimetres	mm.	mouldings	natural
metallic	mind.	mm.	moulds	Natural
metallic	mineral	mobile	mounted	natural
metallic	mineral	mobile	mounted	natural
metallic	mineral	mobile-phone	mounted	natural
metallic	minerals	modelling.	mounted.	natural
metallic	mines:	models.	mounting	natural
metallic	miniature	modern	movement	natural,
metallic	miniature,	modulated	movement	natural,
metallic	miniaturization	module	movement	natural,
Metallics,	minimize	module:	MPa.	natural-fibre
Metallization	Minimum	modules	MPa.	NaturAsphalt
metallization	minimum	moisture,	much	NaturAsphalt
metals	Minimum	mollusc	much	NaturAsphalt
metals	minimum	molten	much	nearly
metals).	minutes	Monavision's	multicoloured	nearly
metals,	minutes	Moniflex	multi-head	nearly
metals,	minutes	Moniflex	Multi-layered	near-perfect
metals,	minutes.	monochromic	multi-layered	need
metals.	minutes.	monofilament.	multiple	need
Metapor	minutes.	monolithic	multiple	need
Metapor	MirrorFloor	moon	multiples	need
Metapor	MirrorFloor	moon;	multiplies	needed,
Metapor	MirrorFloor	more	multipurpose	needed.
method	misperceived	more	muscles	needle.
method	mission	more	muscles.	needled
methods	missions	more	museum	needs
methods	mix	more	museum	needs.
METO	mix	more	museum	needs.
metre	mixed	more	museum	negative
metre.	mixed	more	museum,	negatives,
metre.	mixture,	more	museums	neither
metres	mm	More	musical	Neoparies
metres	mm	more	musical	Neoparies
metres.	mm	more	musical	Neoparies
metres.	mm	more	must	Neoparies
metres.	mm	More	naked	Neoparies
metres.	mm	more	name	nested,
metres.	mm	more	name	netting
metro	mm	More	name	Nettle
mica	mm	more	name	nettle
Mica,	mm	more	name	nettles,
MicaPaper	mm	more	name	Nettles,
MicaPaper	mm	more	name	network-controlled
MicaPaper	mm)	morning	name	neurosurgery,
micro-encapsulation	mm)	moro.	name	new
microfibres.	mm)	Morphogenese	nano-components	new
micro-laminate	mm),	Morphogenese	Nanogel	new
micro-louvres,	mm).	Morphogenese	Nanogel	new
micron)	mm).	mosaic	Nanogel	new
Micronal	mm):	most	Nanogel	new
microns	mm,	most	Nanogel,	new
microns),	mm.	most	nano-particles	new
microns.	mm.	most	Nanotube	new
micro-organisms	mm.	most	nanotubes	new
microorganisms,	mm.	mother-of-pearl	Nanotubes	new
micro-points	mm.	mother-of-pearl	nanotubes	new
microporous	mm.	mother-of-pearl	nappies	new
microsphere	mm.	mother-of-pearl	nappies	new
might	mm.	motif.	NASA	new
might	mm.	motifs	NASA	New
Mikor	mm.	motifs	natalensis,	new
Mikor	mm.	motifs	natural	new
Mikor	mm.	motifs	natural	new
military	mm.	motifs:	natural	new
military	mm.	motors	natural	New
military	mm.	mould	natural	new.
military	mm.	moulded	natural	nickel
milk	mm.	moulded	natural	nickel,
milky	mm.	moulded	natural	nickel,

Optical

The optical aspects of a material often surprise us and appeal
to our senses. Something as simple as a clear block of glass or
polymer, which most of us take for granted, boasts a miraculous
molecular structure that makes its transparency or translucence
possible. In the not-too-distant past, people were unaware that
solid objects could be invisible, and the inability of animals
and insects to detect invisible barriers further underlines the
'sorcery' conjured up by transparency. Other sources of optical
delight are the effects created by lenticular film, filters that
block certain wavelengths of light, and kinetic wonders that draw
us into a realm of pure magic. Appearances are deceptive.

Manufacturer
APLM
3, rue de l'Est
75020 Paris
France

T +33 (0)1 4358 1002
info@alioscopy.com
www.alioscopy.com

385

Alioscopy

A conventional lenticular animated image relies on a series of five or six frames to create the impression of movement or depth. Alioscopy offers between 15 and 60 embedded frames, depending on the degree of depth and fluidity desired. This impressive innovation enables genuine 3-D viewing of photos, videos and animated images on screens and panels. No spectacles needed. Applications include video games, museum displays, amusement parks, advertising and medical imaging.

Manufacturer

Meadowbrook Inventions
260 Minebrook Road
Bernardsville,
NJ 07924-0960
USA

T +1 908 7660 606
F +1 908 7666 878
info@meadowbrookinventions.com
www.meadowbrookinventions.com

Angelina

381, 390, 385

388

385

392

387, 385

384

387

385

Like angels' hair, these polyester fibres, with their superb metallic and iridescent optical properties, have an almost supernatural texture. Angelina fibre is used in woven and non-woven textiles to produce an enchanting chameleon-like effect. Light striking the fibre evokes the shimmer of gemstones, the iridescence of diamonds, the fragility of a dew-coated cobweb in the morning light or the sparkle of fresh snow. Angelina fibre is widely used in the automotive, furniture and fashion industries. Other applications are interior design and packaging.

3d@monavision.com
www.monavision.com

385

385

Deep 3D

Lenticular film, which adds the illusion of depth and movement to an image, is a well-known product. Invented in the early 20th century, the technology behind this phenomenon involves a prismatic film superimposed onto an image that is broken down into successive bands. Monavision's Deep 3D combines contemporary photographic techniques with image processing and a new image-mastering technology to further enhance the illusion of depth.

Manufacturer
Nippon Electric Glass
1-14, Miyahara 4-chome,
Yodogawa-ku
Osaka 32-0003
Japan

T +81 (0)6 6399 2711
F +81 (0)6 6399 2731
www.neg.co.jp/arch/

Neoparies

385

385

389

385

387, 386

392

387

Covering the interior walls of the Tokyo metro are translucent
and opaque Neoparies glass tiles, a product also used
for building façades. Not only an aesthetic addition to a
building project, with their deep colours and brilliant
shine, Neoparies tiles are composed of a highly resilient,
nonporous, crystallized glass that is factory-sealed for extra
protection and nearly impossible to damage, mark, scratch
or soil. Neoparies can be shaped and worked in the same
manner as glass. Depending on colour and structure, the
product can be made to resemble the more uniform varieties
of Carrara marble or the darker and finer grades of granite.
It is suitable for all interior and exterior walls, including
those of kitchens and bathrooms, and for tiled seating.
When lit from behind, certain types of Neoparies reveal an
intriguing milky structure. Tiles are available in a range
of sizes and thicknesses. They are waterproof and heat
resistant. Colours: white, light beige and dark beige.

Manufacturer
Fresnel Optics T +49 (0)3644 5011 0
Flurstedter Marktweg 13 F +49 (0)3644 5011 50
99510 Apolda info@fresnel-optics.de
Germany www.fresnel-optics.de

Optical Lenses

The principle is the same: a circular, straight, undulating or
other prismatic structure is created on a plastic material
(PMMA, PC or PVC, depending on usage restrictions and
the desired quality) to create unique and often disturbing
optical effects: distortion, angular reflection, diffusion,
refraction, magnification, deformation (mirrors), fish-eye
effect and so on. Applications vary from lenses that expand
a driver's field of vision to retro-projection optical systems
and laser control.

Manufacturer
Degussa
Advanced Polymer
Shapes Röhm
Kirschenallee
64293 Darmstadt
Germany

T +49 (0)6151 1818 18
F +49 (0)6151 1818 19
info@plexiglas.fr
www.plexiglas.fr

Plexiglas Heatstop

The aesthetic iridescent quality of this sine-wave panel is not all this product has to offer. Because the Iriodin pigments used in this smooth, translucent PMMA panel reflect UV light, the product provides excellent thermal insulation. It is so effective that the air inside a space equipped with Plexiglas Heatstop absorbs 50% less heat than an identical space equipped with normal glass. The room feels remarkably cool. The 1045-mm-wide panel comes in a variety of lengths (maximum 700 cm). A transparent panel is also available.

90
92, 387, 383
381
385

Manufacturer
DuPont Displays
Company
625 Alaska Avenue
Torrance, CA 90503
USA

T +1 310 3209 768
sales@polarvision.com
www.polarvision.com

Polarisant

387, 392, 385

A sheet of this transparent, slightly tinted film becomes
totally opaque when another sheet of Polarisant is placed
at right angles to it. The result is a product, long used in
optical filters for scientific and industrial purposes, with the
capacity to generate intriguing optical effects. Designers
of lamps and other products can make stunning creations by
combining two or more sheets. A single sheet serves as
an anti-reflection surface, such as that used in corrective

385, 381, 385

eyewear. The film is available in acrylic and glass in a range
of thicknesses.

Manufacturer

Inox-color
Industriegebiet Walldürn
Dreistein Heumatte 6
74731 Walldürn
Germany

T +49 (0)6282 9238-0
F +49 (0)6282 9238-99
info@inox-color.com
www.inox-color.com

Polispectral

Polispectral colouring is an electrochemical process in which a layer of chrome oxide (0.05 to 0.3 micron) is deposited on the surface of submerged stainless steel. Highly resistant to wear and tear, Polispectral panels can be used in the same way as traditional stainless-steel panels. Available in smooth or engraved stainless steel. Colours are gold, cobalt, brown, bronze, green, black, champagne, steel grey and blue. Applications include building façades, sculpture and all sorts of interior design (such as lift doors). When used in a spatial arrangement, the panels reveal the full beauty of their colours. Maximum dimensions: 200 x 600 cm. Minimum thickness: 0.5 mm

383, 389, 388
392
392
384, 392
385, 382
392

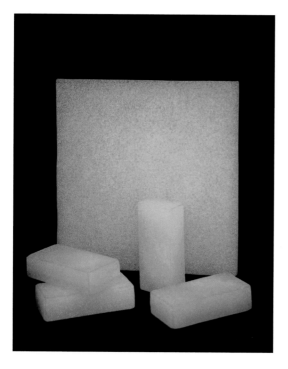

Manufacturer
Nippon Electric Glass
1-14, Miyahara 4-chome,
Yodogawa-ku
Osaka 532-0003
Japan

T +81 (0)6 6399 2711
F +81 (0)6 6399 2731
www.neg.co.jp/arch/

Veluna

385, 390
Nippon Electric Glass has managed to fuse phosphorescent
385
pigments, which are averse to heat, in melted glass.
387, 385
Veluna's glow-in-the-dark spots of light, suspended in glass
387
bricks and panels, emit a bluish light for an hour or so after
387
being exposed to fluorescent light for 20 minutes.
Applications in interior design include walls, partitions,
counters and decorative effects. Brick dimensions: approx.
97 x 197 x 50 mm. Panel dimensions: approx. 447 x 447 x 18 mm.

nickel-titanium	not	of	of	of
Nippon	not	of	of	of
Niti	not	of	of	of
Niti	not	of	of	of
nitric	not	of	of	of
nitride,	not	of	of	of
nitrogen	notably	of	of	of
nitrogenized	notably	of	of	of
nitrogen-oxide	notably	of	of	of
nitrogen-oxide	notebook-cum-battery,	of	of	of
no	nothing	of	of	of
no	notion	of	of	of
no	nougat,	of	of	of
no	now	of	of	of
no	now	of	of	of
no	nuclear-power	of	of	of
No	number	of	of	of
no	number	of	of	of
No	number	of	of	of
no	number	of	of	of
No	number	of	of	of
no	number	of	of	of
no	numerous	of	of	of
no	Numerous	of	of	of
no	numerous	of	of	of
no	numerous	of	of	of
No,	nut	of	of	of
nodes	nut	of	of	of
nonallergenic	nut	of	of	of
non-conducting,	nut:	of	of	of
non-corrosive,	nylon	of	of	of
nonflammable,	nylon	of	of	of
non-perforated	nylon	of	of	of
nonpolluting	Ø	of	of	of
nonporous,	Ø	of	of	of
nonradioactive	oak	of	of	of
non-slip	oak,	of	of	of
non-slip	object	of	of	of
non-textile	object	of	of	of
non-toxic	objects	of	of	of
nontoxic,	objects	of	of	of
nontoxic,	objects	of	of	of
nontoxic,	objects	of	of	of
nontoxic,	objects	of	of	of
nonwoven	objects,	of	of	of
non-woven	objects.	of	of	of
non-woven	objects.	of	of	of
non-woven	objects.	of	of	of
nonwovens	observer	of	of	of
nonwovens	obtain	of	of	of
nonwovens.	obtain	of	of	of
nor	obtain	of	of	of
normal	Obvious	of	of	of
normal	occasions,	of	of	of
normally	occurs	of	of	of
normally	Oceanshell	of	of	of
normally	Oceanshell	of	of	of
not	ochre,	of	of	of
not	of	of	of	of
not	of	of	of	of
Not	of	of	of	of
Not	of	of	of	of
not	of	of	of	of
not	of	of	of	of
not	of	of	of	of
not	of	of	of	of
not	of	of	of	of
not	of	of	of	of
not	of	of	of	of
not	of	of	of	of
Not	of	of	of	of
not	of	of	of	of

of	of	of	offer	on
of	of	of	offer	on
of	of	of	offer.	on
of	of	of	offered	on
of	of	of	offers	on
of	of	of	offers	on
of	of	of	offers	on
of	of	of	offers	on
of	of	of	offers	on
of	of	of	offers	on
of	of	of	offers	on
of	of	of	offers	on
of	of	of	offers	on
of	of	of	offers	on
of	of	of	Often	On
of	of	of	often	on
of	of	of	often	on
of	of	of	often	on
of	of	of	often	on
of	of	of	often	on
of	of	of	often	on
of	of	of	oil	on
of	of	of	oil,	on
of	of	of	oil‑,	on
of	of	of	oil.	on
of	of	of	oiling	on
of	of	of	oils,	on),
of	of	of	oily	on).
of	of	of	old	on.
of	of	of	oldest	on.
of	of	of	on	once
of	of	of	on	Once
of	of	of	on	once
of	of	of	on	Once
of	of	of	on	one
of	of	of	on	one
of	of	of	on	one
of	of	of	on	one
of	of	of	on	one
of	of	of	on	one
of	of	of	on	one
of	of	of	on	one
of	of	of	on	One
of	of	of	on	one
of	of	of	on	one
of	of	of	on	one,
of	of	of	on	one‑off
of	of	of	on	only
of	of	of	on	Only
of	of	of	on	only
of	of	of	on	only
of	of	of	on	only
of	of	of	on	only
of	of	of	on	only
of	of	of	on	only
of	of	of	on	only
of	of	of	on	Only
of	of	of	on	only
of	of	of	on	only.
of	of	of	on	onto
of	of	of	on	onto
of	of	of	on	onto
of	of	of	on	onto
of	of	of	on	onto
of	of	off	on	opaque
of	of	off	on	opaque
of	of	off‑axis	on	opaque
of	of	offcuts	on	opaque
of	of	offcuts.	on	open‑cell
of	of	offer	on	opening
of	of	offer	on	Opening:

Smart

After the disappointment that followed the collapse of the
'new economy', new technologies are back on centre stage,
promising a plethora of new materials, enhanced realities and
intelligent objects. Nanotechnologies – the source of advances
such as miniature electronic chips, RFID tags and information
technology – can also be used to imbue inanimate objects
with a degree of 'intelligence' that enables them to interact
with humans. Homes, schools and workplaces are no longer
inert: walls speak to us, objects anticipate our desires, and the
material world docilely submits to our will. The nanotech dream?
Perhaps. Just keep in mind that materials that cater to our
every need, that morph and model our daily lives, can also play
havoc with industry, society and the economy. When entering the
'smart' market, tread carefully.

Manufacturer
International Fashion
Machines
1205 East Pike Street,
suite 2g
Seattle, WA 98112
USA

T +1 206 8605 166
info@ifmachines.com
www.ifmachines.com

Electric Plaid

Electric Plaid programmable, hand-woven textiles change colour when electrically actuated. The patented technology behind this achievement injects animation and evolution – gradual waves of colour and dynamic patterns – into the previously static world of textiles. The material is reflective; it does not light up. Each woven module has eight colour-changing zones (comparable to pixels), and each zone includes four to eight electric strands of yarn that form a pattern. Numerous applications are possible, notably in interior design (curtains and architectural surfaces), contemporary art and fashion.

387

393

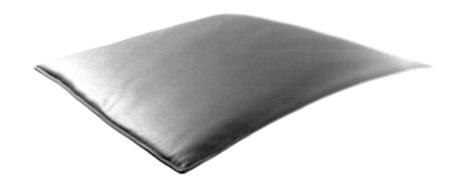

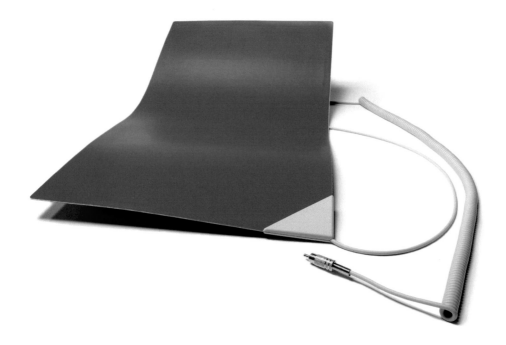

Manufacturer
Emfit
Konttisentie 8b
40800 Vaajakoski
Finland

T +358 (0)14 3329 000
F +358 (0)14 3329 001
info@emfit.com
www.emfit.com

EMFiT

390, 385
384, 384
385

390

384

390

EMFiT is a flexible plastic film that converts mechanical force into electricity. When electricity is applied, the film bends. The amount of energy produced is directly proportional to the mechanical force exerted, and vice versa. Like piezoelectric products, EMFiT also converts heat into electricity. The method employed is totally different, however, and because it is not based on piezoelectricity, EMFiT has the advantages of being flexible, strong, inert and relatively inexpensive.

Manufacturer

Dynalloy
3194-A Airport
Loop Drive
Costa Mesa,
CA 92626-3405
USA

T +1 714 4361 206
F +1 714 4360 511
order@dynalloy.com
www.dynalloy.com

Flexinol

Flexinol is the trade name for a range of shape-memory alloys which, when actuated by an electric current, contract and twist in much the same way as human muscles do. They are manufactured in the form of thin nickel-titanium wires. Their capacity to flex or contract, thus increasing in size by up to 5%, is a characteristic of a number of alloys whose internal structure changes dynamically at temperatures generated by an electric current. The result is a highly durable product that can replace motors and solenoids in mechanical toys, for example, as well as in precision instruments used in the automotive, medical and electronics industries.

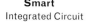
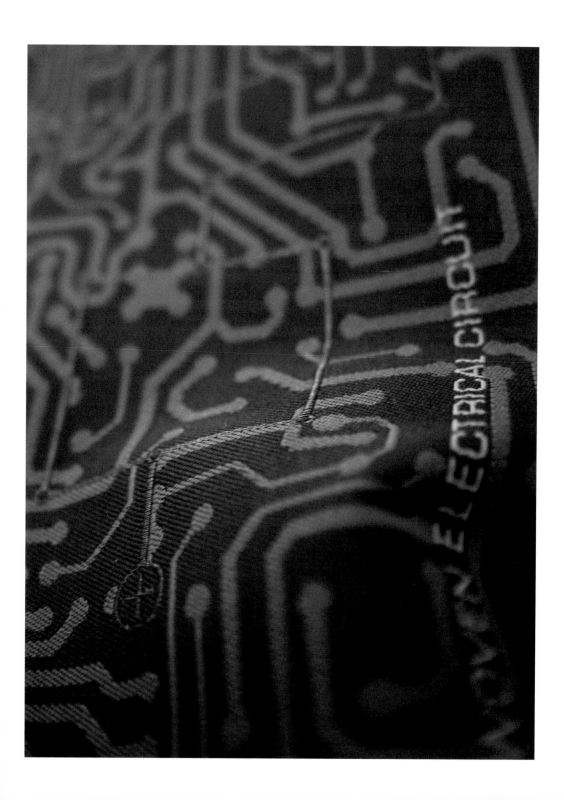

Manufacturer
Avery Dennison Rinke
Kleinbeckstrasse 3-17
45549 Sprockhövel
Germany

T +49 (0)2324 7002-0
F +49 (0)2324 7002-292
rinke@eu.averydennison.com
www.ris.averydennison.com

Integrated Circuit

388, 393

384, 384

A textile that doubles as an electrical circuit, this product features interwoven metal yarns and relies on an intricate weaving technology similar to that used to make clothing labels. Barcodes and photographs can be woven into the fabric. Anticipated are garments that 'communicate' thanks to integrated diodes and all sorts of electronic devices. Other potential applications include luminous identity cards, security systems, and labels woven directly into garments to facilitate fashion-related operations.

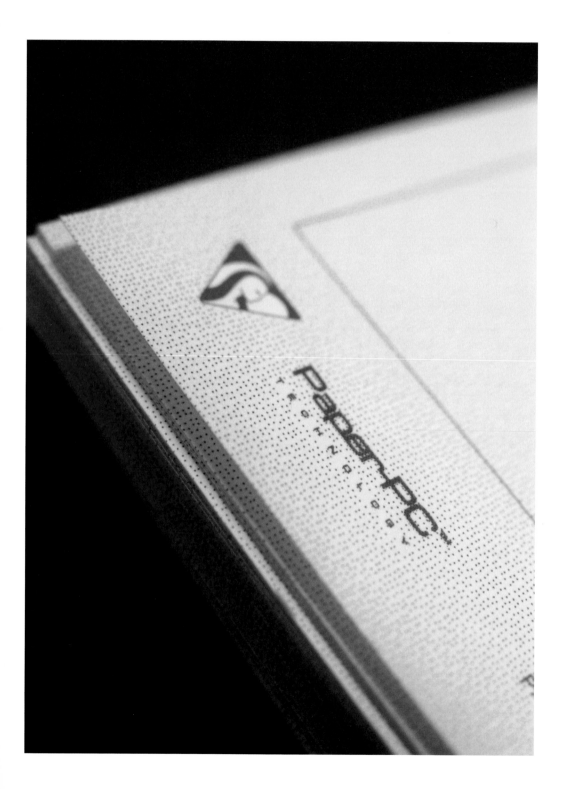

Manufacturer
Clairefontaine
RD 52
68490 Ottmarsheim
France

T +33 (0)3 8983 3750
F +33 (0)3 8983 3751
contacts-en@paperpc.info
www.clairefontaine-paperpc.com

PaperPC

389, 389
389
391
389, 389
384

PaperPC looks, feels, smells and functions like ordinary paper. So what makes it 'digital'? A closer look reveals thousands of precisely located, almost invisible micro-points that enable constant tracking of a digital pen on the page. PaperPC can be used to save and send data, texts and drawings in an electronic format. By combining two technologies with endless applications, the product breathes new life into a material that has been around for nearly two millennia.

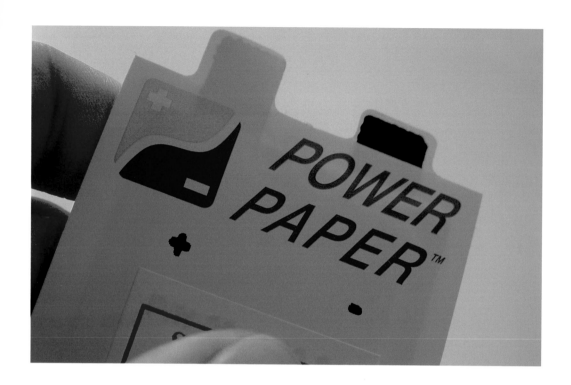

Manufacturer
Power Paper
21 Yega Kapayim Street,
Kiryat Arye, Petah Tikva
PO Box 3353
Israel 49130

T +972 (0)3 9204 200
F +972 (0)3 9204 222
info@powerpaper.com
www.powerpaper.com

Power Paper

384, 389, 389

Designed to store electricity in paper, Power Paper is a strong, ultra-thin, flexible, multipurpose 1.5V battery that is easy to integrate wherever desired. When used in product labels, it can transmit data within a radius of several metres. This function, known as radio-frequency identification, is expanding fast in the areas of inventory management, product authentication, security, and automatic product

389

registration at supermarket checkouts. Power Paper can also be used to create a notebook-cum-battery, with

384

integrated screen or other electronic element. It is already proving popular in the cosmetics industry as a facial mask; the electric current hydrates and energizes the skin. Thickness: 0.5 to 0.7 mm.

Manufacturer

Leas
ZA de la Batie,
175, allée de Champrond
38330 Saint Ismier
France

T +33 (0)4 7652 1330
F +33 (0)4 7652 1860
info@lab-leas.fr
www.lab-leas.fr

Sensitive Carpet

This carpet locates and tracks people walking on it. It consists of a multi-layered fabric containing conductive powder. Compressing the fabric causes its electrical properties to change. The carpet can be cut, segmented and configured (by varying the level of detectable pressure) to differentiate between human and animal footsteps. High on the list of applications are security and alarm systems. Then, too, a Leas smart carpet embedded with network-controlled LCDs might be used as a guidance system to direct a visitor through a museum, for example. Sensitivity: 500 g / dm^2. Sizes: 10 x 10 cm to 100 x 100 cm. Cost: approximately € 10 per square metre.

386

Manufacturer
Sensitive Object
8, rue Danjou
92517 Boulogne cedex
France

www.sensitive-object.com

Sensitive Object

Sensitive Object technology enables the user to interact with practically any object simply by touching it. This innovative process relies on the careful placement of acoustic sensors, which provide interactive capability to objects made from all sorts of materials, including glass, wood, plastic and plaster. Transform a wall into a light switch, turn a table into a remote control and reconfigure these interactive objects as desired. Applications range from home automation and interactive window displays to public events and education, not to mention games, art and design.

385

390, 390, 387

Manufacturer
Softswitch
Little Lane, Ilkley
West Yorkshire LS29
8UG
England

T +44 (0)1943 6037 03
F +44 (0)1943 6038 03
info@softswitch.co.uk
www.softswitch.co.uk

SOFTswitch

The use of soft, flexible fabrics that function as conventional switches, keypads, keyboards, buttons and knobs opens up the possibility of a roll-up keyboard, a jacket that interfaces with your mobile phone, a television remote control sewn into the armrest of a sofa, and light switches embedded in curtains and carpeting. SOFTswitch, the technology behind these ideas, transforms textiles into interfaces for the control of electronic devices, without the need for signal processing or complex software. Touch-sensitive SOFTswitch fabrics can also be used for proportional control and pressure sensing. The product is aesthetically pleasing, durable, washable, and capable of operating in extreme environments.

387
392

384

392

Manufacturer

Splashpower
The Jeffreys Building
Cowley Road
Cambridge CB4 0WS
England

T +44 (0)1223 4223 40
F +44 (0)1223 4223 39
info@splashpower.com
www.splashpower.com

SplashPad

Imagine a perfectly ordinary base or platform – unconnected to a power source – on which you can recharge any type of electronic device, such as telephone, PDA, computer or digital camera. The potential for a wireless life lies in electromagnetic-induction technology for energy transmission. The SplashPad platform emits magnetic waves that are received and transformed into electrical energy by whatever device has been placed on it.

Openings	or	other	paint	paper,
opens	or	other	paint.	paper,
open-weave	or	other	paints.	paper,
operability	or	others)	palm	paper,
operating	or	others):	palm	paper.
operating	or	Others,	panel	paper.
operation.	or	others.	Panel	PaperPC
operations.	or	others.	panel	PaperPC
operators;	or	otherwise	panel	PaperPC
ophthalmology,	or	our	panel	paraffin
opportunity	or	out	panel	paraffin,
optic	or	out	Panel	paraffin:
optic	or	out	panel	paraffin-encapsulated
Optic	or	out	panel)	parallel.
Optic	or	out	panel).	Parchment
Optic	or	out	panelling	parchment
optical	or	out.	panelling,	Parchment
optical	or	out.	panelling.	parchment,
optical	or	outdoor	panels	Paris,
optical	or	outdoor	panels	Paris.
optical	or	outdoor	panels	parks,
Optical	or	outdoor	panels	parks,
optical	or	outdoor	panels	part
optical	or	outerwear,	panels	part
optical	orange,	output)	panels	part
optical	ordinary	outside)	panels	part
optical	ordinary	over	panels	partially
optics	ordinary	over	panels	particle
optimal	ordinary	over	panels	particle
optimize	ordinary	over	panels	particles
option	ordinary	over	panels	Particles
options,	ordinary	over	panels	particles
or	ordinary	over	panels	particles
or	ordinary	over	panels	particular
or	original	over	panels	particularly
or	original	over	panels	particularly
or	originally	over	panels	partitions,
or	Originally	overlaying	panels	partitions,
or	Originally	oversize	Panels	parts
or	originally	oversleeve	Panels	pass
or	origins	oversleeves	panels	pass
or	OsmoFilm	Owing	Panels	pass
or	OsmoFilm	owing	panels	passes
or	OsmoFilm	Oxeon	panels	passes
or	OsmoFilm	oxidation	panels	passing
or	OsmoFilm	oxide	panels	passing
or	other	oxide	panels	past
or	Other	oxidized	panels,	past,
or	Other	packaging	panels.	paste
or	other	packaging	panels.	pastries
or	Other	packaging	panels.	patented
or	other	packaging	panels.	Patented
or	Other	packaging	panels.	patented
or	Other	packaging	panels:	patented
or	other	packaging,	panes	patented
or	other	packaging.	panes	patented
or	other	packaging.	panes.	patented
or	other	packaging.	PanLin	Pathfinder
or	Other	Packing	PanLin	patina
or	other	packing	PanLin	patina,
or	other	Paco	Paper	patina.
or	other	padding.	paper	pattern.
or	other	pads	paper	pattern.
or	Other	pads.	paper	patterns
or	other	page.	Paper	patterns
or	other	pain.	Paper	patterns
or	Other	paint	Paper	patterns
or	other	paint	paper	Paul
or	Other	paint	paper	Paumelle
or	other	paint	paper	paving
or	other	paint	paper,	PC

PC	PhotoGlas	plastic,	polyamide	power
PCM	PhotoGlas	plastic,	polycarbonate	Power
PCM	PhotoGlas,	plastic,	polycarbonate	Power
PCM	photographic	plastic.	polyester	Power
PCMs	photographic	plastic.	polyester	Power
PCMs	photographs	plastic.	polyester	Power
PDA	photography	Plasticana	polyester	power
PDA,	photography,	Plasticana	polyester	power,
PE,	photons	Plasticana	polyester,	powered
peanuts	photos,	Plasticana-based	polyester-and-Lycra	powerful
pebble	phyllosilicate	plasticizers.	polyethylene	powerful
pebbled	physical	plastics	polyethylene	powerLED
pebbled	pick	plastics	polymer	PP
pebbles	picked	plastics,	polymer	PP,
pebbles	picture	Plastics,	polymer	practitioners
pebbles	Pictured	Plate	polymer	precious
Pebbles	piece	Plate	polymer	precise
pectin	pierced	Plate	polymer,	precisely
pedestrian-frequented	pierced,	Plate	polymerized	precision
peeled	pierced.	Plate	polymers	precision
pellets	piezoelectric	Plate	polymers	precision
pellets,	piezoelectricity,	Plate	polypropylene	precision
pen	pigments	plates,	polypropylene	precision,
penetrates	pigments	platform	polypropylene	precooked
penetration	pigments	platform	polypropylene	prefabricated
people	pigments	Platinum	polypropylene	prefabricated,
people	pigments,	play	polypropylene)	pre-mounted
per	pigments.	play	polystyrene	prepare
per	pigs.	plays	polystyrene,	preserve
per	Pillow	pleasant	polystyrene-acrylate	preserving
perceived	Pillow	pleasing,	polythene	preserving
perfect	Pillow	pleasing,	polyurethane	preshaped
perfectly	piping	pleasing,	polyurethane	Press
perforated	pixel	pleasure	polyurethane,	pressing
perforated	pixel,	Plexiglas	polyvalence	pressure
perforations,	pixels),	Plexiglas	pontoons	pressure
perforations,	PLA	plies	pool,	pressure
performance	place	plies,	popular	pressure)
performance	place	PluriGigaBall	populated	pressure.
performance.	placed	PluriGigaBall	porous.	pressure.
permanence	placed	PluriGigaBall	portraits	pressure:
permanent	placed	Plylin	possibilities	prêt-à-porter
permanently	placed	Plylin	possibility	prevent
permeable	placed	PMMA	possible	prevent
permeable	placed	PMMA	possible	prevents
Permeable	placed	PMMA	possible	previously
permeated	Plaid	PMMA	possible).	primarily
personalized	Plaid	PMMA.	possible,	primarily
Pertinax	plant	pockets	possible.	primary
Pertinax	plant	point	postage	principle
Pertinax	plant	point	Potato	principle,
pesticides	plants	point	potatoes	Print
pesticides,	plants,	point	potential	print
PET).	plasma	point	potential	print
PET-reinforced	plaster,	point,	potential	print
petrochemical	plaster.	point.	Potential	print
petroleum-alternative	plastic	point-of-purchase	potential	print
pharmaceuticals	plastic	Polarisant	potential	Printed
pharmaceuticals,	plastic	Polarisant	potential	printed
phenolic	plastic	polarization	potential	printing
phenolic	Plastic	Polish	pouch	printing
phenomenon	plastic	polished	pouch	printing,
phenomenon	plastic	polished	pouch,	printing,
phenomenon;	plastic	polished	pouch,	printing.
phone,	plastic	polished	pouch.	Prinz's
Phosphorescent	plastic	Polispectral	pouches.	prism.
phosphorescent	plastic	Polispectral	pours	prismatic
phosphorescent	plastic	Polispectral	powder	prismatic
phosphorescent	plastic	pollution	powder	prismatic
photo	plastic	pollution	powder.	privacy
PhotoGlas	plastic	pollution.	powdered	private
PhotoGlas	plastic	Polsterflex	powdered	Prize

Surface

'Surface' once referred to nothing more than the outside covering of an object or a material, and the traditional conception of a surface or finish was based on two functions that have cohabited and conflicted down through the ages: protection and decoration. In an era of reconceived and remoulded relationships between people and objects, however, we often speak in terms of 'interface' or 'skin'. The idea of a smooth or textured skin appeals to our senses. Although objects that are waterproof, fireproof and soundproof are still an important part of our lives, we have fallen in love with surfaces that beg to be touched, that call out for contact. And at a time when basic materials have returned to favour, while others are mutating into an artificiality that interacts with nature, we are seeing a resurgence of decoration and pattern, much of it accompanying conventional finishes and screen-printing techniques intended to improve the appearance of the object in question.

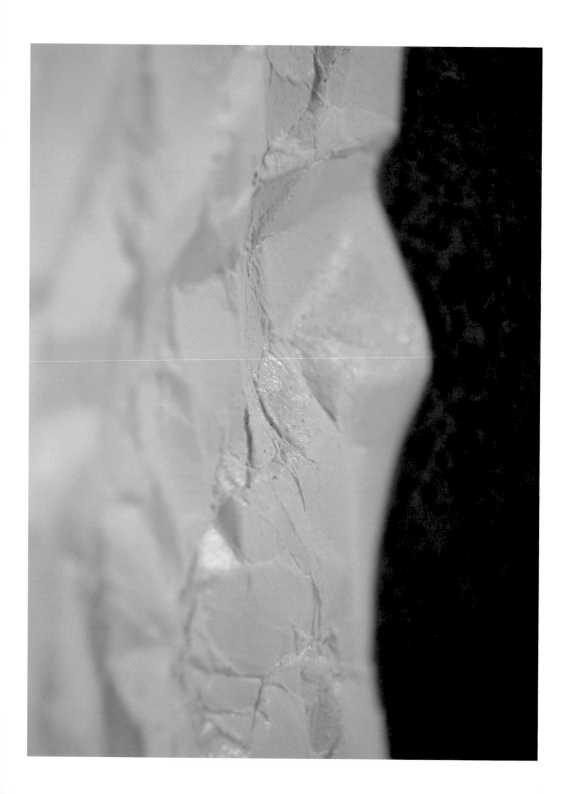

Manufacturer
Carea
17, Burospace F
91573 Bièvres cedex
France

T +33 (0)1 6935 5363
F +33 (0)1 6935 5369
contact.facade@carea.fr
www.carea-facade.fr

Artema

389
383
392

They may look like big sheets of crumpled paper, but each of these concrete panels weighs 40 kg. Waterproof, as well as frost and fire resistant, Artema prefabricated panels have a distinctive surface texture ideal for the creation of unique building façades. Available in black and white. Dimensions: 2.5 x 1 m.

Printer

Laville Imprimerie
189, rue Aubervilliers
75018 Paris
France

T +33 (0)1 4038 8480
F +33 (0)1 4038 8490
imprimerielaville@wanadoo.fr
www.imprimerie-laville.com

Blow Print

Relief printing, a time-honoured technique for making fine
cards for memorable occasions, is a disappearing art. Today,
however, companies such as Laville Imprimerie combine
tradition and modern technology for highly convincing
results. Contemporary relief printing, suitable for all types
of paper, is done by overlaying ink with a transparent
substance, such as varnish. The texture of the ink and the
height of the print can be varied to suit the purpose. Braille
printing is a promising new area for this technology.

392

392

389, 386

386

392

Manufacturer
Arjo Wiggins
Fine Paper House
Lime Tree Way
Chineham, Basingstoke
Hampshire RG24 8BA
England

T +44 (0)1256 7289 00
F +44 (0)1256 7288 89
curious.collection@ arjowiggings.com
www.curiouscollection.com

Curious Collection

Curious Collection, a range of print paper, includes Metallics, Translucents, Flexi, Particles (a thermosensitive product) and Touch. The latest addition is Curious Plastics, currently represented by its first product line: Mellow. Entirely synthetic and soft beyond compare, Mellow is powdered with a deliciously subtle layer of mother-of-pearl for a smooth, silky look. Resistant to tears, grease stains, chemicals and changes in temperature, Mello is completely grain free, recyclable and washable. Available in two mother-of-pearl shades: silver moon and blue moon; and in two weights: 120 g / m² and 250 g / m².

Manufacturer
Atelier SAM
Hangar G2, bassin à
flot n°1
Quai Armand Lalande
33300 Bordeaux
France

T + 33 (0)5 5611 2000
F + 33 (0)5 5611 2001
bordeaux@atelier-sam.com
www.atelier-sam.com

DigiMotifs

Thanks to an entirely new design material, Atelier Sam can print large-format surfaces in a four-colour process on a wide variety of flexible and rigid materials (in both serial and one-off print runs). Ideal for exterior walls, carpeting and rugs, personalized wallpaper, furniture and related applications. Maximum dimensions: 5 x 3 m; 5 cm thick.

392

389

Manufacturer

Ecologie Developpement
Systems (EDS)
18, avenue de la Marne
92120 Montrouge
France

T +33 (0)1 4656 3608
F +33 (0)1 4656 5430
eco.ds@noos.fr

Ecosolution

388, 389

388

392, 389, 382

392, 387, 388, 389

388, 389

Ecosolution was designed to reduce nitrogen-oxide pollution in highly populated areas. Its secret lies in nano-particles of titanium dioxide and calcium carbonates, which bind with the base component of the paint. These particles absorb UV light and use it to convert nitrogen oxide into nitric acid, which is washed away when it rains. Ecosolution makes it possible to reduce nitrogen-oxide pollution in urban areas by 60%. When used on building façades, the effect lasts up to five years.

Manufacturer
MagPaint
Elsterweg 3a
7076 AZ Veldhunten
the Netherlands

T +31 (0)315 3864 73
F +31 (0)315 3864 80
info@magpaint.com
www.magpaint.com

MagnetPaint

The idea could not be simpler: mix ordinary paint with metal powder to make paint that can be magnetized. More complicated are the problems that rise with respect to oxidation and homogeneity. Made from latex and water, the dark-grey paint can be covered with normal paint without losing its magnetic properties, although each additional coat of paint does lessen the magnetic force. Use it in interior design (walls and ceiling) or for items of furniture that would benefit from having one or more magnetic surfaces.

Manufacturer
Metal Composite
156, Chemin des Merles
34400 Lunel
France

T +33 (0)467 8318 59
F +33 (0)467 8329 49
info@metalcomposite.com
www.metalcomposite.com

Metallization

Metal Composite's metallization process provides a wide variety of surfaces – wood, MDF, plaster, concrete, carbon, PMMA and even metal – with a fine, seamless metallic skin. It can be used to clad volumes big and small, simple or complex in design, in a metal coating without damaging the basic structure. Choices include bronze, copper, steel, tin, nickel, aluminium, titanium and a copper-zinc alloy; finishes range from polished and oxidized to aged. For use in furniture design, interior design and a range of decorative applications.

388, 388

388, 390, 383, 382

390, 388, 388

388, 392

382, 383, 392

392, 388, 381, 392,
383, 381

Manufacturer
Janvic
228, rue Jules Ferry
95360 Montmagny
France

T +33 (0)1 3983 6722
F +33 (0)1 3983 6066
janvic@janvic.fr
www.janvic.fr

388

Mirror Floor

Look into the depths of Mirror Floor and catch a glimpse of your reflection. Walking across this floor is like venturing onto the smooth surface of a pool, without a ripple in sight. Available in different colours, motifs (flakes, for example) and effects (such as the 'depth effect'), Mirror Floor is a highly prized addition to interior design. Although a little maintenance is required, the effect is worth the effort.
A black version has been installed at Jean-Paul Gaultier's showroom-cum-headquarters in Paris.

Manufacturer
Grace
1001, rue de
Maissonneuve
71580 Saillenard
France

T +33 (0)3 8576 4500
F +33 (0)3 8574 1084
info.gracepieri@grace.com
www.pieri.com

Sérilith

383
388

391, 392, 392

388

383

Sérilith is a process for transferring black-and-white photography onto rough concrete panels, leaving a permanent motif. A photo is reworked and scanned, pixel by pixel, before being reproduced on the desired surface by means of silk-screen printing. The resulting screen-printed panel is placed at the bottom of a mould that is subsequently filled with freshly mixed concrete. Sérilith can be used for everything from exterior walls and gravestones to street furniture.

Manufacturer
Print-Groupe Abet
BP 9154 Avenue Aristide
Bergès ZI 73091
Chambéry cedex 9
France

T +33 (0)4 7962 1326
F +33 (0)4 7962 2044
stratifies@print-france.fr
www.print-france.fr

Silver

384

388, 392, 391

392

389, 392, 391

391

381, 389

388

Although there seems to be a relief engraved in this '30s-look metallic sheeting, the surface is as smooth as silk. The optical illusion is created by impregnating several sheets of kraft paper with a thermosetting resin, using heat-compression (150°C) to fuse them together, and applying a decorative layer to the surface. Pictured is Silver, which is clad in a sheet of aluminium foil featuring a faux relief. Several motifs are available. Applications include interior and furniture design. Dimensions: 305 x 122 mm. Thickness: 1 mm.

Manufacturer

Marotte
47, rue Eugène
Berthoud - BP 87
93402 Saint Ouen cedex
France

T +33 (0)1 4948 1360
F +33 (0)1 4012 2887
contact@marotte.fr
www.marotte.fr

Thalweg

A successful marriage of artisanal furniture making and the precision of digital tools gives flat wood surfaces a sculptural dimension. Used on MDF, this tool-programming technology creates surfaces with various motifs (infinite repetitions of perforations, folds, waves, grooves and so forth). An exaggerated 3-D effect occurs when MDF featuring layers of different colours is 'carved' to show high relief. Ideal for architectural applications such as walls, doors and ceilings (also, in some cases, water- and fire-resistant surfaces). Surfaces include veneers, mother-of-pearl and soft textures.

388

388

388

prized	product	products	provided	range
prized	product	products	provides	range
prized	product	products	provides	range
problems	product	products	provides	range
problems	product	products,	provides	range
procedure,	product	products,	provides	range
procedure.	product	products,	provides	range
procedures	product	products,	provides	range
process	product	products.	Providing	range
process	product	products.	proving	range
process	product	products.	proving	range
process	product	products.	PS,	range
process	product	professional	PTFE.	range
process	product	profusion	public	range
process	product	programmable,	pulp,	range
process	product	programming,	pumped	range
process	product	programs.	pure	range
process	product	project	purpose	range
process	product	project,	purpose.	range
process	product	projection	purpose-designed	range
process	product	promise	purposes	range
process	product	promising	purposes,	range
process,	product	promotional	Put	range
process,	product	proof	PVB	range
process,	product	properties	PVC	ranges
process,	product	properties	PVC,	ranging
process,	product	properties	PVC,	ranging
process.	product	properties	PVC,	rapidly,
process.	product	properties	PVC,	rather
process.	product	properties	PVC.	ratio
process.	product	properties	qualities	Ravier
processes	product	properties	qualities.	Ravier
processes.	product	properties	quality	rays
processes.	product	properties	quality	rays.
processing	product	properties,	quality)	reaches
processing	product	properties,	quality.	react
processing,	product	properties,	quantities	react
Prodotti	product	properties,	quantities	reaction
produce	product	properties,	quantities	readily
produce	product	properties,	question.	realization
produce	product	properties.	quilted	rearrange.
produce	product	properties.	quite	reasonable
produce	product	properties.	quite	Rebound
produce	product	property,	quite	Rebound
produce	product	proportional	quite	Rebound,
Produced	product	proportional	Rabanne	received
produced	product	protect	racquets,	recent
produced	product	protecting	Radiant	recent
produced	product)	protection	Radiant	recent
produces	product,	protection	Radiant	recently
produces	product,	protection	radiation,	recently
produces	product,	protection	radiators	receptacles
produces	product,	protection	radical	recharge
produces	product,	protection	radio-frequency	recharge
produces	product.	protection	radius	recharged,
producing	product.	protection,	rail	recipe
producing	product.	protection.	rail-transport	recipe
product	product.	protection.	railway	recommended
product	product.	protection.	railways	reconstituted
product	product.	protective	rain,	record
product	product.	protective	rainbow	recyclable
product	product.	protective	rainbow	recyclable
product	product's	protective	rains.	recyclable
product	product's	protective	raises	recyclable
product	production	protective	ramps,	recyclable
product	production,	protective	range	recyclable,
product	products	protective	range	recyclable.
product	products	protects	range	recyclable.
product	products	protein,	range	Recycle
product	products	prototyping	range	recycled
product	products	provide	range	recycled
product	products	provide	range	recycled
product	products	provide	range	recycling
product	products	provided	range	

recycling,	remains	resistance	ripple	sample
red	remarkable	resistance.	rise	sand
red	remarkably	resistant	rise	sandals
red,	remnants,	resistant	rise	sanded,
red,	remote	Resistant	river-bed	Sandrine
red,	remove	resistant	Riverstone	sandwich
red-green-blue.	repaired	resistant	Riverstone	sandwich
rediscovered	repeat	Resistant	Riverstone	sandwiched
reduce	repeated	resistant	Riverstone	sandwiched
reduce	repetitions	resistant	Road	sandwiched
reduces	replace	resistant	road	Sandwiching
reels,	replacement	resistant,	road	sandwiching
referred	replaces	resistant,	road	SaniFriz
refined	represented	resistant,	road-haulage	SaniFriz
reflect	representing	resistant.	roads.	SaSa's
reflection,	represents	resistant.	robust.	save
reflection.	represents	resistant.	rock.	saving
reflections,	reproduced	resistant.	rock.	savings
reflective	Reptile	resists	rock.	savings.
reflective;	Reptile	resists	rocks	saw
refracted	Reptile,	resists	role	sawdust
refraction	reptilian	resources	roll	sawdust:
refraction	request.	respect	rolled	sawed
refraction,	request.	respect	rolled	Say
refracts	request.	respond	rolls	scanned,
refracts	request.	responds	rolls	scenes
refrigerated	request.	restore	rolls	Schiffli
regenerating	require	restrictions	rolls,	Schott
regions	required,	result	rolls,	Schott-Rohrglas's
registration	required.	result	rolls.	scientific
regulated	requirements	result	roll-up	scored
regulating	requires	result	roll-up	scraped
regulation	requires	result	roof	scratch
regulator,	requires	result	roof,	scratch-proof,
Reholz	requires	result	roof-mounted	screen
Reholz's	requiring	result	roofs,	screen
reinforced	Requiring	resulting	room	screen
reinforced	researchers	resulting	rooms	screen
Reinforced	researches,	resulting	rough	screen
related	resemble	results	rough	screen
relatively	resembles	results	rows	screen-printed
relatively	resembles	results	rubber	screens
release	reserved	results.	Rubitherm	screens
release	reservoirs,	retaining	Rubitherm	screens
releases	reshaped	retains	Rubitherm	screens
releases	residue	retro-projection	rugged	screens,
releases	residues	return	rugs,	screens,
releasing	resilience	returns	Rumen	screens,
releasing	resilient	reusable,	Rumen,	screens.
releasing	resilient,	reveal	Rumen.	screens.
reliability	resilient,	reveal	running	screw
Relief	resilient,	reveals	runs).	sculpted,
relief	resin	reveals	rust,	sculptural
relief	resin	revolutionary	safely.	sculpture
relief	resin	revolutionary	Sahara	sculpture.
relief.	resin,	revolutionary	saltwater	Seal
relief.	resin.	revolutionized	saltwater	sealed
relies	resin.	revolutionizing	Sam	sealed,
relies	resin.	reworked	same	sealing
relies	resin-production	reworking	same	seals
relies	resins	rhythmic	same	seamless
relies	resins	ribbon	same	seamless
relies	resins,	right	same	seamless,
relies	resistance	rigid	same	seamlessly.
relies	resistance	rigid,	same	seating
relies	resistance	rigid.	same	seating
relies	resistance	rigidity	same	seating
remaining	resistance	rigid-walled	same	seating,
remaining	resistance	rings	same	seating.
remaining	resistance	rings,	same	seating.
remains	resistance	rings.	same	seaweed
remains	resistance	ripens,	same:	seconds

Sustainable

Sustainability is such a 21st-century leitmotif that one could
almost see it as a fad. That would be a mistake, however, for
sustainability is a necessity that becomes more urgent with each
passing day. The complex issue of caring for the environment
should not be reduced to a simplistic debate that pits 'good' and
'bad' materials against each other, but too often this is what
happens. (Unfortunately, a completely eco-friendly material
does not exist.) More realistic is to approach the design of a
product by considering not only the material to be used, but
also how to use it, how the product can be manufactured, and
whether or not it can be recycled. The most environmentally
friendly solution is often the solution that uses the least amount
of material. Sustainability should not be a way for manufacturers
to gain a clear conscience at a low cost, but a guiding principle
for design projects from start to finish.

Manufacturer
Nap'tural
94, route de la Roche
85210 Sainte Hermine
France

T +33 (0)2 5128 8831
F +33 (0)2 5128 8864
naptural@naptural.com

BatiPlum

381, 392

Feathers are a powerful thermal insulator with a high capacity for retaining air and regulating moisture, and their volume remains constant. Feathers can absorb up to 70% of their weight in water without losing their insulation properties. BatiPlum was developed with these facts in

393

mind. Composed of 70% feathers, 10% wool and 20% textile

385

fibres, BatiPlum meets HQE requirements and offers exceptional thermal, acoustic and hydrothermal insulation. Three types of BatiPlum are available to the building industry: roof, wall and floor. The product can also be used as furniture padding. Thickness: 10 to 100 mm.

Manufacturer

Ferrari
BP 54
38352 La Tour du
Pin cedex
France

T +33 (0)4 7497 4133
F +33 (0)4 7497 6720
ferrari@tesf.fr
www.ferrari-textiles.com

Canatex

Canatex, a new version of Batyline architectural textile, is made by coating a blend of natural fibres with hemp-reinforced PVC, which gives the mat fabric a more natural appearance with a slightly irregular surface. More importantly, Canatex represents a new use for hemp, an eco-friendly material that is easy to grow, requires no pesticides, and absorbs carbon dioxide efficiently. Large-scale cultivation of hemp both reduces the greenhouse effect and facilitates sustainable development. Canatex is available in two colours and can be recycled using the Texyloop technique. Applications include outdoor furniture.

392, 385, 386
391
387
386
382, 389
386

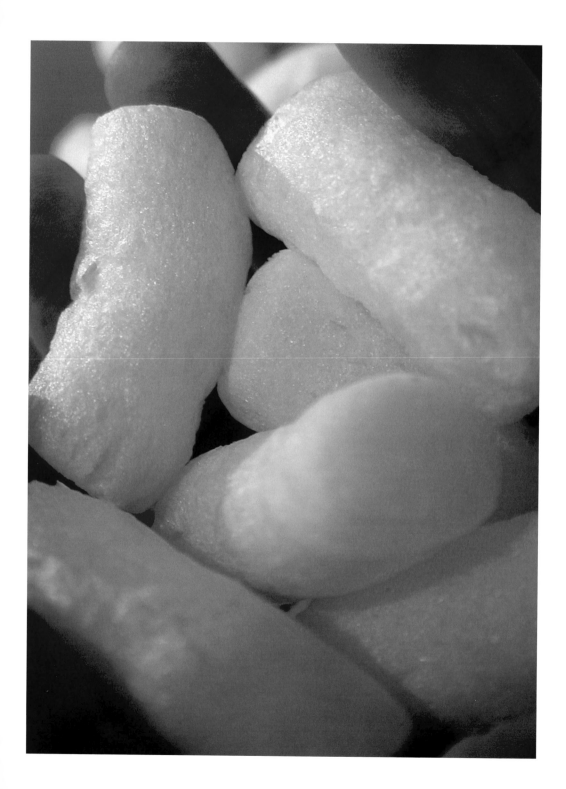

Manufacturer
StarchTech
720 Florida Avenue
Minneapolis, MN 55426
USA

T +1 800 5977 225
sti@starchtech.com
www.starchtech.com

Clean Green Packing

A starch-based, biodegradable product that dissolves in water or as part of a compost mixture, Clean Green does not have the environmentally negative image associated with polystyrene packaging materials. Used to protect everything from fine china to gears and bearings, these peanuts fill up the spaces between products, settling around fragile items to eliminate breakage and easing into empty corners to prevent shifting. This is a packing solution that is lightweight, resilient, durable, reusable, static free, clean, cost competitive and environmentally friendly.

390
383

383
392

387

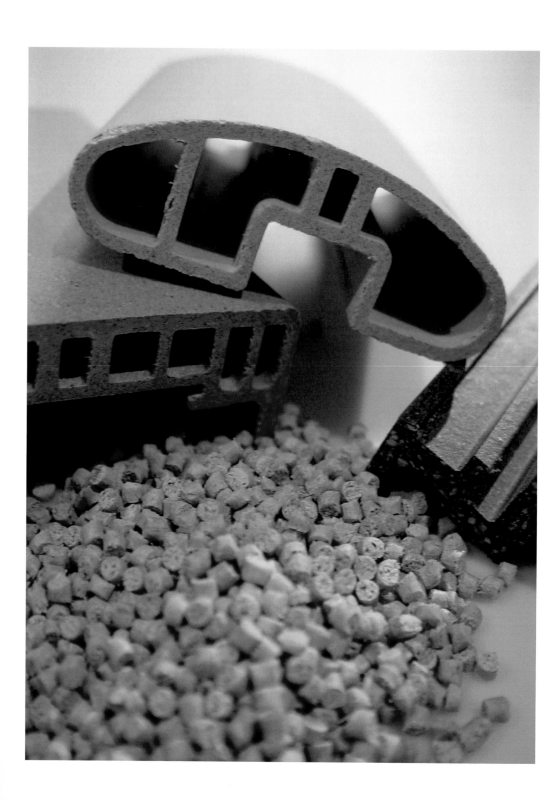

Manufacturer
Austel
Wurmsergasse 3/22
1150 Vienna
Austria

T +43 (0)664 1416 661
haglijan@fasal.at
www.austel.at

Fasal

387

391, 390

390

Fasal which comes in the form of pellets, is made from recyclable materials like wood and maize, in combination with resins and natural plasticizers. The environmentally friendly material, which boasts a unique appearance that resembles both plastic and wood, is compatible with most types of injection and extrusion machines. Applications range from toys and packaging to musical instruments and loudspeakers – and a host of uses still to be discovered.

Manufacturer
Cargill Dow
PO Box 5830, MS 114
Minneapolis,
MN 55440-5830
USA

T +1 989 6331 746
info@cargilldow.com
www.cargilldow.com

Ingeo

385, 390

383

385

Ingeo, a fibre made from petroleum-alternative PLA
(polylactate) residues (straw, cornstalk), combines the
properties of natural and synthetic fibres. The strength and
resilience of Ingeo fabrics are enhanced by their soft texture
and appealing drape. They react well to humidity, are
biodegradable, and are flame and stain resistant. Available
in woven and non-woven versions, Ingeo high-performance
fabrics are suitable for the fashion and furniture industries,
among others.

Manufacturer

Isoflex
Soldatvägen 1
78350 Gustafs
Sweden

T +46 (0)243 8415 0
F +46 (0)243 2292 00
info@isoflex.se
www.isoflex.se

Moniflex

For more than 70 years this material, which is made from cellulose (a vegetable product used in the manufacture of paper and textiles), has been used as insulation in railway coaches. Glued together, transparent corrugated sheets of cellulose, with air trapped between them, provide good thermal and sound insulation. Highly resistant to UV light and humidity, Moniflex is also lightweight, recyclable, nontoxic, durable and fibre-free. Maximum dimensions: 935 x 3000 mm. Thickness varies depending on the number of layers.

383
389
383, 381
392
387, 387
385

Manufacturer
J.Dittrich & Söhne
Industriezentrum
Westrich
Carl-Zeiss-Strasse 9
66877 Ramstein-
Miesenbach
Germany

T +49 (0)6371 9647-0
F +49 (0)6371 9647-22
www.dittrichvliesstoffe.de

Natural Fibre

386

381, 390

385

This needled fabric is composed of 40.5% hemp, 40.5% ambary and 19% polystyrene-acrylate binder. Heat-pressing the material at 190°-210°C for 90 seconds produces solid, three-dimensional panels. Other natural-fibre blends, with or without binders, are available upon request. The product has numerous applications for the construction, medical, footwear and automotive industries, among others.

Manufacturer
Grado Zero Espace
Via 8 Marzo, 8
50053 Empoli (FI)
Italy

T +39 0571 8036 8
F +39 0571 8036 8
contact@gzespace.com
www.gzespace.com

Nettle

384

385, 381, 392

392, 385, 392

381

392

388, 389

This textile is made from nettles, a weedy plant used for centuries to make, among other things, textiles and dyes. The long, hollow fibres of the nettle trap air, thus contributing to a product that provides thermal insulation. This natural form of insulation can be regulated by twisting the fibres, limiting their capacity to entrap air, which results in a cooler fabric for summertime use. Nettles, an interesting alternative to traditional crops, are a hardy plant family that can grow on nitrogenized and fertilizer-saturated soils. There is no need for pesticides, as insects tend to steer clear.

Manufacturer
Unilin info@unilin.com
 www.unilin.com

PanLin

387
387

The creation of PanLin relies on leftover particles of linen formerly discarded by textile manufacturers. Linen, a fabric made from flax, is 100% natural, fully recyclable (and thus environmentally friendly) and flame resistant. It has good acoustic properties. Although it is a solid particle board, PanLin is lighter than particle board made from compressed wood chips. Thicknesses vary from 25 to 50 mm and densities from 350 to 570 kg / m³. Main applications include doors, furniture and industrial packaging. Standard sizes: 5110 x 2050 mm and 2550 x 2050 mm. The product can also be cut to measure.

387

Manufacturer
André Ravachol
52, boulevard de
Sébastopol
75003 Paris
France

T +33 (0)1 4804 7771
F +33 (0)1 4277 6057
andreravachol@yahoo.fr
www.plasticana.com

Plasticana

390 Plasticana takes the form of recyclable pellets whose
392, 392, 386 thermoplastic (mainly vinyl) matrices contain hemp
385, 386 microfibres. (From 30% to 50% of the product is hemp.) The
392, 386, 385 material is brown owing to pectin in the hemp fibres. Beach
391, 390 sandals were among the first Plasticana-based products
to be marketed; the list of footwear now includes thongs and
386, 383, 382 anatomical clogs. Hemp, with its excellent carbon-bonding
389 property, could well become a viable replacement for oil.
390, 390 And Plasticana could well become the plastic of sustainable
development.

Manufacturer

PotatoPak
4 Dodson Street
Blenheim
New Zealand

T +64 (0)3 5791 079
F +64 (0)3 5791 089
richard@potatoplates.com (Richard Williams)
www.potatoplates.com

Potato Plate

392

390

On their journey from the fields to the crisp factory, potatoes are washed, peeled and fed into slicing tubes. Starch remaining in the water used for this process is filtered, dehydrated and thermoformed into bowls, plates, trays and the like. The environmentally friendly process relies on recycled water as its feedstock and produces a minimum of waste, which is fed to pigs. The 100% biodegradable product is used to make disposable packaging materials. A good alternative for polystyrene, it is manufactured in New Zealand under licence from Britain.

Manufacturer

Smile Plastics
Mansion House, Ford
Shrewsbury SY5 9LZ
England

T +44 (0)1743 8502 67
F +44 (0)1743 8510 67
smileplas@aol.com
www.smile-plastics.co.uk

Soft and Squishy

Cleaning out the cupboard? Recycle those old photographic negatives, film reels, postage stamps, love letters, visiting cards, banknotes – in other words, interesting traces of the past – by preserving them between sheets of flexible, transparent plastic. Use the new material thus created to cover furniture, for example, or to enhance a contemporary interior. It's an extraordinary way to give a new lease of life to all kinds of objects that often end up in the bin. Standard dimensions: 200 x 100 cm. One sheet is 3 mm thick.

385, 392

392

390

Manufacturer

Harvest SPF Textile
A2101, Soho New Town,
88, Jianguo Road,
Chaoyang
Beijing 100022
Republic of China

T +86 10 8580 5251
F +86 10 8580 5250
info@spftex.com
www.spftex.com

Soybean Fibre

385

392

385

385

383, 383

386, 390, 391

Made from soybean protein, this unique, eco-friendly fibre is the result of a nonpolluting manufacturing process. Soybean fibre, a by-product of a plant that is abundant and cheap, combines the properties of natural fibres with those of synthetics: it feels like cashmere, absorbs like cotton, resists wrinkling like polyester and has the sheen of silk. Obvious applications for this innovative material, which is a pleasure to touch, lie in the fashion industry and in interior design.

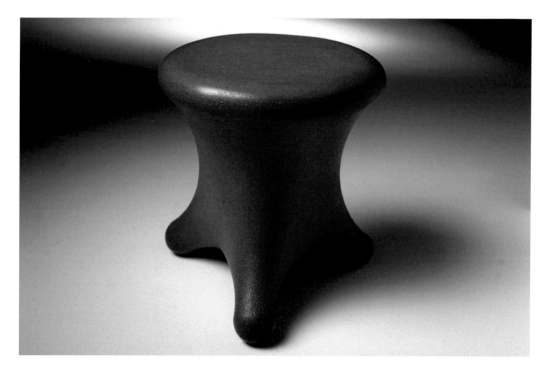

Manufacturer

Omodo
Samariterstrasse 25
10247 Berlin
Germany

T +49 (0)30 4280 8523
info@omodo.org
www.zellform.com

Zelfo

389

383

386, 382, 386

383

A warm material with an attractive patina, Zelfo is the name given to a new range of 100% biodegradable materials, without binders or additives, made from cellulose derived from wood, hemp, bamboo, jute and so forth. The ground and dampened cellulose becomes a compact paste to which natural pigments are added. After it dries, the finished product can be used to make musical instruments, furniture, boxes and all types of objects normally made from conventional wood. Zelfo is available in brown, ochre, black, white, green, blue, red, yellow and violet.

secret	sharp	shrouds,	skin,	so
section	shavings	side	skin.	so
sector	shavings	side,	skin.	so
sector.	She	sides	skin.	soaked
sector.	sheen	sight)	skin.	sodium-acetate
sectors.	sheen	sight.	skins	sofa,
security	sheen.	signal	skins	soft
security	sheep	signal	skis	soft
security	Sheet	signalling,	slats	soft
security,	sheet	silicate-	slats	soft
sediment	sheet	Silicio	slay	soft
seed	sheet	silicon	sleeves	soft
seem	sheet	silicon	slice	soft
seem	sheet	silicon	slices	soft
seems	sheet	silicon.	slices)	Soft
sees	sheet	silicon-carbide	slicing	soft,
segmented	sheet	silicone	slides.	Soft,
self-reinforcing	sheeting	silicone,	slightly	soft,
semi-permeable	sheeting,	silk.	slightly	soft,
semirigid	sheets	silk.	slippers,	softness
send	sheets	silk-screen	slow	SOFTswitch
sensational	sheets	silky	SLP	SOFTswitch
sensing.	sheets	silky	SLP	SOFTswitch,
Sensitive	sheets	silver	SLP	software.
sensitivity	sheets	silver	small	Sohn
Sensitivity:	sheets	silver	small	soil
separated	sheets	silver	small	soil.
serial	sheets	Silver	small	soils.
series	sheets	Silver,	small	solar
series	sheets	similar	small	Solatube
Sérilith	sheets	similar	small,	Solatube
Sérilith	sheets	similar	small,	sold
Sérilith	sheets	similar,	smaller)	solenoids
serious	sheets	simple	Smalley's	soles
serves	sheets	simple	smart	soles,
serves	sheets	simple	smart	solid
services,	sheets	simple	smells	solid
set	sheets	simple.	Smoke,	solid
sets	sheets.	simpler:	smoke,	solid,
settings.	sheets.	simplest	smoke.	solid,
settling	shell	simply	smooth	solid,
several	shell.	simply	smooth	solidifies
several	shields	sine-wave	smooth	solution
several	shift	single	smooth	solution
several	shifting.	site.	smooth	solution
several	shimmer	six	smooth	solution
several	shine,	size	smooth,	solution
several	shipbuilding,	size	smooth,	solution
several	shock	size	smooth,	Some
several	shock	size	smooth,	some
Several	shock	size)	smooth,	sorts
sewed	shock,	size.	snow.	sorts
sewn	shock.	size:	snow.	sorts
shades:	shockproof	size:	so	sorts
shape	shockproof.	Sizes	so	sorts
shape	shock-resistant	sizes	so	sorts
shape	shocks.	sizes	so	sound
shape	shoe	sizes	so	sound
shape),	shoes	sizes	so	sound
shape.	shoes,	sizes	so	sound,
shape;	shoes,	sizes	so	sound,
shaped	shoes,	sizes	so	sound-absorption
shaped	shoes,	sizes	so	sound-absorption
shaped	shoes.	sizes)	so	sound-insulation
shaped	short	sizes,	so	soups
shaped	should	sizes:	so	source
shape-memory	show	Sizes:	so	source
shapes	showroom-cum-	sizes:	so	source
shapes	headquarters	Sizes:	so	South
shapes	shredding	sizes:	so	southern
shapes,	shrink	Skin	so	Soviet
shapes.	shrink.	skin	So	Soviet

Soybean	sq	store	stunningly	suitable
soybean	square	storing	sturdy	suitable
Soybean	square	storing	sturdy	suitable
space	square	straight,	style.	suitable,
space	squares	stranded	subjected	suited
space	Squishy	strands	sub-layers	suited
space	stabilizing	strategic	submerged	summertime
space,	stable	strawberry	subsequently	sun
spaced	stable	street	substance	sun
spaces	stable	street	substance	sun.
spaces.	stable	street	substance	super
space-saver,	stable	strength	substance	superb
sparkle	stable,	stretch	substance,	super-cooling.
Sparkling	stable,	stretch	substances	super-elastic
Sparoc	stackable	stretch	substances	superimposed
Sparoc	stain	Stretch	substantial	superimposed
spatial	stainless	Stretch	substitutes,	supermarket
special	stainless	stretch	substrate.	supernatural
special	stainless	Stretch	subtle	supple
special	stainless	Stretch.	subtle	supple,
special	stainless-steel	stretched	success	supplied
special	stainless-steel	stretched	success	support
special	stainless-steel	stretched,	success	support,
special,	stainless-steel,	strictly	successful	supports.
specialized	stains	striking	successful	Supracor
specializing	stains,	strip	successful	Supracor
specially	stains,	strong	successfully	Supracor
specific	stairways	strong,	successive	Supracor/Stimulite
specific	stamps,	strong,	such	sure
specifications	Standard	strong,	such	surely
spectacles	Standard	strong,	such	surface
spectacles,	standard	strong,	such	surface
Spectra	standard	stronger	such	Surface
Spectra	Standard	stronger	such	surface
Spectra	Standard	structural	such	surface
Spectra	standards).	structurally,	such	surface
Spectra	stands	structure	such	surface
Spectra	Starch	structure	such	surface
Spectra	starch-based,	structure	such	surface
Spectra-spandex	state	structure	such	surface
spectrum	state	structure	such	surface
spheres	state,	structure	such	surface
spider's	static	structure	such	surface,
SpiraWave	static	structure	such	surface,
Spirawave	stationary,	structure	such	surface.
SpiraWave	steel	structure	such	surface.
SplashPad	steel	structure	such	surface.
SplashPad	steel	structure	such	surface.
Splitting	steel	structure	such	surface.
sponge),	steel,	structure,	suggests,	surface.
sponge,	steel,	structure,	suggests,	surface.
spongelike	steel,	structure.	suit	surface?
spontaneously	steel,	structure.	Suitable	surfaces
sports	steel,	structure.	suitable	surfaces
sports	steel,	structure.	suitable	surfaces
sports	steel.	structured	suitable	surfaces
sports,	steel.	structures	Suitable	surfaces
spot	steer	structures	suitable	Surfaces
spots	step	structures	suitable	surfaces
spots,	sterilized)	structures	suitable	surfaces),
spraying	stews	structures	suitable	surfaces).
Spring	stiffener	structures	suitable	surfaces,
spring	stiffeners	structures	suitable	surfaces.
spring	still	structures	suitable	surfaces.
spring	stitched,	structures	suitable	surfaces.
spring.	stitching.	structures	suitable	surfaces.
springs	Stockosorb	structures,	suitable	surfaces.
springs	Stockosorb	structures,	suitable	surfaces.
springs	Stockosorb	structures.	suitable	surfacing
springs	stop	studied	suitable	surfacing
springs,	store	studies	suitable	surgical
sq	store	stunning	suitable	surrounding

Temperature

Fire resistance, heat resistance, cooling capacity – we demand
more and more from materials, requiring them to protect us and
to provide us with the ultimate in comfort. Certain highly heat-
resistant polymers are moving into areas that were once the
exclusive preserve of metals. Silicon used in kitchen appliances
has revolutionized baking. The material can be shaped
and coloured, and designers appreciate silicon for its heat
resistance and suitability for food use. Another temperature-
related material allows us to cool a can of soda in the middle of
the Sahara in no time at all, thanks to a technology that has been
around for centuries and that has been given a new lease of life.
Sit back and relax. Materials are looking out for your wellbeing.

Manufacturer

Eutit
Stará Voda 196
35301 Mariánské Lázně
Czech Republic

T +420 354 6913 01
F +420 354 6914 80
eutit@eutit.cz
www.eutit.cz

Cast Basalt

382
392
382, 388
384
386
382
388

Basalt is a dark, fine-grained volcanic rock. When heated to 1300°C, it melts in the same way a thermoplastic does. Eutit pours molten basalt into moulds of varying sizes and shapes to produce a high-density product that is resistant to most chemicals, as well as being shockproof and frost-, hydrocarbon- and heat-proof. In other words, it is virtually indestructible. As a tile, cast basalt is used for industrial floors (in chemical plants, breweries, furniture factories and so forth). It is also suitable for urban infrastructure (footpaths, drains, street furniture), for electrical insulation, and for conduits and tubes that convey hot ash. In terms of aesthetics, this vitreous mineral gives off beautiful, iridescent reflections, which seem to emerge from deep within the black rock.

Manufacturer

SaSa
ZI 1 – BP 9
59360 Le Cateau
Cambrésis
France

T + 33 (0)3 2784 6300
F + 33 (0)3 2777 6308
sasa@sasa-industrie.com
www.sasa-industrie.com

Cooking Tiles

Used in the making of pastries and confectionery, SaSa's
cooking tiles consist of a glass-fibre textile coated with
silicon and fluoro-polymers. This food-compatible, anti-stick
product tolerates high temperatures and repeated use.
Depending on the coating used, various surface textures
are possible. An easy-to-clean product (wash in warm
water with a soft sponge), the translucent tile has numerous
applications.

385, 385
391, 390
392

Manufacturer

Thermagen
France

T +33 (0)1 6982 4282
F +33 (0)1 6982 4295
inquiries@thermagen.com
www.thermagen.com

Glacé

It looks like a 37.5-centilitre champagne bottle, but its volume is 20 centilitres. Press the 'active' bottom of the bottle, and an auto-cooling system chills the contents by more than 15°C in five minutes. The system relies on a special industrial ceramic and the evaporation of 10 grams of water in a vacuum. Sparkling wine remains chilled for 15 minutes. A glass of bubbly in the Sahara or atop the Great Wall of China? Get out the glasses and celebrate in style. Current applications include the cosmetics industry. Glasses and exterior packaging design: Frédérick Crozet / METO & Silicio (www.metosilicio.com). Bottle design and technology: Thermagen.

383

385

383, 385

385

Manufacturer

Brandschutzsysteme
Neuweg 1-4
67308 Zellertal
Germany

T +49 (0)6355 9539 10
F +49 (0)6355 9539 15
info@hapuflam.de
www.hapuflam.de

Hapuflam

Hapuflam is an intumescent fire-protection lattice that forms an insulating layer when it comes in contact with fire or excessively high temperatures, which cause the coating on the textile to expand by 60 times. The result is a thick, stable foam barrier that insulates and protects the underlying surface. Reinforced with woven fibreglass, Hapuflam is highly resistant to tearing and releases little smoke. The latticed structure allows heat generated by electric cables to dissipate safely. In addition to fire protection for cabling, Hapuflam is also suitable for other types of electrical equipment. Can be applied by spraying or with a brush.

392
392

385
385

Manufacturer

BASF
Carl-Bosch-Strasse 38
67056 Ludwigshafen
Germany

T +49 (0)621 6099 729
marco.schmidt@basf-ag.de (Marco Schmidt)
www.basf.de

Micronal

Certain substances are capable of storing or releasing heat when they change from one state to another (from a solid to a liquid, for instance). In the 1960s, studies of this phenomenon targeted PCM (phase-change material) paraffin, originally used in the aerospace industry. The '90s saw the emergence of a new application for PCM paraffin: climate-specific textiles. Today, thanks to a micro-encapsulation technique developed by BASF, the construction industry is employing PCMs in the form of paint and plaster. A wall treated with PCMs becomes a heat regulator, absorbing and storing excess heat and releasing it when the temperature drops. The results are enhanced comfort, no more need for air conditioning, and substantial savings on energy consumption.

387
389
389
389, 389

389
390, 389

381

Manufacturer

Rubitherm
Worthdamm 13-27
20457 Hamburg
Germany

T +49 (0)40 7811 5-721
F +49 (0)40 7811 5-544
info@rubitherm.com
www.rubitherm.com

Rubitherm GR / FB

Rubitherm is the name given to a PCM (phase-changing material) that can store heat and release it at a fixed temperature. The GR / FB range comes in the form of granules and panels with a special paraffin-encapsulated interior. When the paraffin changes from a solid to a liquid state, it releases heat without changing the shape of the container (granule or panel). The product is used for floor-heating systems, the packaging of precooked meals and building insulation. Rubitherm is environmentally friendly, nontoxic, durable and 100% recyclable.

389

389

389, 387

392

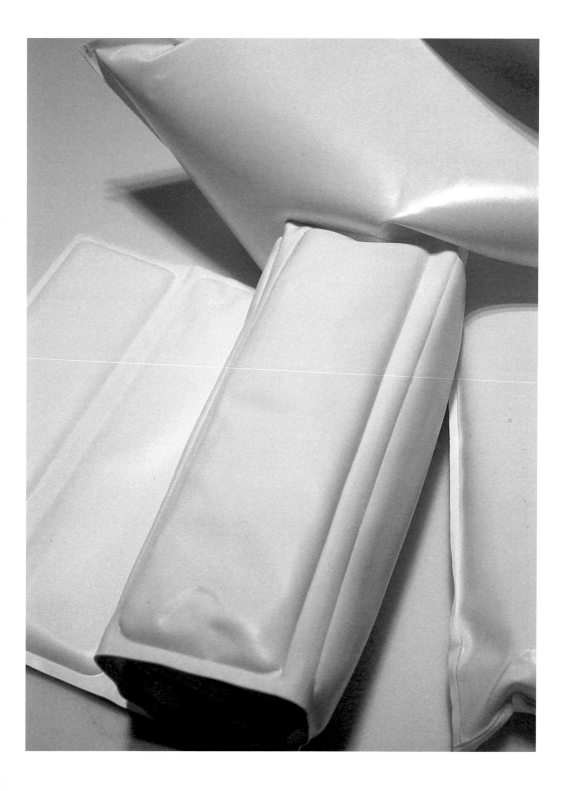

Manufacturer

Sofrigam
22, rue Lavoisier
92022 Nanterre cedex
France

T +33 (0)1 4669 8500
F +33 (0)1 4725 9844
informations@sofrigam.com
www.sofrigam.com

SaniFriz

SaniFriz – a viscous, non-toxic liquid that retains cold temperatures before gradually releasing them – comes in a flexible polyethylene envelope. This eutectic battery can be used for the precise regulation of temperatures in industrial packaging, notably in laboratories and the pharmaceuticals industry: tubes are wrapped in the plastic envelope to preserve the properties of the contents. It can also be used to keep beverages chilled or as a compress for the relief of pain.

Manufacturer

Thermo-Pad
5918 Kennedy Street
Summerland, BC
Canada V0H 1Z1

T +1 250 4945 002
F +1 250 4945 003
admin@thermo-pad.com
www.thermo-pad.com

Thermo-Pad

A sodium-acetate solution and a small metal disc enclosed in a pouch of flexible PVC – the user flexes the disc, and the pouch releases instant heat (54°C). The technology is simple. The substance inside the pouch, which has a freezing point of 54°C, maintains its liquid state thanks to super-cooling. Clicking the disc sets off a chain reaction (involving a crystallization process visible to the naked eye) that causes the temperature of the solution to rise to the freezing point (quite warm by human standards). By regenerating the Thermo-Pad for a few minutes in boiling water, the user can repeat the process hundreds of times. The product is ideal for medical applications, as well as for outdoor activities and promotional goods.

Manufacturer
WarmX info@warmx.com

Wx Film

It may have the appearance of an ordinary film, but it adheres to all kinds of curved and flat surfaces (wood, plastic and glass, among others) and heats up to 240°C when an electric current passes through it (12-380 V, alternating or direct current). Only 0.2 mm thick, Wx is a great space-saver, as it replaces radiators and other traditional heating systems.

suspended	technique	tempered	than	that
suspended	technique	temporarily	than	that
sustainable	technique	tend	than	that
sustainable	technique,	tender	than	that
SVP	technique.	tennis	than	that
sweet	techniques	tension:	than	that
switches	techniques	tenths	than	that
switches,	Technologies	terms	than	that
swivels	technologies	terraces,	than	that
sycamore,	technologies	testa	than	that
Synderme	technology	TexFlex	than	that
Synderme	technology	TexFlex	than	that
synthetic	technology	TexFlex	than	that
synthetic	technology	textile	than	that
synthetic	technology	textile	than	that
synthetic	technology	textile	than	that
synthetics:	technology	textile	than	that
Synthetix	technology	Textile	Thanks	that
Synthetix	technology	textile	Thanks	that
Synthetix	technology	textile	Thanks	that
Synthetix	technology	textile	Thanks	that
system	technology	textile	Thanks	that
system	technology	textile	Thanks	that
system	technology	Textile	Thanks	that
system	technology	textile	thanks	that
systems	technology	textile	thanks	that
systems	technology	textile	Thanks	that
systems,	technology	textile	thanks	that
systems,	technology	textile	thanks	that
systems,	technology	textile	Thanks	that
systems,	Technology.	textile	that	that
systems.	technology.	textile	that	that
systems.	technology:	textile,	that	that
systems.	Teflon	textile,	that	that
Tagua	telephone,	textile,	that	that
Tagua,	telephones	textile.	that	that
tagua.	television	textiles	that	that
tailored	television	Textiles	that	that
tailored	television,	textiles	that	that
take	televisions	textiles	that	that
take	teller	Textiles	that	that
take	temperature	textiles	that	that
takes	temperature	textiles	that	that
takes	temperature	textiles	that	that
takes	temperature	textiles	that	that
takes	temperature	textiles	that	that
tanning	temperature,	textiles	that	that
tanning	temperature,	textiles	that	that
tanning	temperature,	textiles	that	that
tanning,	temperature,	textiles	that	that
tape	temperature.	textiles),	that	that's
tapes	temperature.	textiles.	that	the
Tapes	temperature:	textiles.	that	the
tape-woven	temperatures	Textreme	that	the
target	temperatures	texts	that	The
target	temperatures	texture	that	The
target	temperatures	texture	that	the
targeted	temperatures	texture	that	the
tear,	temperatures	texture	that	the
tear.	temperatures	texture	that	the
tearing	temperatures	texture,	that	the
tear-resistant	temperatures	texture,	that	the
tears	temperatures	texture.	that	the
tears,	temperatures	textures	that	the
technically	temperatures	textures	that	the
technique	temperatures	textures	that	the
technique	temperatures,	textures.	that	the
technique	temperatures,	textures.	that	The
technique	temperatures.	Texyloop	that	the
technique	temperatures.	Thalweg	that	the
technique	temperatures.	than	that	the
technique	temperatures.	than	that	the

the the The the The
the the the the the
the the the the the
the the the The The
the The the the the
the the the the the
the the the the the
the the the the the
The the the the the
the the the the the
the the the the the
the The the the the
the the the The the
The the the the the
the the the the The
the the the The The
the the the the the
the the the the The
the the The the the
the the the The The
the the the the the
the the the The the
the the the The the
the the the the the
the The The the the
the the the the the
The the the the The
the the The the the
The the The The The
the the the the the
the the the The the
the the the the The
the the the the the
The the the the The
the the The the the
the The The the The
the The the the the
the the The The The
the the the the the
The the The the the
The the the the the
the the The the the
The the the the the
the the The the the
The the The the the
the the the the the
the the the the the
the The the the the
The the the the the
the the The the the
the The the the the
the the the the the
the the the the the
the the The the the
The the the the the
the the the The the
the The the the the
the the the the the
the the the the the
The the the the the
the The The the the
the the the the The
the the the The the
the the the The The
the the the the the
the the The the the
the the the the the
the the The the the
the the the the the
the the the the the
the the The the the
The The the the the
the the the the the
the the the the the
the the the The the
the the the the the
the the The the the
the the the the The
the the the the the
the the the the the

Water

Water makes up three-quarters of the earth's surface and more than 60% of the mass of all organic materials. But water is scarce and thus precious, a liquid that has become a key strategic issue in terms of conservation, distribution and recycling. This section of the book features a selection of water-related materials. Some are simply visually reminiscent of water (like the Living Floor), while others rely on characteristics or phenomena caused by water (such as Osmofilm and Stockosorb). Still others began their lives in water (such as Ocean Shell). We suggest that it's time for our readers to take the plunge!

Manufacturer

B.Lab
Via Marmolada, 20
21013 Gallaraté (VA)
Italy

T +39 0331 7744 45
F +39 0331 7348 44
living@blabitalia.com
www.blabitalia.com

Living Floor

The recipe is simple – take two sturdy sheets of flexible PVC, weld them at the edges and encapsulate one or two coloured fluids between the two – but the realization is complex. The resulting product features chromatic and lighting effects that respond to pressure. The immiscible colours create an endless range of patterns while temporarily preserving footprints or conveying printed messages. B.Lab offers clients a rainbow of colours, including those with a metallic look, and a variety of viscosities. As its name suggests, Living Floor is used mainly as a floor covering, but it can also play a role in furniture design (tabletops). Tiles are 7 mm thick and 50 to 100 cm wide.

391

385

392

387, 392

388

Manufacturer
Ocean Shell T +64 (0)3 2349 065
PO Box 42 F +64 (0)3 2349 059
Riverton team@oceanshellnz.com
New Zealand www.oceanshellnz.com

Oceanshell

387, 386

388, 386

386

387

386

383

Fine slices (only 0.3 mm thick) of natural mother-of-pearl are reconstituted into half-millimetre laminates, which can be mounted easily on any type of backing. The saltwater mollusc used to make the laminate is found only in the coastal waters of New Zealand. It feeds exclusively on seaweed and lives on rocks in water no deeper than 10 metres. The laminates come in a range of colours, each with a unique kaleidoscopic effect that takes its cue from the surrounding light and the angle from which it is viewed. Oceanshell laminates are also available pre-mounted on ceramic wall tiles. Dimensions (in mm): 150 x 150, 200 x 200 and 300 x 300.

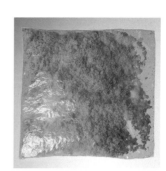
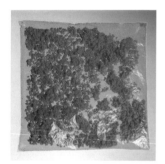

Manufacturer

Alizée
1, rue du Pommier Rond
95240 Cormeilles-en-
Parisis
France

T +33 (0)1 3415 7888
F +33 (0)1 3415 7799
info@osmofilm.com
www.osmofilm.com

OsmoFilm

OsmoFilm – a breathable and semi-permeable material (vapour can pass through, but liquid cannot) – has revolutionized dehydration, desiccation and dry-conservation processes. After a product is placed in a sealed OsmoFilm pouch, light passes through the film and heats the contents, producing a smart greenhouse effect that raises the temperature and accelerates the evaporation process. Water vapour passing through the film (inside to outside) prevents liquid from entering the pouch. While conceivably OsmoFilm could be used to dry laundry in the rain, it is found more often in areas such as waste disposal, pharmaceuticals, and the chemical and food industries. OsmoFilm is economical and clean, because all the energy it requires comes from natural light. The material can be heat welded and glued, and it is print compatible. Thickness: 15 to 100 microns.

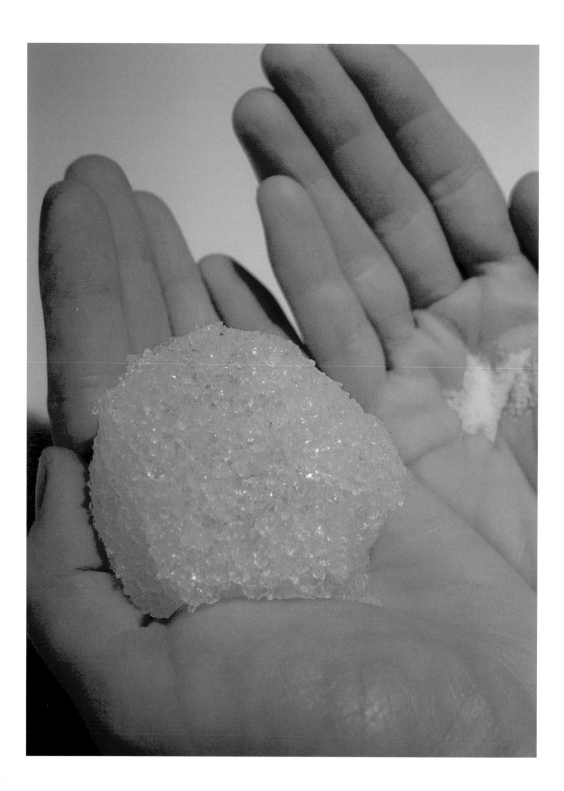

Manufacturer

Stockhausen
Bäkerpfad 25
47805 Krefeld
Germany

T +49 (0)2151 38-1314
F +49 (0)2151 38-1147
creaservice@degussa.com
www.creasorb.com

Stockosorb

Stockosorb is a nontoxic, water-retaining polymer often referred to as hydrogel. It comes in the form of small white granules that can absorb up to 300 times their weight in water. Put a few granules into a glass of water, and minutes later you have a compact block of water-saturated gel. Thanks to its unique composition, Stockosorb remains active for years. Used mainly for soil irrigation, water-retaining polymers are also a boon to manufacturers of medicine and to the food (preservation) and paper industries.

Manufacturer

Freudenberg Vliesstoffe
KG
Interlining Division
69465 Weinheim
Germany

T +49 (0)6201 8039 99
F +49 (0)6201 8830 67
vilene@freudenberg-nw.com
www.vilene.com

Vilene

The Vilene collection comprises a wide range of quality interlinings, from light to heavy, as well as high-volume nonwovens. Examples are flame-retardant nonwovens and an innovative backing for embroidering a thin fabric. This leaves no remnants, as the nonwoven interlining dissolves in lukewarm water (25° to 40°C). This low temperature, as well as the lack of formaldehyde in the product, means that the fabric does not fade, change colour or shrink. Vilene is suitable for underwear embroidery (made on Schiffli machines) and on multi-head embroidery, which does not irritate the skin. Water-soluble nonwovens offer clothing manufacturers a host of creative options, including individually designed garments.

387

388, 388

388

386

384

384

388

The	the	the	their	these
The	the	the	their	these
The	the	the	their	these
the	the	the	their	these
The	the	The	their	These
the	The	the	them	these
the	the	the	them	these
the	The	the	them	They
the	the	the	them	they
The	the	the	them	They
the	the	the	them	they
The	the	the	them	They
the	The	the	them	they
The	the	the	them	they
the	the	the	them	they
The	The	The	them,	They
the	the	The	then	they
the	The	the	then	They
the	The	the	Then,	They
the	the	the	there	They
The	the	the	There	They
the	The	the	thereof.	They
the	the	the	Thermagen.	They
the	the	the	thermal	they
the	the	the	thermal	thick
the	the	The	thermal	thick
the	the	the	thermal	thick
the	the	The	thermal	thick)
the	the	the	thermal	thick)
The	The	the	thermal	thick,
the	The	the	thermal	thick,
the	the	The	thermal	thick,
The	the	The	thermal	thick.
the	the	The	thermal	thick.
the	the	the	thermal	thick.
the	the	the	thermal	thick.
the	the	The	thermal	Thickness
the	the	the	thermal	Thickness:
the	the	the	thermal	thickness:
The	the	the	thermal	thickness:
The	the	the	thermal	Thickness:
The	The	the	thermal	Thickness:
the	the	the	thermal,	Thickness:
The	the	the	thermal-welded	thickness:
the	the	the	thermoform,	Thickness:
the	the	the	thermoformed	Thickness:
the	the	the	thermo-mechanical	Thickness:
the	the	the	Thermo-Pad	Thickness:
The	the	the	Thermo-Pad	thicknesses
the	the	The	thermoplastic	thicknesses
the	the	the	thermoplastic	thicknesses
the	The	the	thermoplastic	thicknesses
The	the	The	thermoplastic	Thicknesses
the	the	the	thermoplastic	thicknesses.
the	the	the	thermoplastic.	thicknesses.
the	the	the	thermosensitive	thicknesses.
the	the	the	thermosetting	thicknesses:
the	the	theatres,	thermosetting	thin
the	The	their	ThermoStack	thin
the	the	Their	ThermoStack,	thin
the	The	their	These	thin
the	the	their	these	thin
The	the	their	these	thin,
the	The	their	These	thin,
the	the	Their	These	thin,
The	the	their	These	things,
the	the	their	These	this
the	the	their	these	this
the	The	Their	these	this
The	the	their	These	This
the	The	their	These	this

This	three	times	to	to
this	three	times	to	to
this	three	times	to	to
This	three	times.	to	to
This	three	times.	to	to
This	Three	times.	to	to
this	three-dimensional	tin,	to	to
This	three-dimensional	tin,	to	to
this	three-dimensional	tinted	to	to
this	three-dimensional	tinted	to	to
this	three-dimensional	tinted	To	to
this	three-dimensional	Tissavel's	to	to
this	three-dimensional	titanium	to	to
This	three-dimensional	titanium	to	to
this	three-dimensional	titanium	to	to
this	through	titanium	to	to
This	through	titanium,	to	to
This	through	titanium,	to	to
This	through	to	to	to
this	through	to	to	to
This	through	to	to	to
this	through	to	to	to
this	through	to	to	to
This	through	to	to	to
This	through,	to	to	to
this	through.	to	to	to
this	throughout	to	to	to
This	throughout	To	to	to
this	thus	to	to	to
this	thus	to	to	to
this	thus	to	to	to
this	thus	to	to	to
this	thus	to	to	to
this	thus	to	to	to
this	thus	to	to	to
This	tightest	to	to	to
This	Tile	to	to	to
this	Tile	to	to	to
this	tile	to	to	to
this	Tile	to	to	to
This	tile	to	to	to
this	tile	to	to	to
This	tile,	to	to	to
This	tiled	to	to	to
This	tiles	to	to	to
this	tiles	to	to	to
this	tiles	to	to	to
this	tiles	to	to	to
this	tiles	to	to	to
This	tiles	to	to	to
this	tiles	to	to	to
This	tiles	To	to	to
This	Tiles	to	to	to
This	Tiles	to	to	to
thongs	tiles	to	to	to
thorns,	Tiles	to	to	to
thoroughly	tiles	to	to	to
those	tiles	to	to	to
those	Tiles	To	to	to
those	Tiles	to	to	to
those	tiles	to	to	to
those	Tiles	to	to	to
those	tiles,	to	to	to
though,	tiles.	to	to	to
thousand	tiles.	to	to	to
thousands	tiles:	to	to	to
thousands	time	to	to	to
thousands	time.	to	to	to
thread	time.	to	to	to
thread	time-honoured	to	to	to
threads.	times	to	to	to

Glossary

1 centimetre	=	0.39 inches
1 metre	=	3.28 feet
1 kilometre	=	0.62 miles
1 gram	=	0.04 ounces
100 grams	=	3.53 ounces
1 kilogram	=	2.20 pounds (lbs)
1° Celsius	=	32° Fahrenheit

A

abrasion: the process of scraping or wearing down by friction. [69]

abrasion resistance: a measure of toughness rather than hardness and is a necessary quality of flooring materials and surface finishes. [125, 183]

acrylic fibre: a thermoplastic textile fibre, such as Orlon or Acrilan, which has a low moisture regain, is low in density and can be made into bulky fabrics. Acrylic fibres wash and dry easily and are dimensionally stable; they are resistant to bleaches, dilute acids and alkalis, as well as to weathering and microbiological attack.

acrylic resin: any of a class of thermoplastic resins used for casting and moulding plastic parts that are exceptionally transparent, tough and resistant to weather and chemicals, or as the main ingredient in coatings, adhesives and caulking compounds. Often shortened to **acrylic**. [181, 215, 255]

adhesion: the property of sticking together or holding fast. [163]

aerogel: a highly porous substance formed by the suspension of small bubbles of gas in a liquid or solid; an example is silica gel, which can absorb large quantities of water and is used in air-conditioning equipment and to dry gases and oils. [43, 115]

air: the elastic, invisible, gaseous mixture that surrounds the earth (78.08 % nitrogen and 20.95 % oxygen, with lesser amounts of argon, carbon dioxide, hydrogen, neon, helium, and other gases). [35, 39, 45, 105, 141, 155, 161, 253, 315, 325, 329, 355]

alder: any of various deciduous shrubs or trees of the genus *Alnus*, native chiefly to northern temperate regions and having toothed leaves and conelike fruits. [181]

alloy: a metallic material (such as steel, brass or bronze) consisting of a mixture of two or more metals, or a metal and a non-metal. Alloys often have physical properties (strength, corrosion resistance and so forth) markedly different from those of the pure metals. [99, 121, 151, 167, 269, 301]

aluminium: a ductile, malleable, silver-white metal that is used in forming many hard, light alloys; anodized aluminium is used for its colour and hardness, as well as for its excellent resistance to corrosion. The main source of aluminium is bauxite. Symbol: Al. [39, 53, 93, 141, 143, 169, 185, 191, 225, 301, 307]

ambary: a valuable Asian plant (*Hibiscus cannabinus*) grown for its fibre, similar to jute. Uses include ropes, cordage and coarse canvas. Also called brown Indian hemp or kenaf. [327]

anodize: to coat a metal, such as aluminium or magnesium, with a hard, noncorroding film by electrolytic or chemical action. [169]

aramid: any of a group of very strong, lightweight, synthetic fibres used in making radial

tires, bulletproof vests and so forth. Although aramid fibres resist abrasion, as well as chemical and thermal degradation, they decay when exposed to excessive ultraviolet light. Trademarks: Kevlar, Technora, Twaron. 127

asbestos: any of several highly heat-resistant fibrous silicate minerals that can be woven into fabrics and which are used to make brake linings, fireproof materials, electrical insulation and so forth. Inhaling asbestos fibres can cause lung cancer. 53

asphalt: a mixture of dark bituminous pitch with sand or gravel. Uses include paving, waterproofing and roofing. 69, 165

B

bamboo: any of various, usually woody, temperate or tropical grasses of the genus *Bambusa*. Certain species can reach heights of 30 meters (98 feet). Mature stems are used in light construction, crafts, furniture and fishing poles. 341

basalt: the commonest type of solidified lava; a dense, dark-grey, fine-grained igneous rock composed chiefly of calcium-rich plagioclase feldspar and pyroxene. 117, 347

beech: any of several large deciduous trees of the genus *Fagus*, having rounded spreading crowns, smooth grey bark and small, sweet, edible, triangular nuts enclosed in burs; found in northern temperate regions. Used to make furniture. 177

beryllium: a lightweight, corrosion-resistant, steel-grey metal with a high melting point. Used by the aerospace industry and as a moderator and reflector in nuclear reactors. A beryllium-copper alloy is used for springs,

electrical contacts and non-sparking tools. Symbol: Be. 167

birch: any of various deciduous trees or shrubs of the genus *Betula*, native to the northern hemisphere and having unisexual flowers in catkins; alternate toothed leaves; and bark that often peels off in thin papery layers. Uses include furniture, interior finishes and plywood. 181

boron: a very hard, almost colourless crystalline metalloid element that in impure form exists as an amorphous brown powder. Boron is a semiconductor. Its compounds are used in enamels, glass and pottery. Specialized applications include nuclear control rods and neutron detection instruments. Symbol: B. 127

bronze: traditionally, any of various alloys consisting essentially of copper and tin, and sometimes traces of other metals. Currently the word defines any of various alloys having a large copper content with little or no tin. 187, 257, 301

C

carbon steel: ordinary, unalloyed steel in which the residual elements (such as carbon, manganese, phosphorus, sulphur and silicon) are controlled. Any increase in carbon content increases the strength and hardness of the steel but reduces its ductility and weldability. 149, 167

carbon: a nonmetallic element occurring in a pure state as diamond and graphite, or as a constituent of coal and petroleum. Symbol: C. 117, 119, 123, 127, 183, 297, 301, 317, 333

cashmere: a fine soft wool from goats of the Asian region of Kashmir. Used to make cloth or knitted material. 339

cell: the smallest structural unit of an organism that is capable of independent functioning, consisting of one or more nuclei, cytoplasm and various organelles, all surrounded by a semipermeable cell membrane. 31, 41, 51, 55, 123, 155, 215, 235

cellulose: a complex carbohydrate composed of linked glucose units. Cellulose, which forms the main constituent of the cell wall in most plants, is used in the manufacture of products such as paper, textiles, pharmaceuticals, explosives, rayon and film. 325, 341

ceramic: any of various hard, brittle, noncorroding and nonconductive materials formed by the ionic bonding of a metal and a nonmetal at a high temperature. Ceramic ware (bricks, tiles, pottery) is made by firing clay or similar materials in a kiln. 119, 127, 351, 371

china: a translucent ceramic material, bisque-fired at a high temperature and glaze-fired at a lower temperature. Also called porcelain. 319

chipboard: a non-veneered, wood-panel product made by bonding small wood particles with a synthetic resin under heat and pressure, commonly used as a core material for decorative panels and cabinetwork, and as an underlay for floors. Also called particle board. 191

chrome or **chrome plate** (verb): to coat or plate a metal surface with a compound of chromium, usually by electroplating. 147, 257

chromium: a hard grey metallic element that takes a high polish, occurring mainly in chromite; used in steel alloys and electroplating to increase hardness and corrosion resistance. Symbol: Cr.

coil: a series of connected spirals or concentric rings formed by gathering or winding. 143, 151, 167

concrete: an artificial, stonelike building material made by mixing cement and various mineral aggregates with sufficient water to cause the cement to set and bind the entire mass. 37, 53, 135, 179, 223, 289, 301, 305

conductor: a substance, body, or device that conducts heat, sound or electricity. 31

copper: a ductile, malleable, reddish-brown metal that is an excellent conductor of heat and electricity and is widely used for electrical wiring, water pipes and corrosion-resistant parts, either pure or in alloys such as brass and bronze. Symbol: Cu. 31, 97, 167, 185, 187, 301

corn: any of numerous cultivated forms of a widely grown, usually tall, annual cereal grass (*Zea mays*) bearing grains or kernels on large ears. Known as maize in the UK and in many other English-speaking countries. 323

corrosion: the process of destroying or damaging metal by chemical action, as when exposed to weather, moisture or other corroding agents. 159

cotton: any of various herbaceous plants and shrubs (genus *Gossypium*) cultivated in warm climates for the fibre surrounding the seeds and the oil within the seeds. Thread or cloth made from this plant is also called cotton. 157, 339

D

deformation: a change in the shape or dimensions of a body or structure resulting from stress. 41, 251

density: the mass of a substance per unit measure, especially per unit length, area, or volume. 33, 35, 43, 47, 55, 99, 183, 347

diamond: an extremely hard, highly refractive crystalline form of carbon that is usually colourless and is used as a gemstone and in abrasives, cutting tools and other applications. 245

diffuser: any of a variety of translucent materials for filtering glare from a light source and distributing the light over an extended area. 237

diffusion: a scattered reflection of light from an irregular surface or an erratic dispersion and softening of light, as by passage through frosted glass; the desired result is a reduction of glare and harsh shadows. 251

diode: a semiconductor device with two terminals, typically allowing the flow of current in one direction only. 229, 231, 271

dye: a natural or synthetic soluble substance used to add colour to, or to change the colour of, fabric, hair and so forth through the process of absorption. 37, 61, 65, 189, 209, 329

E

elasticity: the property of a material that enables it to deform in response to an applied force and to recover its original size and shape upon removal of the force. 99, 103, 105, 125

elastomer: any material having the elastic properties of natural rubber (such as butyl rubber and neoprene) that is able to resume its original shape when a deforming force is removed. 49, 103

electricity: the science dealing with the physical phenomena arising from the existence and interaction of electric charges; a property of certain fundamental particles of all matter. 229, 267, 275

electrode: a conductor through which an electric current enters or leaves a nonmetallic object or substance. 123

electrolysis: the creation of chemical charges by passing an electric current through an electrolyte, with subsequent migration of positively and negatively charged ions to the negative and positive electrodes. 31

electron: an elementary particle of matter with a negative charge. 123

emboss: to raise, mould or carve a surface design in relief. 191

embroidery: decorative needlework. 209, 377

enamel: a vitreous, usually opaque, decorative or protective coating applied by fusion to the surface of metal, glass or pottery. 187

engrave: to carve, cut or etch designs on a hard surface, as of metal, stone, or the end grain of wood. 197, 257, 307

epoxy resin: any of various thermosetting resins (usually amber or brown) capable of forming tight cross-linked polymer structures characterized by toughness, strong adhesion and high chemical and corrosion resistance.

Used in surface coatings, laminates and adhesives, epoxy resins exhibit low shrinkage during cure (for minimal fabric print-through and little internal stress). Also called epoxide resin and often shortened to **epoxy**. 39, 175

EVA (ethyl vinyl acetate): a material consisting of a rubbery copolymer of ethylene and vinyl acetate. Used as cushioning in running shoes. 55

F

felt: a matted and usually smooth fabric of wool (often mixed with other materials, such as fur, hair, cotton or rayon) made by working the fibres together under pressure or by heat or chemical action, rather than by weaving or knitting. 153

fibre: a natural or synthetic thread or filament that may be spun into yarn, such as cotton or rayon. 37, 53, 119, 123, 125, 127, 129, 183, 187, 221, 223, 227, 245, 315, 317, 323, 325, 327, 329, 333, 339, 349

fibreglass: a material composed of extremely fine glass filaments embedded in a resin matrix and woven into fabric. Fibreglass is strong, durable and impervious to many caustics and to extreme temperatures. Fibreglass fabrics are widely used for industrial purposes. Trademark: Fiberglas. 53, 55, 83, 125, 157, 353

film: plastic sheeting having a nominal thickness not greater than 10 mils. 67, 189, 203, 211, 217, 219, 233, 247, 255, 267, 337, 363, 373

fluid: a substance, such as a gas or a liquid, that is capable of flowing, yields easily to pressure and conforms to the shape of its container. 39, 97, 243, 369

foam rubber or **foam plastic**: any of various light, porous, semirigid or spongy materials used for thermal insulation or shock absorption, as in packaging. Often shortened to **foam**. 31, 41, 47, 53, 107, 155, 183, 195, 353

G

galvanize: to coat metal, especially iron or steel, with zinc; to immerse in molten zinc to produce a coating of zinc-iron alloy. 149

gas: the state of matter distinguished from the solid and liquid states by relatively low density and viscosity, relatively great expansion and contraction owing to changes in pressure and temperature, the ability to diffuse readily, and the spontaneous tendency to disperse uniformly throughout any container. 53, 137, 147

glass: any of a large class of materials with highly variable mechanical and optical properties that solidify from the molten state without crystallization; are typically made by silicates fusing with boric oxide, aluminium oxide or phosphorus pentoxide; are generally hard, brittle, and transparent or translucent; and are considered to be supercooled liquids rather than true solids. 43, 53, 81, 119, 127, 189, 197, 207, 211, 215, 219, 223, 227, 229, 233, 235, 249, 253, 255, 259, 279, 349, 351, 363, 375

gold: a soft, yellow, corrosion-resistant metal. The most malleable and ductile metal, gold occurs in rocks and alluvial deposits. A good thermal and electrical conductor, gold is generally alloyed to increase its strength. It serves as an international monetary standard, is used in jewellery, for decoration, and as a plated coating on a wide variety of electrical and mechanical components. Symbol: Au. 97, 187, 233, 257

granite: a very hard, coarse-grained igneous rock composed mainly of quartz, feldspar and mica or other coloured minerals. Granite is widely used for building. 249

H

hardboard: a thin, stiff sheet made of compressed sawdust and wood pulp bound together with plastic adhesive or resin under heat and pressure. 191

hemp: any of various plants of the genus *Cannabis sativa*, having tough fibres for making canvas, rope and so forth. 137, 317, 327, 333, 341

honeycomb: a framework of hexagonal cells resembling the waxy structure built by bees. 41, 49, 51, 55, 183

hydrocarbon: any organic compound containing only carbon and hydrogen; examples are benzene, methane and paraffin. 163, 347

I

ink: a pigmented liquid or paste used for writing or printing. 291

IR or **infrared**: of or pertaining to electromagnetic radiation having wavelengths from about 800 nm, contiguous to the red end of the visible spectrum, to 1 mm, on the border of the microwave region. 213, 231

ivory: a hard, smooth, yellowish-white substance composed primarily of dentine. Ivory makes up a major part of the tusks of elephants, walruses and narwhals. Uses include jewellery and ornaments. 77

J

jute: either of two Asian plants (*Corchorus capsularis* or *C. olitorius*) yielding a strong fibre used for sacks, rope and the like. 341

K

knit: to make a fabric or garment by intertwining yarn or thread in a series of connected loops. Knitting can be done by hand (with knitting needles) or on a machine. 97

L

laminate: a product made by uniting two or more layers of material by an adhesive or other means, as plywood and plastic laminate. 61, 67, 79, 89, 103, 189, 197, 203, 211, 219, 371

laser (light amplification by stimulated emission of radiation): any of several devices that emit highly amplified and coherent radiation of one or more discrete frequencies. One commonly used laser makes use of atoms in a metastable energy state that, as they decay to a lower energy level, stimulate others to decay, resulting in a cascade of emitted radiation. The laser is valued for its intense, finely focused beam. 161, 175, 197, 251

latex: a milky fluid produced by many plants. Latex from the rubber tree (*Hevea brasiliensis*) is used in the manufacture of rubber. The latex used in paints and adhesives is a water emulsion of synthetic rubber or plastic globules obtained by polymerization. 75, 299

LCD (liquid-crystal display): a flat-screen display in which an array of liquid-crystal elements can be selectively activated to generate an image, an electric field applied to each element altering its optical properties. Uses

include portable computers, digital watches and calculators. 123, 277

lead: a soft, malleable, ductile, bluish-grey metallic element extracted chiefly from galena. Lead is used in roofing, plumbing, ammunition, storage batteries, solder and radiation shielding. Lead compounds are used to make crystal balls and are added to petrol as an anti-knock agent. Symbol: Pb. 31

leather: a material consisting of the skin of an animal made smooth and flexible by tanning, removing the hair and so forth. 63, 65, 75, 79, 105, 125, 147, 195

LED (light-emitting diode): a semiconductor diode that emits light when voltage is applied. Applications include lamps, alphanumeric displays (digital watches), measuring instruments, microcomputers and lasers. 213, 229

light: electromagnetic radiation, visible to the human eye, with a wavelength ranging from about 380 (violet) to about 780 (red) nanometres; the medium of illumination that makes sight possible. 43, 51, 55, 61, 73, 81, 95, 143, 145, 169, 189, 203, 205, 207, 209, 211, 213, 215, 217, 221, 223, 227, 229, 231, 233, 237, 245, 253, 259, 265, 279, 281, 297, 325, 369, 371, 373

lime: a white or grey-white, caustic, odourless solid obtained by heating forms of calcium carbonate, such as shells or limestone, at a high temperature. Also called calcium oxide, calx, caustic lime and quicklime. 71

linen: thread or fabric made from fibres of the flax plant. 187, 331

liquid: the state of matter in which a substance exhibits a characteristic readiness to flow, little or no tendency to disperse and

relatively high incompressibility. 33, 139, 141, 153, 355, 357, 361, 373

luminescence: the emission of light at low temperatures by any process other than incandescence, such as phosphorescence, fluorescence and bioluminescence. Luminescence is caused by chemical, biochemical, or crystallographic changes; the motions of subatomic particles; or radiation-induced excitation of an atomic system. 209

Lycra: trademark for a type of synthetic elastic fabric and fibre made from a polymer containing polyurethane. Lycra is used to make elastic garments, such as tight-fitting swimming costumes and other sports clothing. 89

M

maize: see corn. 321

maple: any of numerous deciduous trees or shrubs of the genus *Acer*, found in northern temperate regions. The maple has opposite, lobed leaves and long-winged fruits borne in pairs. Used for furniture and flooring. 177

marble: a metamorphic rock of crystallized limestone, consisting mainly of calcite or dolomite, capable of taking a high polish, and used especially in architecture and sculpture. The presence and distribution of numerous minerals account for the distinctive variegated appearance that many marbles have. The commercial term includes many dense limestones and certain coarse-grained dolomites. 73, 249

marquetry: a pattern of inlaid veneers of wood, brass, ivory and the like, fitted together to form a picture or an intricate design, used chiefly as ornamentation of furniture. 77, 79

MDF (medium-density fibreboard): an engineered wood product formed by breaking down softwood into wood fibres (often in a defibrator), combining it with wax and resin, and forming panels with the use of heat and pressure. While not suitable for outdoor use (it swells on contact with water), MDF tolerates moisture better than particle board does. It has a remarkably consistent structure and is easy to machine or employ in woodworking applications. MDF is often used with melamine or wood veneers. 301, 309

metal: any of a class of elementary substances (gold, silver, copper and the like), all of which are crystalline when solid and many of which are characterized by opacity, ductility, conductivity, and a unique lustre when freshly fractured. 31, 35, 39, 67, 89, 93, 121, 161, 175, 185, 187, 195, 233, 271, 299, 301, 361

micron: a unit of length; the millionth part of a metre. Also called micrometre. Symbol: mu or μ 33, 223, 233, 257, 373

mineral: any of a class of naturally occurring solid inorganic substances, including certain elements (such as gold and silver), organic derivatives (such as coal and petroleum) and substances extracted or obtained from the ground or water (such as stone, sand, salt and coal). 53, 67, 179, 347

mollusc: any of numerous chiefly marine invertebrates of the phylum *Mollusca*, typically having a soft unsegmented body, a mantle and a protective calcareous shell. Examples are edible bivalves (clams and mussels), gastropods (snails and slugs) and cephalopods (cuttlefish and octopuses). 371

monofilament: synthetic thread or yard composed of a single strand rather than twisted

fibres. Also called monofil. 91

mosaic: a picture or decorative pattern made by inlaying small, usually coloured pieces of tile, enamel or glass in mortar. 179

motif: a distinctive and recurring shape, form or colour in a design. 197, 303, 305, 307, 309

mould: a hollow form or matrix used to give a definite shape to fluid or plastic material. 67, 121, 137, 177, 185, 219, 225, 305, 347

N

nano-: a prefix denoting a factor of 10^{-9}. 123, 297

nickel: a hard, silvery-white, malleable, ductile metal used in steel and cast-iron alloys and in electroplating metals that require corrosion resistance. Symbol: Ni. 31, 99, 269, 301

nitride: a compound of nitrogen with a more electropositive element, such as phosphorus or a metal. 53

nitrogen: a nonmetallic element that constitutes nearly four-fifths of the air by volume, occurring as a colourless, odourless, almost inert diatomic gas (N_2) in various minerals and in all proteins. Nitrogen is an ingredient of ammonia, nitric acid, TNT and many fertilizers. Symbol: N. 297, 329

nonwoven: a material or fabric that is neither woven nor knit, such as felt. Most nonwovens are not strong (unless reinforced by a backing) and do not stretch. They are cheap to manufacture. 377

nylon (polyamide): any of a class of inexpensive thermoplastics characterized by extreme toughness, strength and elasticity and capable

of being extruded into filaments, fibres and sheets; made by copolymerizing dicarboxylic acids with diamines. Applications include bearings, blow mouldings and fabric. A disadvantage is poor dimensional stability caused by water absorption. 97, 125, 175

O

oak: any of numerous monoecious deciduous or evergreen trees or shrubs of the genus *Quercus*, bearing acorns as fruit. An important source of hard, durable timber, oak is used chiefly in building and in the manufacture of furniture. 177, 181

oil: any of a number of viscous liquids with a smooth sticky feel. Oils are generally flammable, insoluble in water and soluble in organic solvents. They are obtained from plants and animals, from mineral deposits and by synthesis. Uses include lubricants and fuels. 69, 147, 149, 153, 163, 333

oxide: a binary compound of oxygen with another element. 257, 297

P

paper: a material made from cellulose fibres derived mainly from wood, rags and certain grasses; processed into flexible sheets or rolls by deposit from an aqueous suspension; and used chiefly for writing, printing, drawing, wrapping and covering walls. 81, 149, 157, 159, 273, 275, 289, 291, 293, 295, 307, 325, 375

paraffin wax: a waxy white or colourless solid hydrocarbon mixture used to make candles, wax paper, lubricants and sealing materials. Also called **paraffin**. 355, 357

patina: a greenish film or encrustation produced by oxidation on the surface of old bronze and copper and often admired for its ornamental value; any fine layer on a surface; the sheen on a surface caused by much handling. 65, 77, 341

PC (polycarbonate): a tough, transparent, thermoplastic characterized by its high-impact strength, remarkable thermal resistance and good electrical properties. Polycarbonate resins are used in moulding materials and laminates: examples are light fixtures, safety glazing and hardware. Trademark: Lexan (a product used for shatterproof windows and decorative resins). 55, 251

PCM (phase-change material): collective term for materials capable of altering their physical state within a given range of temperatures: from solid to liquid and vice versa. 355, 357

PE (polyethylene, polyethene or polythene): a tough, light, flexible thermoplastic material made from ethylene. The properties of this synthetic resin depend on the molecular weight of the polymer used. The world's most popular plastic, PE is used for packaging, toys, insulation, textiles, coatings (of metals, for example), damp-proofing and bulletproof garments. The versatility of the material is complemented by its simple structure, the most uncomplicated of all commercial polymers. 55

PET (polyethylene terephthalate): a synthetic resin made by copolymerizing ethylene glycol and terephthalic acid. Chief applications are bottles and fibres. 55

phenolic resin: any of a class of hard, heat-resistant thermosetting resins formed by the

condensation of phenol with formaldehyde. Used for moulded products, adhesives and surface coatings such as paints. This dense material is made by applying heat and pressure to layers of paper or glass cloth impregnated with synthetic resin. The result is a chemical reaction (polymerization) that transforms the layers into a high-pressure thermosetting industrial laminated plastic. Also called phenoplast. Trademark: Bakelite. 157, 159

phosphor: any of a number of substances that emit light when excited by radiation. 205, 259

pick: a weft yarn in weaving. 135

piezoelectric: able to convert mechanical signals (such as sound waves) into electrical signals and vice versa. Piezoelectric crystals, such as quartz, are used in the manufacture of microphones, earphones and the like; they can also generate a spark for lighting gas appliances. 267

PLA or **PLLA** (polylactic acid): a biodegradable aliphatic thermoplastic derived from lactic acid. Like most thermoplastics, PLA can be processed to make fibre and film. It also has biomedical applications, such as sutures, dialysis media and drug-delivery devices. PLA is an attractive sustainable substitute for petrochemical products. Trademarks: Natureworks, Ingeo. 323

plaster: a composition of gypsum or lime, water, sand and sometimes hair or other fibre, applied in a pasty form to the surfaces of walls or ceilings in a plastic state and allowed to harden and dry. 279, 301, 355

plastic: any of numerous synthetic or natural organic materials that are mostly thermo-

plastic or thermosetting polymers of high molecular weight and that can be moulded, extruded or drawn into objects, films or filaments. 55, 81, 107, 109, 121, 189, 197, 203, 205, 213, 219, 223, 227, 233, 251, 267, 279, 321, 333, 337, 359, 363

PMMA (polymethylmethacrylate): a clear vinyl polymer. This acrylic resin is used as a shatterproof replacement for glass. Trademarks: Plexiglas, Lucite. 181, 221, 233, 251, 253, 301

polyamide: see nylon. 135

polycarbonate: see PC. 215, 217

polyester: any of a large group of thermosetting resins used in the manufacture of plastics, textile fibres and adhesives. These polymers are characterized by extremely long molecules, each of which is several thousand atoms long; a polyester fibre resembles a tiny rope made from microscopic spaghetti. Trademarks: Dacron (polyester fibre), Mylar (polyester film). 89, 91, 135, 137, 233, 245, 339

polyethylene: see PE. 125, 359

polymer: a naturally occurring or synthetic compound of high molecular weight formed by polymerization and consisting essentially of repeating structural units. 31, 55, 73, 137, 219, 349, 375

polyproylene: see PP. 135, 137, 139, 183

polystyrene: see PS. 319, 327, 335

polythene: see PE. 45

polyurethane: any of various thermoplastic or thermosetting resins used in flexible and rigid foams; in elastomers; and in resins for sealants, adhesives and coatings. The material is made by copolymerizing an iso-

cyanate and a polyhydric alcohol. Flexible polyurethane rubber is used in furniture and automobile cushions, mattresses and carpet backings. Rigid polyurethane foam is used as packaging, as well as for the thermal insulation of refrigerators, trucks and buildings. 95, 107, 155

PP (polypropylene): a tough, flexible thermoplastic that is resistant to heat and chemicals. The material is made by polymerizing propylene. Applications include moulded articles, laminates, bottles, pipes, electrical insulation and films, as well as fibres for ropes, bristles, upholstery and carpets. 55, 103

PS (polystyrene): a hard, tough, stable thermoplastic obtained by polymerizing styrene. PS is easily coloured, moulded, expanded and rolled into sheeting. This synthetic resin is used as a lightweight, rigid foam (expanded polystyrene) for insulating and packing, and as a glasslike material in light fittings and water tanks. Other applications are films and chemical apparatus. 55

PTFE (polytetrafluoroethylene): a white, thermoplastic material with a waxy texture, made by polymerizing tetrafluoroethylene. It is nonflammable, resists chemical action and radiation, and has a high electrical resistance and an extremely low coefficient of friction. PTFE is used to make gaskets, hoses, insulators and bearings; to coat metal surfaces in chemical plants; and to coat cooking vessels. Trademark: Teflon. 109

PVB (polyvinyl butyral): a thermoplastic resin used chiefly as the interlayer of laminated safety glass. 189, 211

PVC (polyvinyl chloride): a white, water-insoluble, synthetic thermoplastic material made by polymerizing vinyl chloride. Properties depend on the added plasticizer. PVC is widely used in the manufacture of floor coverings, insulation and pipes. Other applications are shoes, garments and moulded articles. 45, 55, 251, 317, 361, 369

R

resin: any of numerous solid or semisolid organic substances prepared by polymerization and used with fillers, stabilizers and other components to form plastic. 33, 73, 137, 307, 321

rubber: a material made by chemically treating and toughening natural rubber, valued for its elasticity, nonconduction of electricity, and resistance to shock and moisture. 101

S

sand: a loose granular material, typically pale yellowish brown, resulting from the erosion of siliceous and other rocks and forming a major constituent of beaches, deserts, and the beds of rivers and seas. 47, 135

shape memory: a property exhibited by certain alloys able to recover their initial shape when they are heated after having been plastically deformed. 97, 99, 187, 269

silicon: a nonmetallic element having amorphous or crystalline forms and used doped or in combination with other materials in glass, semiconducting devices, concrete, brick, refractories, pottery and silicones. Symbol: Si. 43, 115, 119, 187, 349

silk: a fine, strong, soft lustrous fibre produced by silkworms to make cocoons. An important component is sericin, a glutinous protein that bonds the two gossamer filaments of raw silk.

Thread and fabric made from this material are also called silk. 307, 339

silver: a lustrous white, ductile, malleable metal, occurring both uncombined and in ores such as argentite, and having the highest thermal and electrical conductivity of the metals. It is highly valued for its ornamental use (jewellery, tableware). Other applications include coinage, photography, dental and soldering alloys, electrical contacts, and printed circuits. Symbol: Ag. 89, 97, 235

sodium: a soft, light, extremely malleable, silver-white metal that reacts explosively with water. Sodium is naturally abundant in combined forms, especially in common salt, and is used in the production of a wide variety of industrially important compounds. Symbol: Na. 361

stainless steel: any of various steels alloyed with at least 12% chromium. The metal is resistant to corrosion and to oxidation caused by exposure to water and moist air. 145, 149, 167, 187, 227, 257

steel: any of various iron-based alloys having a carbon content less than that of cast iron and more than that of wrought iron, and having qualities of strength, hardness, machinability and malleability, which vary according to composition and to the way in which the alloy has been treated. 35, 129, 149, 161, 185, 257, 301

sycamore or American plane tree: any of various deciduous trees of the genus *Platanus*, especially *P. occidentalis* of eastern North America, having five-lobed leaves; ball-like, nodding, hairy fruit clusters; and bark that flakes off in large colourful patches. Also called buttonball and buttonwood. 181

T

thermoforming: a method of shaping a thermoplastic sheet by heating and forcing it against the contours of a mould with compressed air. 183, 335

thermoplastic: a plastic capable of softening or fusing when heated without a change in any inherent properties, and of hardening again when cooled. 49, 51, 137, 183, 333, 347

thermosetting: a method of shaping a plastic or resin that becomes permanently rigid when heated and cannot be softened again. 137, 307

tin: a malleable, silvery metal obtained chiefly from cassiterite. It is used to coat other metals to prevent corrosion. Tin is an ingredient of numerous alloys, such as soft solder, pewter, type metal and bronze. Symbol: Sn. 187, 301

titanium: a strong, low-density, highly corrosion-resistant, lustrous white metal that occurs widely in igneous rocks and is used to alloy aircraft metals for low weight, strength and high-temperature stability Symbol: Ti. 99, 121, 161, 185, 269, 297, 301

U

UV (ultraviolet): of or relating to the range of invisible radiation wavelengths from about 4 nanometres, on the border of the X-ray region, to about 380 nanometres, just beyond violet in the visible spectrum. 43, 73, 207, 213, 231, 253, 297, 325

V

vinyl: any of various tough, flexible plastics made from polyvinyl resin, especially PVC. 333

viscose: an amber-coloured, viscous solution made by treating cellulose with sodium hydroxide and carbon disulphide. It is used to make rayon thread and fabrics, as well as cellophane. Viscose rayon has a shinier finish and holds dye better than cotton does. 97

W

walnut: any of several deciduous trees of the genus *Juglans*, having pinnately compound leaves and a round, sticky outer fruit wall that encloses a nutlike stone with an edible seed. The wood of the walnut tree is used for cabinetwork and panelling. 177, 181

warp: the yarns arranged lengthways on a loom, forming the threads through which the weft yarns are woven to make cloth. 187

wax: any of various viscous or solid materials of natural origin. Characteristically lustrous, insoluble in water and having a low softening temperature, waxes consist largely of esters of fatty acids. Examples are ozocerite, paraffin and beeswax. Applications are paper coatings, insulation, crayons and medicinal preparations. 71, 73, 147

weft: the yarns woven across the width of the fabric through the lengthwise warp yarns. Also called filling or woof. 187

wool: yarn spun from the fleece of sheep (primarily), goats or llamas; cloth or a garment made from this yarn. 53, 153, 187, 315

Y

yarn: a continuous twisted strand of natural or synthetic fibres (such as wool, silk, flax, cotton, nylon or glass) used in weaving, knitting and so forth. 187, 265, 271

to	to	top-quality	transparent	two
to	to	top-quality	transparent	Two
to	to	tops	transparent	two
to	to	Tortoiseshell	transparent	two
to	to	Tortoiseshell	transparent	two
to	to	tortoiseshell	transparent	two
to	to	tortoiseshell	transparent	two
to	to	total	transparent,	Two
to	to	totally	transparent,	two
to	to	totally	transport,	two
to	to	totally	transverse	two
to	to	totally	trap	two
to	to	touch	trap	two
to	to	touch,	trapped	two
to	to	Touch.	trays	two
to	to	Touch-sensitive	trays,	two
to	to	tough,	treated	two
to	to	toughness	treated	two.
to	to	toxic	treated	two-dimensional
to	to	toxic	treated	type
to	to	toys	treatment	type
to	to	toys,	treatment	type
to	to	toys.	treatments	types
to	to	traces	treatments.	types
to	to	tracking	tree	types
to	to	tracks	trendwatchers	types
to	to	traction-	triangular	types
to	to	trade	tri-colour	types
to	to	trade	true	types
to	to	trade.	Truly	types
to	to	tradition	truly	types
to	to	traditional	TSP	types
to	to	traditional	TSP	types
to	to	traditional	TSP	types
to	to	traditional	Tube	types
to	to	traditional	tube	Tzuri
to	to	traditional	tube	ultimately,
to	to	traditional	Tube	ultra-high
to	to	traditional	tube	ultra-light
to	to	traditionally	tube	ultra-light
to	to	Traditionally	tube,	ultra-light,
to	to	transferred	Tubes	ultra-light.
to	to	transferring	tubes	ultra-strong
to	to	transform	tubes	ultra-thin,
to	to	transformative	tubes	ultra-tough
to	to	transformed	tubes	unconnected
to	to	transformed	tubes	under
to	to	transformed	tubes	under
to	Today,	transforming	tubes	under
to	today,	transforms	tubes	under
to	Today,	translucence	tubes.	under
to	Today,	translucence	tubing	undergarments.
to	today's	translucence,	turns	undergone,
to	toe	translucent	turns	underlying
to	together	translucent	turtle,	underlying
to	together	translucent	Turtleskin	underwear
to	together,	translucent	Turtleskin	undulating
to	together,	translucent	Turtleskin	undulating
to	together,	translucent,	Turtleskin	undulating
to	together,	translucent,	Twice	unfair
to	Tokyo	translucent.	twist	unhazardous
to	tolerates	translucent.	twist.	uniform
to	tones	translucent.	Twisted	uniform
to	too	Translucents,	twisted	uniform
to	too,	transmission.	twisting	uniform
to	took	transmit	two	uniform,
to	took	transparency	two	uniformly
to	tool	transparency	two	uniformly
to	tool-programming	transparency,	Two	unique
to	tools	transparent	Two	unique
to	tools.	transparent	two	unique
				unique

unique	Use	used	valued	version
unique	use,	used	vapour	version,
unique	use.	used	variations	versions
unique	use.	used	variations	versions
unique	use.	used	varied	versions,
unique	use.	used	varied	very
unique	use:	used	varies	very
unique,	used	used	varies	vests
unique,	Used	used	varies	viable
units	used	used	varieties	vibration-proof
unlike	used	used	varieties,	vibrations,
unlike	used	used	variety	vibrations,
unlikely	used	used	variety	vice
unlimited.	used	used	variety	video
unpolished.	used	used	variety	videos
until	used	Used	variety	viewed
until	used	used	variety	viewed
until	used	Used	variety	viewed.
up	used	used	variety	viewed.
up	used	used	variety	viewer
up	Used	used	various	viewing
up	used	used	various	viewing
up	used	used	various	viewing
up	used	used	various	Vilene
up	used	Used	various	Vilene
up	used	used	various	Vilene
up	used	used	various	vinyl)
up	Used	used	various	violet.
up	used	used	various	Virtually
up	used	used	various	virtually
up	used	used	various	virtually
up	Used	used	various	virtuoso,
up	Used	Used	various	viscose.
up	used	used,	various	viscosities.
up	used	used,	Various	viscous
up	used	used,	various	viscous,
up	used	used,	various	viscous,
up	used	user	various	visibility,
up	used	user	various	visible
up.	used	user	Varius	vision
updated	used	user	varnish.	visiting
upon	used	Users	varnished.	visitor
upon	used	Users	vary	visual
upon	used	uses	vary	visual
urban	used	uses	vary	vitreous
urban	used	uses	varying	VitroLux
usage	used	uses	varying	volatile
use	used	using	varying	volcanic
use	used	using	Vegetable	volcanic
use	used	using	vegetable	volume
use	used	using	vegetable	volume
use	used	using	vegetable	volume
use	used	using	vehicles.	volume.
use	used	usually	Veluna	volumes
use	used	UV	Veluna's	vulcanized
use	used	UV	Veneer	Vulcarix
use	used	UV	veneer	Vulcarix
use	used	UV	veneer	Wacotech's
Use	used	UV	veneer,	waist
use	used	UV	Veneer.	walking
use	used	UV	veneers,	Walking
use	used	UV	ventilated).	walkways,
use	used	UV	ventilation	wall
use	used	UV	ventilation.	wall
use	used	V,	venturing	wall
use	used	vacuum	Vereinigte	wall
use	used	vacuum	versa.	Wall
use	used	vacuum	versatile,	wall
use	used	vacuum	version	wall
Use	used	vacuum	version	wallpaper,
use	used	vacuum.	version	walls
use	used	vacuum-tube	version	walls

Material World 2

Innovative Materials for Architecture
and Design

Publishers

Frame Publishers
www.framemag.com
Birkhäuser – Publishers for Architecture
www.birkhauser.ch

Introduction by

Quentin Hirsinger and Elodie Ternaux,
matériO. www.materio.com

Materials selected
and described by

Quentin Hirsinger and Elodie Ternaux,
matériO. www.materio.com

Photography by

matériO and Véronique Huyghe

Glossary written by

Tessa Blokland

Editor

Tessa Blokland

Graphic design

Thomas Buxó in collaboration with
Sarah Infanger. www.buxo.nl

Translation

Brian Keegan

Copy editing

Donna de Vries-Hermansader

Colour reproduction

Graphic Link, Nijmegen

Printing

Grafisch Bedrijf Tuijtel, the Netherlands

About matériO

MatériO is an independent information
centre devoted to materials and innovative
products. The centre provides creative people
from diverse backgrounds – architecture, in-
dustrial design, scenography, fashion design,
publishing, art and the like – as well as manu-
facturers, engineers and researchers, with a
large selection of specific, reproducible and
obtainable materials: key elements meant
to trigger and aid the process of creation.
Essentially, matériO is a Paris-based show-
room displaying literally thousands of prod-
ucts and samples of materials. MatériO also
provides members with a quality database:
www.materio.com.

Distribution

Benelux, China, Japan, Korea and Taiwan
ISBN-13 978-90-77174-00-5
ISBN-10 90-77174-00-1
Frame Publishers
Lijnbaansgracht 87
1015 GZ Amsterdam
the Netherlands
www.framemag.com

All other countries
ISBN-13 978-3-7643-7279-8
ISBN-10 3-7643-7279-6
Birkhäuser – Publishers for Architecture
PO Box 133
4010 Basel
Switzerland
Part of Springer Science+Business Media
www.birkhauser.ch

© 2006 Frame Publishers
© 2006 Birkhäuser – Publishers for
Architecture

A CIP catalogue record for this book is
available from the Library of Congress,
Washington D.C., USA

Bibliographic information published by Die
Deutsche Bibliothek
Die Deutsche Bibliothek lists this publication
in the Deutsche Nationalbibliografie; detailed
bibliographic data is available in the internet
at http://dnb.ddb.de.

Printed on acid-free paper produced from
chlorine-free pulp. TCF∞
Printed in the Netherlands
987654321

walls	Wavecore	well	which	will
walls	wavelength	well	which	will
walls,	wavelengths	well	which	will
walls,	wavelike,	well	which	windbreakers,
walls,	waves	well	which	window
walls,	waves	well	which	window,
walls,	waves,	well	which	windowless
walls,	wax	well-funded	which	windowless
walls,	Waxed	well-known	which	wine
walnut	waxed	well-known	which	wine
walnut.	waxed,	wells.	which	wire
warm	way	went	which	wire
warm	way	were	which	wire
warm	way	were	which	wire.
warm	way	were	which	wire.
warp	way	were	which	wireless
was	way	What	which	wires.
was	way	what	which	with
was	way	what	which	with
was	way.	whatever	which	with
was	we	when	which	with
was	wear	when	which,	with
was	wear	when	which,	with
was	wear-	when	while	with
washable,	wear,	when	while	with
washable.	wearing	when	while	with
washed	weatherproof	when	While	with
washed	weave	when	while	with
washed	weaving	When	while	with
washed,	weaving	When	When	While
waste	Web	when	while	with
waste,	Web	When	While	with
water	Web	when	white	with
water	web,	When	white	with
water	weed	when	white	with
water	weedy	When	white,	with
water	Weft	when	white,	with
water	weighs	When	white.	with
water	weight	when	white.	with
water	weight	When	whose	with
water	weight	when	whose	with
water	weight	when	whose	with
water	weights:	When	whose	with
water	welcomed	when	whose	with
water	weld	where	whose	with
water	welded	where	whose	with
Water	welded	wherever	whose	with
water	welded	which	wide	with
water-	welded	which	wide	with
water,	welded	which	wide	with
water,	welded	which	wide	with
water,	welding	which	wide	with
water,	welding	which	wide	with
water.	welding	which	wide	with
water.	well	which	wide	with
water.	well	which	wide	with
water.	well	which	wide	with
water-based	well	which	wide	with
waterproof	Well	which	wide	with
waterproof	well	which	wide.	with
Waterproof,	well	which	wide.	with
water-resistant,	well	which	widely	with
water-retaining	well	which	widely	with
water-retaining	well	which	Widely	with
waters	well	which	Widely	with
water-saturated	well	which	widely	with
Water-soluble	well	which	widely,	with
watertight,	well	which	width	with
watertight.	well	which	width).	with
Wave	well	which	width:	with
Wave	well	which	width:	with
Wavecore	well	which	widths	with
			will	with

with	withstand	Wx	yields
with	withstand	x	you
with	withstand	x	you
with	withstand	x	you
with	withstand	x	you're
with	withstands	x	your
with	withstands	x	your
with	withstands	x	your
with	withstands	x	your
with	withstands	x	Ypsilon.
with	withstands	x	Zealand
with	wood	x	Zealand.
with	wood	x	Zelfo
with	wood	x	Zelfo
with	wood	x	Zelfo
with	wood	x	Zero
with	wood	x	Zero
with	Wood	x	zone
with	Wood	x	zones
with	wood	x	Zostera
with	wood	x	zostera
with	wood	x	zostera
with	wood	x	ZosteraMat
with	wood	x	ZosteraMat
with	wood	x	
with	wood	x	
with	wood,	x	
with	wood,	x	
with	wood,	x	
with	wood,	x	
with	wood.	x	
with	wood-and-acrylic	x	
with	wood-based	x	
with	wood-like	x	
with	wool	x	
with	wool	x	
with	wool	x	
with	wool,	x	
with	words,	x	
with	words,	x	
with	work	x	
with	Work	x	
with	work	x	
with	work	x	
with	worked	x	
with	worked	x	
with	worked,	x	
with	works	x	
with	world	yarn	
with	world	yarns	
with	world	yarns	
with	world's	yarns	
with	worlds	yarns	
with	worn	yarns,	
with	worth	years	
with,	would	years	
within	woven	years	
within	woven	years	
within	woven	years,	
without	woven	years,	
without	woven	years,	
without	woven	years.	
without	woven	years.	
without	woven	yeast	
without	woven	yellow	
without	woven	yellow	
without	woven	yellow	
without	woven	yellow,	
without	wrack)	yellow.	
without	wrap,	yet	
without	wrapped	yet	
without	wrinkling	yields	
without	Wx		